Buckhead
Atlanta's First Address

Sponsored by the Buckhead Coalition

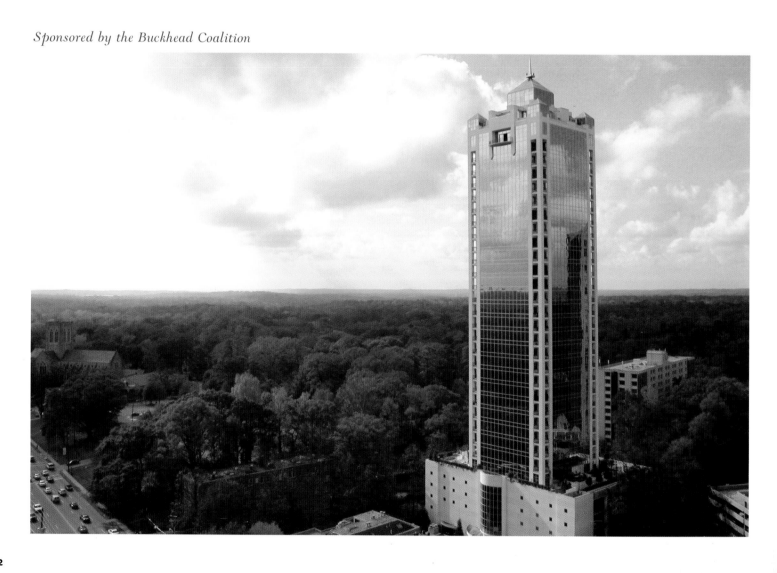

Buckhead

Atlanta's *First Address*

by Jan Hickel • Corporate Profiles by Candace T. Botha
Photography by L.A. Popp & Patrick Kelly

Buckhead, Atlanta's First Address

By Jan Hickel

Corporate Profiles by Candace T. Botha
Featuring the photography of L. A. Popp,
Patrick Kelly & Jennifer Shermer Pack

Indigo Custom Publishing
Publisher Henry S. Beers

National Sales Manager/
Project Coordinator William S. Koons

Editor-in-Chief Candace T. Botha
Editorial Associate Suzanne Vargas
Art Director/Designer Jennifer Shermer Pack
Director of Photography L.A. Popp
Profile/Caption Editor Candace T. Botha

Cover Photography by Lawrence A. Popp, Patrick Kelly
& Jennifer Shermer Pack

Indigo Custom Publishing
Macon, Georgia

Henry S. Beers, Chief Executive Officer & President

Indigo Custom Publishing, Macon 31210-3088
© 2003 by Indigo Custom Publishing
All rights reserved
Published 2003
Printed in China

First Edition: 00-00001
Library of Congress Number: 2003090145
ISBN: 0-972595l-0-4

For additional copies of this book, contact:
Indigo Custom Publishing
135 Summerfield Dr.
Macon, Georgia 31210
866.311.9578
478.471.9578

acknowledgements

Indigo Custom Publishing gratefully acknowledges the invaluable assistance and support of the following individuals, businesses, community entities, and organizations in the research and writing of *Buckhead, Atlanta's First Address.*
Their contributions have significantly enhanced the telling of the fascinating story of Buckhead.

Susan Kessler Barnard, Author of *Buckhead: A Place for All Time*
Lisa LeClair Klingmeyer, Owner of Legworks
Sam Massell, President of the Buckhead Coalition

Ahavath Achim
Atlanta Community Food Bank
The Atlanta Convention and Visitor's Bureau
Atlanta History Center
Bennett Street
BCD Holdings
Bitsy Grant Tennis Center
Blue Cross Blue Shield of Georgia
Buckhead Business Association
Buckhead Christian Ministries
Buckhead Life Restaurant Group
Carter's
Cathedral of Christ the King
Cathedral of St. Philip
Christ the King School
Concert Southern Promotions
Deering Antiques
Galloway School
Georgia Power
Goldstein, Garber, Salama & Beaudreau , LLC

Grand Hyatt Atlanta
Harry Norman, Realtors®
The Heiskell School
Jenny Pruitt & Associates, REALTORS
Lenox Square
Pace Academy
Peachtree Presbyterian Church
Peachtree Road United Methodist Church
Phipps Plaza
Piedmont Medical Center
PricewaterhouseCoopers
Regent Partners
Reliance Financial Corporation
Second-Ponce de Leon Baptist Church
Shepherd Center
State of Georgia
Wachovia
Westminster School
Wieuca Road Baptist Church

The author respectfully wishes to acknowledge the use of valuable information obtained from the following publications:

Barnard, Susan Kessler. *Buckhead: A Place for All Time.* Georgia: Hill Street Press, 1996
Fraley, Phyllis S. ATLANTA: A Vision for the New Millennium. Georgia: Longstreet Press, 1996
Atlanta Business Chronicle. January 31-February 6, 1997; September 11-September 17, 1998
Massell, Sam (ed.) *Buckhead Guidebook.* Georgia: The Buckhead Coalition, Inc., 2002
Georgia Trend Magazine. February 1998

Chapter 1 **metamorphosis**

With twenty-eight square miles of old world charm and contemporary character, pioneers and visionaries prudently created a community that has become one of the East Coast's most esteemed addresses.

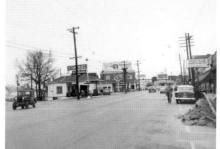

page **10**

Chapter 2 **lifestyle & neighborhoods**

The past and the present artfully blend in Buckhead, where historic homes and picturesque districts make this community a truly extraordinary place to enjoy the good life.

page **20**

Chapter 3 **arts, attractions & recreation**

Activities abound in Buckhead, where everyone from fitness enthusiasts and history buffs to art connoisseurs and fun seekers can always find an endless array of pleasurable pastimes.

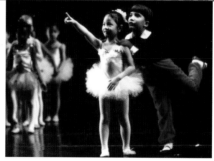

page **34**

Chapter 4 **the business of enterprise**

From quaint shops to corporate conglomerates, Buckhead is a thriving community of entrepreneurship, industry, and commerce.

page **48**

Chapter 5 **from ABCs to MBAs**

As a community devoted to the pursuit of learning, Buckhead earns an "A+" for its exceptional educational institutions, which rank among the finest in the nation.

page **64**

a people of faith *Chapter 6*

page **78**

Home to several of the country's largest congregations, Buckhead has a flourishing spiritual community that, time and time again, has proven to be an inspiration to one and all.

one hand, many hearts *Chapter 7*

page **92**

Buckhead is undeniably a community of friends and neighbors, as evidenced by its prevailing generosity and a willingness to reach out to others in need.

treasures & pleasures *Chapter 8*

page **106**

Attracting patrons from throughout the South, Buckhead's premier retail venues make this community a frequent and favored destination on the map of those in search of the finer things in life.

dining & nightlife *Chapter 9*

page **124**

Around the table and under the stars, there's always a whole lot cookin' for those lookin' for good fun and great food in Buckhead.

blueprint for the future *Chapter 10*

page **148**

Community leaders have laid the foundation for a promising future through exhaustive research, strategic planning, and sound recommendations for measured growth and development.

7

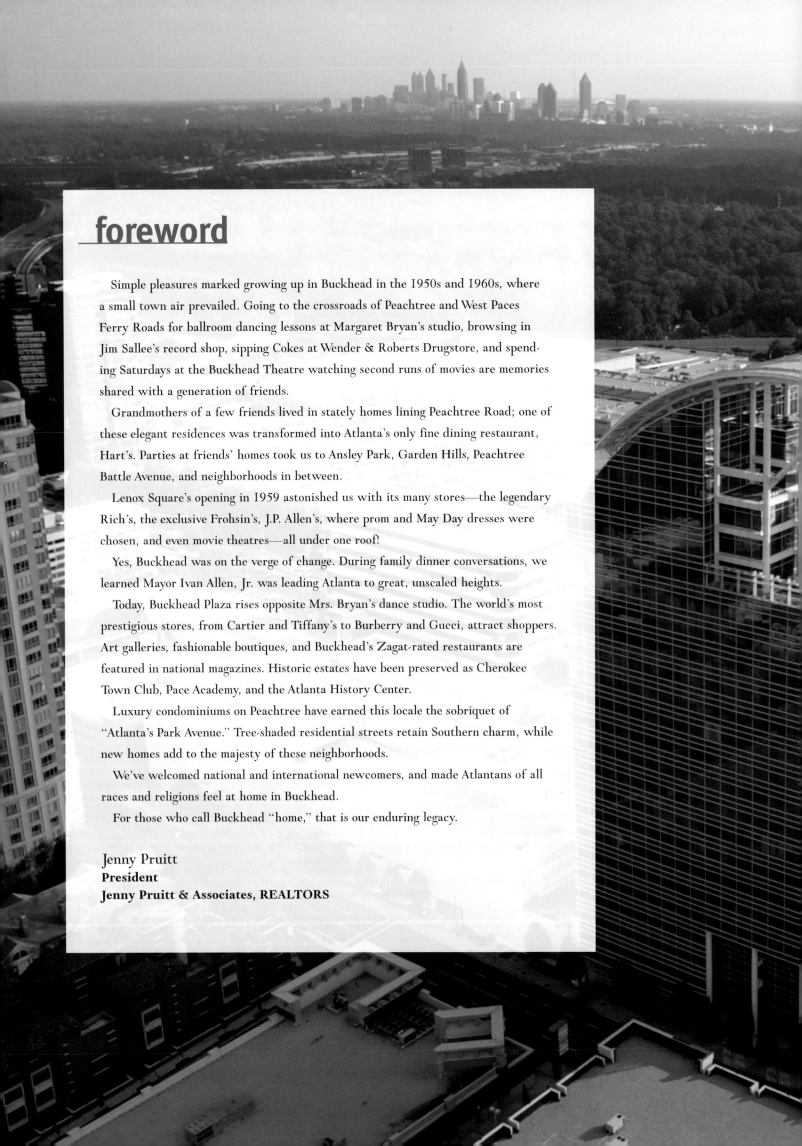

foreword

Simple pleasures marked growing up in Buckhead in the 1950s and 1960s, where a small town air prevailed. Going to the crossroads of Peachtree and West Paces Ferry Roads for ballroom dancing lessons at Margaret Bryan's studio, browsing in Jim Sallee's record shop, sipping Cokes at Wender & Roberts Drugstore, and spending Saturdays at the Buckhead Theatre watching second runs of movies are memories shared with a generation of friends.

Grandmothers of a few friends lived in stately homes lining Peachtree Road; one of these elegant residences was transformed into Atlanta's only fine dining restaurant, Hart's. Parties at friends' homes took us to Ansley Park, Garden Hills, Peachtree Battle Avenue, and neighborhoods in between.

Lenox Square's opening in 1959 astonished us with its many stores—the legendary Rich's, the exclusive Frohsin's, J.P. Allen's, where prom and May Day dresses were chosen, and even movie theatres—all under one roof!

Yes, Buckhead was on the verge of change. During family dinner conversations, we learned Mayor Ivan Allen, Jr. was leading Atlanta to great, unscaled heights.

Today, Buckhead Plaza rises opposite Mrs. Bryan's dance studio. The world's most prestigious stores, from Cartier and Tiffany's to Burberry and Gucci, attract shoppers. Art galleries, fashionable boutiques, and Buckhead's Zagat-rated restaurants are featured in national magazines. Historic estates have been preserved as Cherokee Town Club, Pace Academy, and the Atlanta History Center.

Luxury condominiums on Peachtree have earned this locale the sobriquet of "Atlanta's Park Avenue." Tree-shaded residential streets retain Southern charm, while new homes add to the majesty of these neighborhoods.

We've welcomed national and international newcomers, and made Atlantans of all races and religions feel at home in Buckhead.

For those who call Buckhead "home," that is our enduring legacy.

Jenny Pruitt
President
Jenny Pruitt & Associates, REALTORS

Buckhead is different things to different people. To our young visitors, it's the nightclub of Atlanta; to the gourmand, it's the dining room of Georgia; to the consumer, it's the shopping mecca of the Southeast; to the homebody, it's an expansive neighborhood of beautiful estates on rolling wooded lands; to the faithful, it's a township of stately houses of worship, and to the businessman, it's the "greatest concentration of small companies anywhere in the U.S." (as reported by *Inc.* Magazine).

When you factor in seventy-four art galleries, almost fifty parks, some of the nation's best schools, extensive public transportation, over two dozen hotels including four luxury flags, a variety of annual public events that draws some 669,000 people, and the numerous other oustanding aspects of this community, it becomes evident that this is a very special place with something for everyone. It's really best described as "a state of mind."

Buckhead is a community of more than fifty-five neighborhoods, and although its skyline of 16,000,000 square feet of office space, 5,000 hotel rooms and highrises with 16,500 multifamily units gives it the profile of a city, it is not a separate governmental unit. It is entirely within the city of Atlanta. Yet, over the years, it has earned many distinctions which have formed its unique identity.

Buckhead has official boundaries as designated by the Atlanta Regional Commission, highway entrance signage by the Georgia Department of Transportation, its own theme song recording, a three-hundred-page history book, an annual guidebook published by the Buckhead Coalition, an aerial map, its own Yellow Pages by BellSouth, and more. It should be no surprise, then, that leading firms have come together to sponsor this prestigious coffee table book, something very few "non-cities" have accomplished.

Those who live, visit, work, or play here have pride in doing so, and this book will be treasured as part of the experience.

Sam Massell
President, Buckhead Coalition
Former Mayor, City of Atlanta

Chapter 1

With twenty-eight square miles of *old-world charm* and *contemporary* character, *pioneers* and *visionaries* prudently created a *community* that has become one of the East Coast's most *esteemed* addresses.

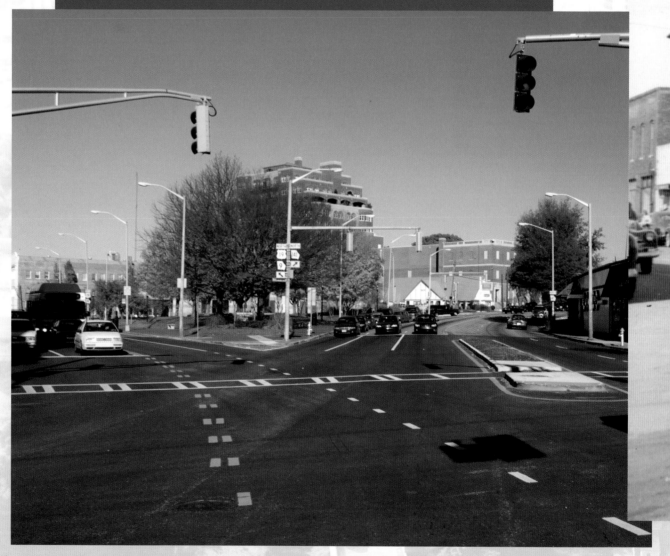

Above and at right, The intersection of Peachtree and Roswell Roads, pictured now and circa 1940, is still considered "the heart of Buckhead." In the community's early years, Peachtree Road, which winds north from Downtown Atlanta, was once lined with some of the city's most impressive homes. Today the busy boulevard boasts some of Buckhead's best apartments, restaurants, bars, and shopping venues, including Phipps Plaza and Lenox Square. Roswell Road has also "grown up," making way for an eclectic array of new loft condos, unusual eateries, gift shops, boutiques, galleries, and home-design showrooms.
Contemporary photo by Patrick Kelly; historic photo courtesy of Atlanta History Center.

metamorphosis

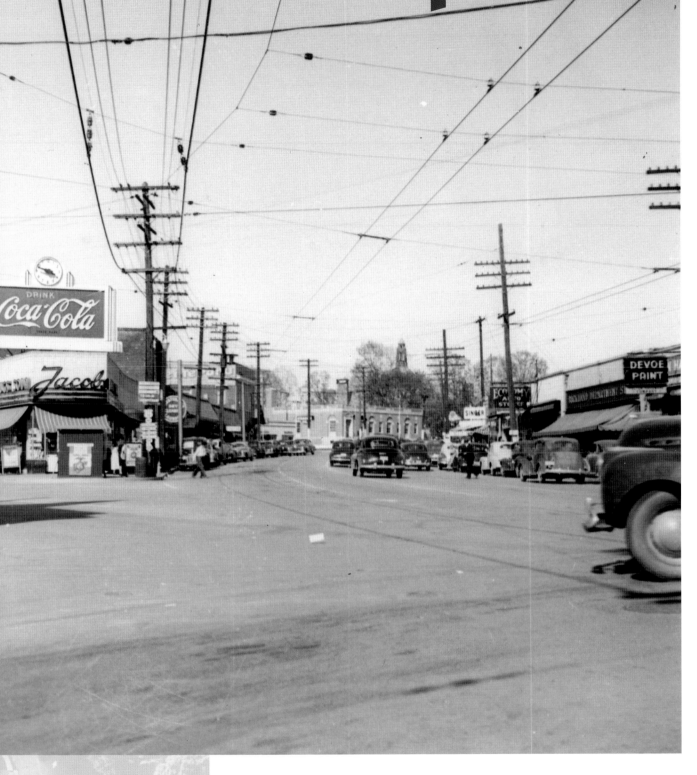

An Insightful Look at How Buckhead Came to Be

Through the years, the community of Buckhead has been christened with many names. It's been referred to as the "Beverly Hills of the East," and, on a grander scale, the "Beverly Hills of the South." It's been affectionately described as the "jewel in Atlanta's crown" and, more abstractly, as a "state of mind" or an "attitude."

Each of the monikers has some element of truth. The glitzy, glamorous shopping associated with Rodeo Drive and the stately mansions of Hollywood are here. So are thriving centers of business and entertainment.

People do, in fact, come from all corners of the city—and from vast distances—to become immersed in the excitement.

Buckhead is inspiration, aspiration, and destination—a place with something for everyone. Yet, it is more than just a place; perhaps, it's a way of life.

All of Buckhead's charms are packed into a mere twenty-eight square miles. The Georgia House of Representatives and the Atlanta Regional Commission have officially delineated the boundaries of the community: the area of north Atlanta bounded by the city limits/DeKalb County line eastward; the city limits line northward; the city limits/Cobb County line westward, and Peachtree Creek, near the point where Interstates 75 and 85 merge, southward.

According to native Atlantan Sam Massell, a person could literally spend his or her entire life in Buckhead. And, he adds in jest, if the community had a commercial cemetery, the stay could be permanent.

Everything a person could need or want—from exceptional schools, shopping, and houses of worship, to neighborhoods, employment opportunities, and playgrounds of all types for every age—it's all here.

Sam Massell may be just a little prejudiced in his assessment of Buckhead, but who can blame him? As a longtime Buckhead resident, the former mayor of Atlanta fervently believes that Buckhead is simply one of the best places on earth. And as president of the Buckhead Coalition and the community's most visible champion, it's his job to spread the message.

Massell says he's always on the job, whether in his Tower

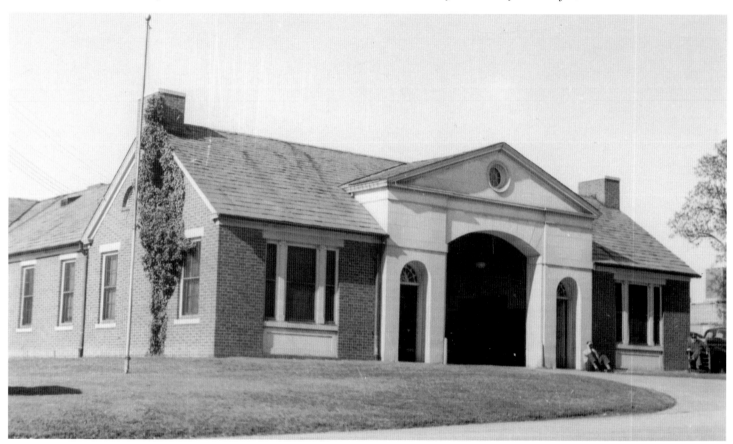

From the archives of the Atlanta History Center, the photograph above depicts the building that served as Buckhead's community firehouse in the 1940s. Photo courtesy of Atlanta History Center.

Buckhead is a place with a special blend of the old and new. As one who grew up here, I appreciate the fact that many of the neighborhoods, churches, schools, and community traditions that I knew as a child continue to thrive, while new progress brings growth and opportunity. Those who have gone before us have laid an excellent foundation for the future. May we remember them with gratitude!

—Jim Heiskell, Jr.
The Heiskell School

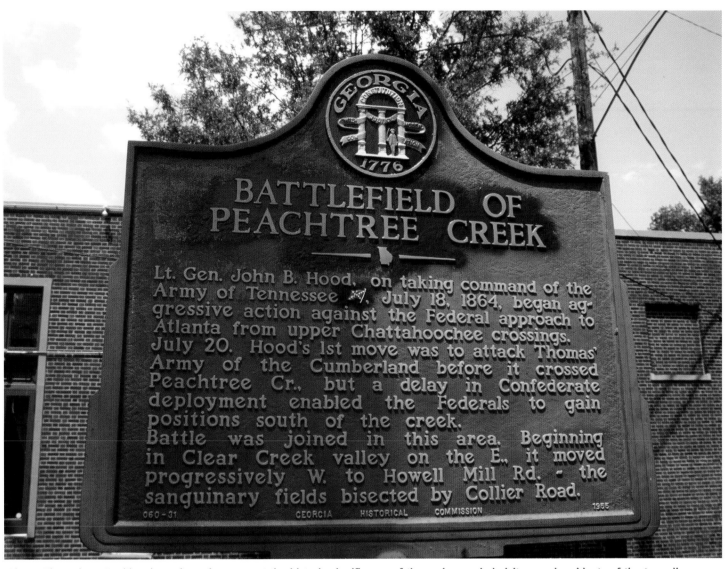

Above, Throughout Buckhead, markers that recount the historic significance of the region remind visitors and residents of the tragedies and triumphs experienced by Atlanta's ancestors. The Battlefield of Peachtree Creek is memorialized by this marker located on Palisades Road near Peachtree Road. Considered a major event in the Civil War, there were an estimated 6,506 casualties during the battle; 4,796 Conferedate soldiers lost their lives as they fought valiantly to defend the South. Photo by L.A. Popp.

Place office or out touting the Buckhead way of life. His office is a profusion of all things Buckhead, from the antique inkwell in the shape of a buck's head that sits on his desk, to the onyx-and-gold buck's head ring on his finger. His walls are adorned with photos from his current days as Buckhead's ambassador and his former political offices. One photograph in particular captures the image of Massell as a young Atlanta City Council president posed with the late Harry S. Truman, who knew a thing or two about bucks and where they stopped.

Massell says the fact that Buckhead has a theme song, a history book, a guide book, community limit signs, and, now, a showcase book of its own is a testament to its unique character.

Part of that uniqueness is based on a successful blend of business, residential, retail, and entertainment. Many communities across the country have one, two, or even three of these industries, but few, if any, have been able to support all four avenues of commerce continuously and simultaneously.

Buckhead's first library, which was located in R. L. Hope School, was founded in 1929 by Ida Williams, a former principal at the school. It eventually moved to the McDuffie Building on Roswell Road and was officially named the Ida Williams Library. In 1942, the neo-classical red-brick building, *pictured above*, became the library's permanent home at 49 Buckhead Avenue. Photo courtesy of the Atlanta History Center.

13

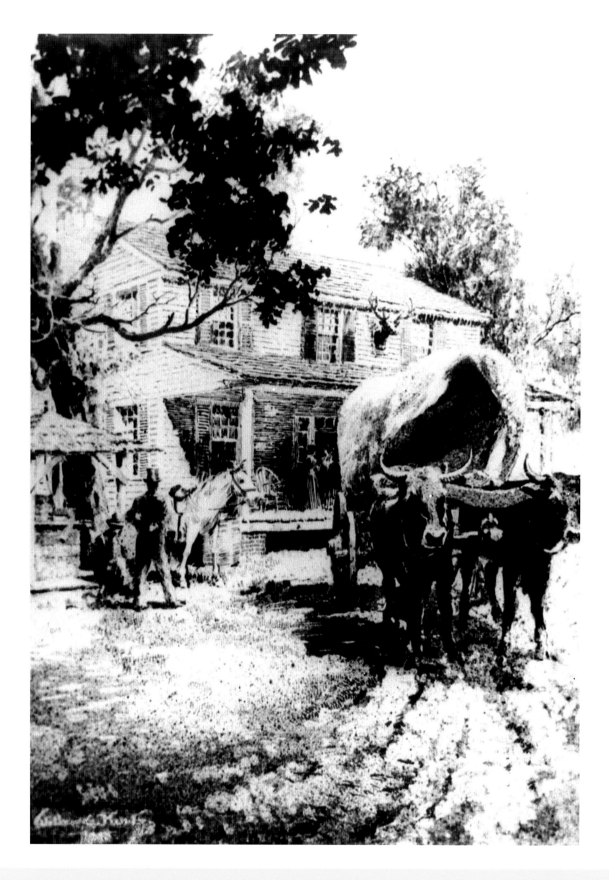

Of course the residents of Buckhead are its greatest assets; the old-line families who trace their heritage back to its early formation, and their new neighbors who are here by design. The esprit de corps abounds, and it is this attitude that generates a state of mind that will forever protect the community's superb quality of life.

—Sam Massell
President, Buckhead Coalition
Former Mayor, City of Atlanta

Buckhead doesn't just have these elements—it has the best of them. Leading businesses, world-class shopping, luxury hotels, award-winning restaurants, trendy nightspots, all surrounded by some of the most beautiful homes in the country, are the hallmark of this distinctive community. Add the region's wealth of trees and natural beauty to the mix, and it's no wonder Buckhead enjoys its reputation as an extraordinary place.

To better understand how Buckhead reached its enviable state of success and prosperity requires a brief look at its past.

The first residents of Buckhead were most likely Muscogee and Cherokee Indians. Documents from the 1770s note an encampment at Standing Peach Tree where the Chattahoochee River and Peachtree Creek meet. The major trail leading out of the village was Peach Tree Trail, beginning in Toccoa, winding down today's Peachtree Road, and splitting to the west at what is now the junction of Peachtree, Roswell, and West Paces Ferry Roads. The southern part of the trail extended to Five Points. To the east, the trail headed toward Stone Mountain.

Following the Revolutionary War, settlers began moving in, and by 1838, after a series of treaties, takeovers, and the "Trail of Tears," Georgia's Native American population had virtually disappeared.

That same year, Henry Irby bought 202 acres around the intersection of Peachtree, Roswell, and West Paces Ferry Roads for $650. He cleared some of the land and built a tavern and general store. The area, which was sparsely populated at the time, became known as Irbyville.

There are several legends that explain how the village originally became known as Buckhead. All accounts agree that it was around 1838 when a buck's head was posted outside of Irby's Tavern. The discrepancy is in who actually slayed and mounted the prized buck—a North Carolina man passing through town, an anonymous Native American, or Henry Irby himself.

Regardless of which legend is accurate, the outcome is the same, and over time, area residents began to meet at Buck's Head. The name endured, and today, this fabled location is still a destination where friends and neighbors gather.

Soon after, the area started growing, with families and businesses establishing roots. The Moores and Howells with their mills and the Paces, DeFoors, Powers, and Montgomerys with their ferries all made their mark on the community.

Buckhead's population continued to multiply throughout the century, with more and more pioneers taking advantage of the abundant acreage and the community's proximity to Atlanta's burgeoning railroad industry.

During the Civil War, the area between Peachtree Battle and Atlanta Memorial Park was the site of the Battle of Peachtree Creek in the summer of 1864. Although many Confederate and

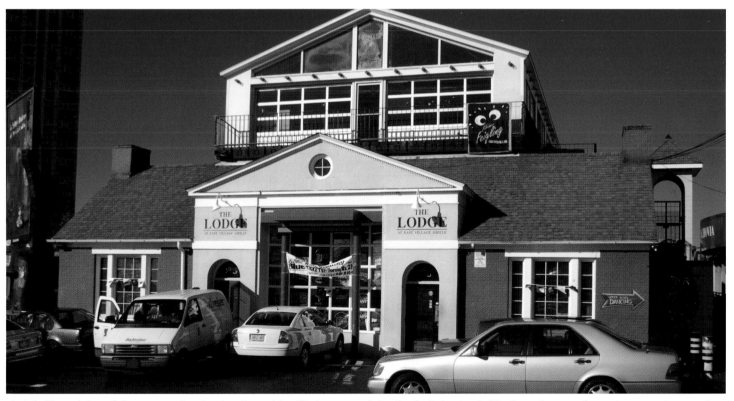

At left, The origins of the community that has been identified as one of the "nation's best subcities" can be traced to a tavern and general store built by Henry Irby in the 1830s. Originally called "Irbyville," the community became known as Buckhead, circa 1838, when the head of a large buck was mounted on a post near the tavern and, soon after, moved above its doorway. Illustration by Wilbur Kurtz, courtesy of the Atlanta History Center.

Above, According to local legend, The Lodge, a popular restaurant and bar in Buckhead, is located on the property that was once the site of Irby's Tavern. Photo by L.A. Popp.

Union lives were lost during the skirmish, when the smoke settled, few homes had been destroyed. Unlike Atlanta, Buckhead was spared the full-scale wrath of General Sherman.

The twentieth century not only brought increased business growth, but an upsurge in the number of affluent Atlantans who visited Buckhead—which was still quite rural—as a place to vacation and build summer cottages. Those homes eventually became permanent residences, and Buckhead experienced a growth in population and an increase in services that continued after World War II. The area was finally annexed into the city of Atlanta in 1952.

While the scope of this book doesn't permit an in-depth look at the history of Buckhead, additional resources are available. Susan Kessler Barnard's book, *Buckhead: A Place For All Time*, for example, provides a comprehensive look at the people and events that shaped the community.

One fact is overwhelmingly clear: The growth and opportunities in Buckhead have never ceased. Looking back to the day Henry Irby opened his tavern until this moment in time, when so many restaurants, bars, stores, galleries, office buildings, and condominiums are opening at any given time, no one—resident or visitor alike—would doubt for an instant that Buckhead's future is as colorful and promising as its past.

There is, indeed, something here for everyone, which is a remarkable tribute to an area that was once little more than dusty crossroads in the pine tree-filled woods of Georgia.

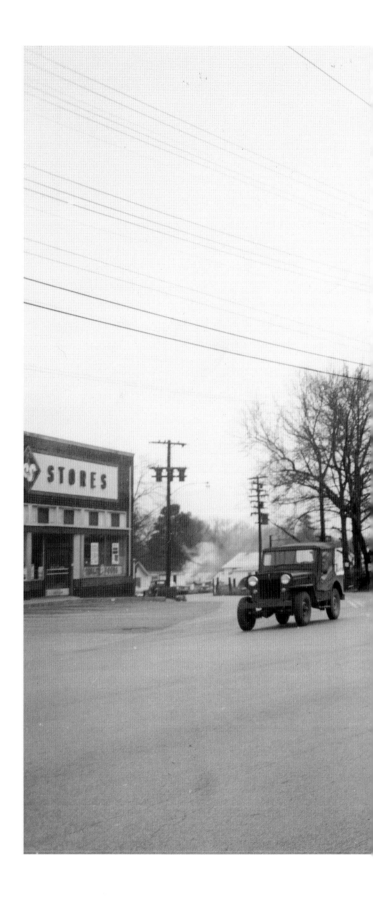

Despite the tremendous gains in technology affecting communications and the workplace, location is still one of the most critical strategic and business decisions which involve customers, employees, business partners, transportation, distribution, and overall service capabilities.

Our Buckhead location is surrounded by some of the best hotels, shopping and restaurants in the country—important benefits to our clients and strategic partners from around the country when they visit us, as well as our associates who work in Buckhead or visit from out-of-state locations. Convenient rail service with Hartsfield International is an added benefit.

We believe an extremely important element is the sense of community—a smaller cosmopolitan city within a large city—and a place and identification that ties our company and people together and with our clients.

—Kenneth J. Phelps
Chairman and Chief Executive Officer
Reliance Financial Corporation

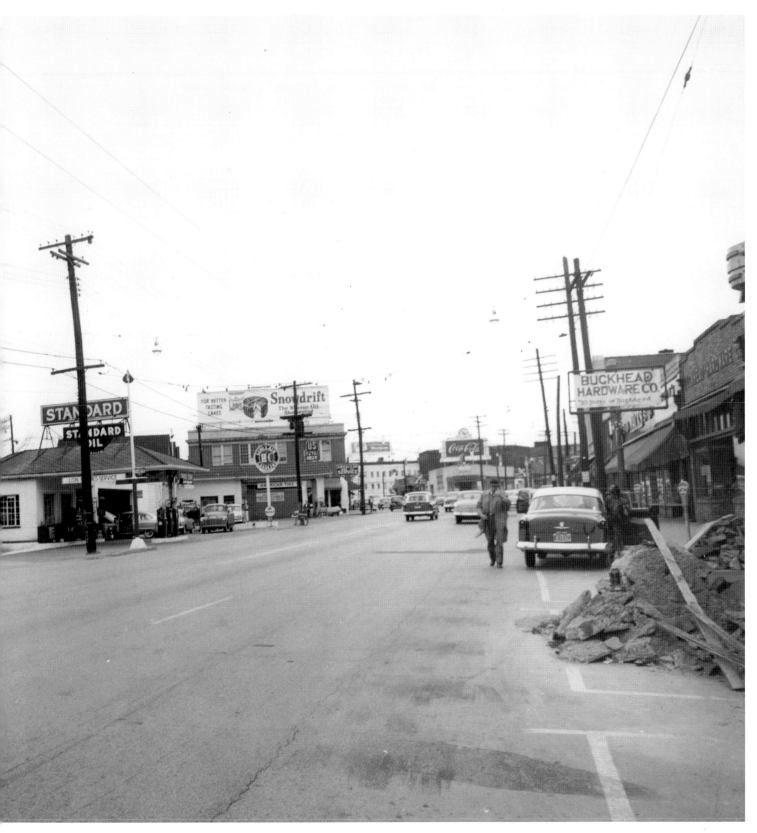

Above, Looking north from Pharr Road to the junction of Roswell and Peachtree Roads provides a unique perspective of the center of Buckhead during the 1940s. Photo courtesy of the Atlanta History Center.

Above, In tribute to the "American valor" demonstrated by the Confederate soldiers who lost their lives in July 1864 during the Battle of Peachtree Creek and to honor the courage of all those who have defended Atlantan and American soil since the Civil War, a monument erected by the Old Guard of Atlanta stands at the site of the historic battleground on Peachtree Battle. Photo by Jennifer Pack.

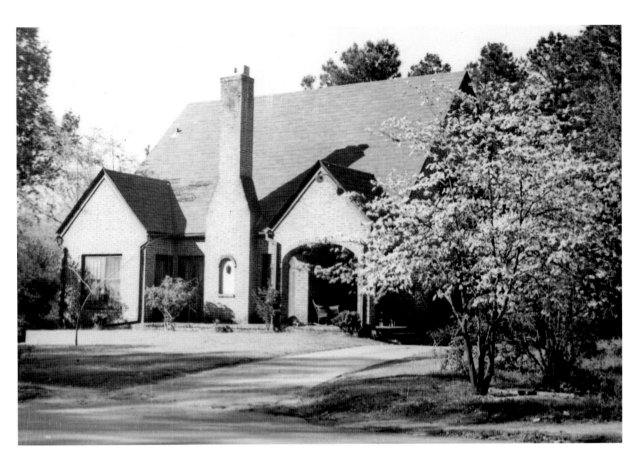
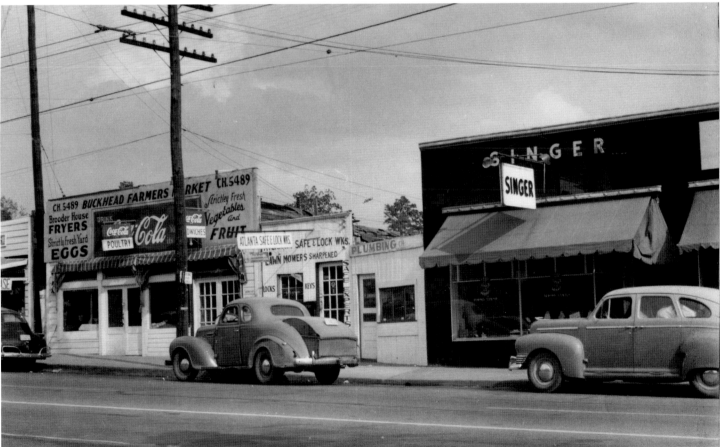

Cozy, one-story houses, or bungalows, that are similar to the residence *pictured at top*, were common throughout Buckhead during the 1940s. In the neighborhood of Peachtree Heights, Lakeview Avenue and Peachtree Way were lined with bungalows and American foursquares, another popular housing style of the era. Bungalows were also built on the bluffs above Peachtree Creek in the neighborhood of Peachtree Hills. *Above*, The Buckhead Farmers Market and Singer, a nationwide sewing store, were among the early tenants on Peachtree Road in the heart of Buckhead during the 1940s. Photos courtesy of the Atlanta History Center.

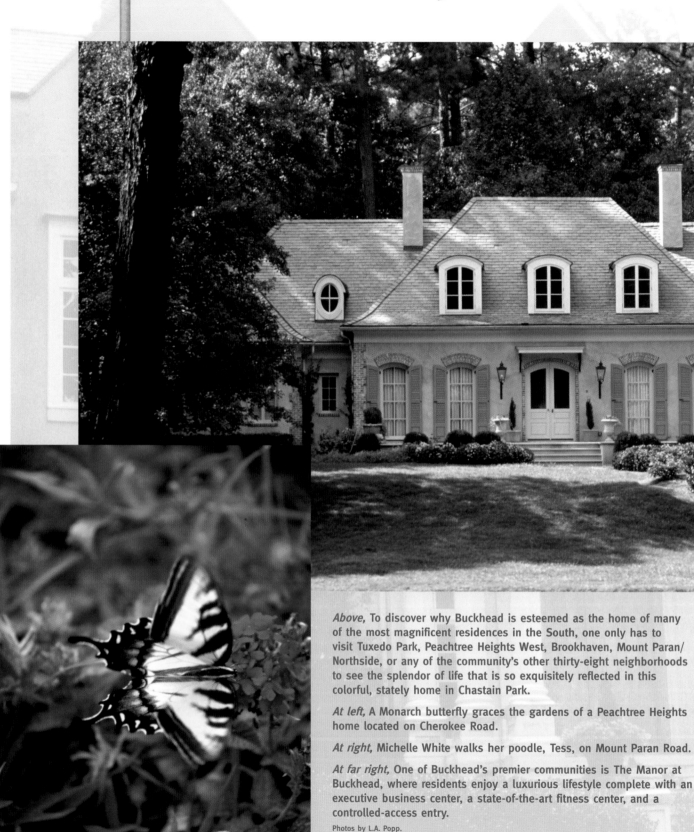

Chapter 2

lifestyles &

Above, To discover why Buckhead is esteemed as the home of many of the most magnificent residences in the South, one only has to visit Tuxedo Park, Peachtree Heights West, Brookhaven, Mount Paran/ Northside, or any of the community's other thirty-eight neighborhoods to see the splendor of life that is so exquisitely reflected in this colorful, stately home in Chastain Park.

At left, A Monarch butterfly graces the gardens of a Peachtree Heights home located on Cherokee Road.

At right, Michelle White walks her poodle, Tess, on Mount Paran Road.

At far right, One of Buckhead's premier communities is The Manor at Buckhead, where residents enjoy a luxurious lifestyle complete with an executive business center, a state-of-the-art fitness center, and a controlled-access entry.

Photos by L.A. Popp.

neighborhoods

The *past* and *present* artfully blend in Buckhead, where *historic* homes and *picturesque* districts make this community a truly *extraordinary* place to enjoy the good *life.*

At Home in the Captivating Community of Buckhead

Before towering, high-rise office buildings dotted the skyline and majestic cathedrals spires pierced the sky, before marble-floored malls lured shoppers from distant places and awards and accolades honored unique eateries, and before fun-loving folks crowded the Village for nocturnal entertainment, Buckhead was a quiet, little community with great promise.

Today the community's residential neighborhoods are the essence of Buckhead.

As a place to call home, Buckhead has few rivals. Its twenty-eight square miles encompass nearly fifty distinct neighborhoods and reflect a mélange of architectural styles—upscale, down-home, and everything in-between. Many of the names of these

mill operators, potters, and small business owners. These are the families whose legacies live on today on the streets of Buckhead; the Irbys, Colliers, Moores, DeFoors, Paces, Howells, and Cheshires all had vast tracts of land in the still undeveloped area. Their homes dotted the landscape with acres of property between them, extending to Buckhead's present-day boundaries.

In the years that followed the Civil War, Buckhead's population continued to grow. It was not long after the turn of the century, however, that Atlanta's civic leaders began buying large parcels of Buckhead's land to build summer cottages in the vicinity of the area that is now West Paces Ferry Road. Within the next several years, the grand Tudor, Colonial, and Italianate villas that continue to define the glamour and style of the area

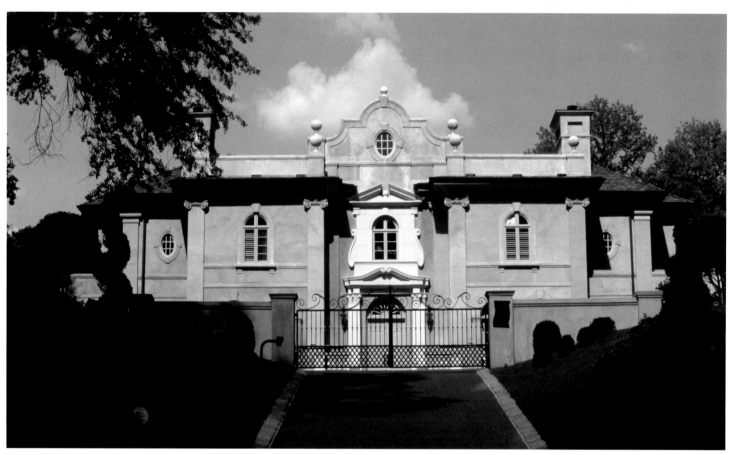

Above, Reminiscent of the villas that are characteristic of Europe's sprawling landscapes, this stately mansion is located in Tuxedo Park, a neighborhood in Buckhead that has evolved from farm and woodlands to a lush environment in which affluent Atlantans planted roots and built their summer estates. With its elegant Georgian, Tudor, Italianate, and Greek Revival estates, Tuxedo Park is now one of Buckhead's most esteemed year-round, residential neighborhoods. Photo by L.A. Popp.

neighborhoods—Peachtree Hills, Argonne Forest, Colonial Homes, Tuxedo Park, Kingswood, and Chastain Park—have become synonymous with gracious living.

From sprawling mansions of awe-inspiring beauty and cozy bungalows with quaint gardens, to high-rise apartments and condominiums attended by doormen, Buckhead's neighborhoods are as diverse and fascinating as its inhabitants.

In the early nineteenth century, Buckhead's first non-Native American residents began settling the area, laboring as farmers,

slowly began to replace the community's early cottages.

Many of these majestic mansions were built by noted architects of the day, including Philip Trammell Shutze and Neel Reid. As a testament to their grandeur, they were given equally elegant names—Villa Juanita, Woodhaven, and Trygveson/Pink Castle.

It's interesting to note that a common tradition among early Buckhead residents was to present large plots of nearby land to their children as gifts to celebrate their weddings.

In the years that followed, the area continued to flourish and

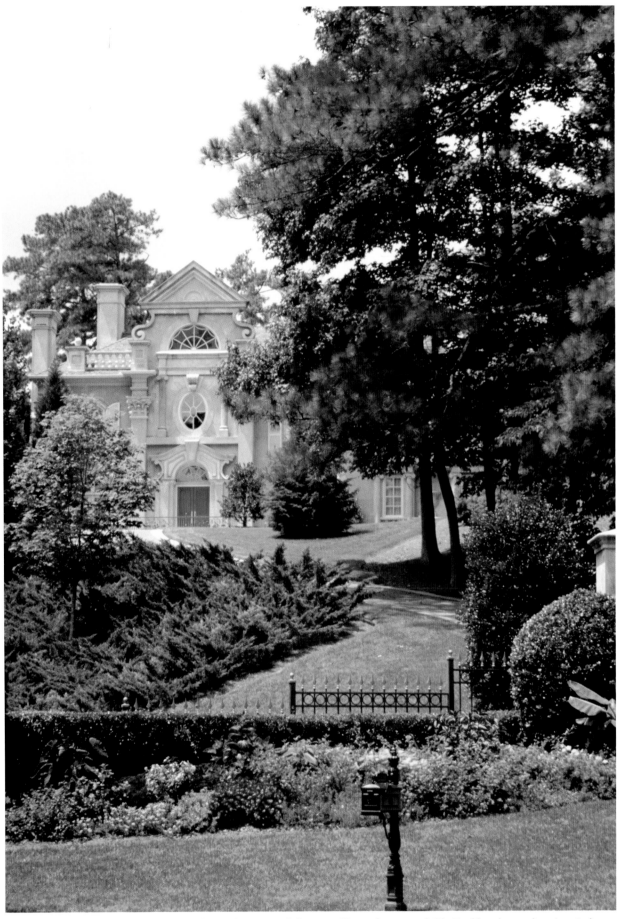

Above, Meticulously landscaped grounds are just one of the magnificent features of this Buckhead mansion. Located in the neighborhood of Mount Paran, this architectural wonder soars gracefully above the property's artfully designed gardens, blending modern design with old-world charm. Photo by L.A. Popp.

eventually became home to some of the area's prominent bank presidents, industry leaders, lawyers, and politicians.

Some of the community's most notable contemporary structures continue to give residents and visitors a glimpse of Buckhead's early days.

The present-day Governor's Mansion, for example, is situated on land once occupied by Woodhaven, while The Southern Center for International Studies is housed in a magnificent home designed by Shutze, circa 1930. This Regency-style building was once dubbed the "Peacock House" because of the colorful birds that inhabited the grounds.

Further down West Paces Ferry Road, Pace Academy, an independent college preparatory school, occupies a quarried rock "castle" that originally served as a lavish, private home in the 1930s.

Some of Buckhead's first neighborhoods emerged in the area about the same time.

Peachtree Battle Avenue and nearby streets like Habersham, West Wesley, Cherokee, and Muscogee were originally part of the Collier family's land. When the area was developed in 1910, it was named Peachtree Heights Park.

Today, Peachtree Heights Historic District encompasses many of those same streets, providing passersby with outstanding examples of residential architecture and exquisite landscape design.

Other early neighborhoods in Buckhead included Peachtree Park, which originally stretched from Piedmont Road to Brookhaven. Today the neighborhood's northern border is Georgia 400 and Lenox Square Mall. This suburb was designed for the middle class of the 1920s and 1930s and is distinguished by homes typifying the English Cottage, Craftsman, and Colonial-Revival styles of the day.

Advertised as a naturally beautiful escape from the noise and smoke of the city, the neighborhood of Garden Hills took more than fifteen years to develop. Listed on the National Register of Historic Places, Garden Hills is divided into three sections—Peachtree-Beverly Hills, Country Club, and Brentwood. During earlier years, the neighborhood flourished with the construction of architect-designed homes, schools, a clubhouse, churches, apartment buildings, and a commercial strip.

On the southern end of Buckhead is Brookwood Hills. The limited-access design of the district, coupled with its park-like landscaping, made this an attractive neighborhood for the upper middle class of the 1920s.

After World War II, the population of Buckhead experienced a growth spurt that has never diminished. Its convenient location and attractive amenities, both natural and manmade, have made Buckhead real estate a prime commodity.

In recent years, the demand for property in town has also exploded, making a Buckhead address even more desirable.

To accommodate the current demand for housing, developers are concentrating their construction efforts on luxury high-rise apartments and condominiums. The need for additional multi-unit housing has

Above, The award-winning, skillfully landscaped gardens of Post Chastain on Roswell Road provide a colorful welcome to residents and visitors alike. Amenities at the apartment complex include a planned social activities, sparkling swimming pools, lighted tennis courts, and fully equipped fitness centers. Photo by L.A. Popp.

evolved for several critical reasons: There is a pronounced scarcity of land; a continuing exodus of prospective residents from the suburbs, who have tired of long commutes into the city; an evident increase in the number of young professionals who wish to live in the community, but are not quite ready to own a single-family house; and a growing number of seniors eager to downsize.

The development of high-rises also serves several vital purposes within the community. They encircle the business core, providing work support and a labor market, as well as patronage for retailers; they serve as a buffer between businesses and single-family homes; and they help curb the traffic gridlock in Buckhead's busiest areas by promoting a pedestrian landscape.

Today the area has approximately sixty-seven thousand residents, with nearly seventeen thousand single-family homes and more than twenty-one thousand multi-family units. And although Buckhead has a little more than 2 percent of all single-family residences in the Atlanta area, 40 percent of the homes here are valued at $500,000 or more.

Throughout the nation, neighborhoods in prime locations that offer both convenience and unbridled beauty are neither plentiful nor inexpensive, but the community of Buckhead clearly offers all this and much more.

Consequently, it seems that the area's early settlers had amazing foresight when they decided the fertile lands of north Atlanta were the perfect place to establish roots, raise families, and develop neighborhoods that would, one day, be deemed among the finest in the Southeast.

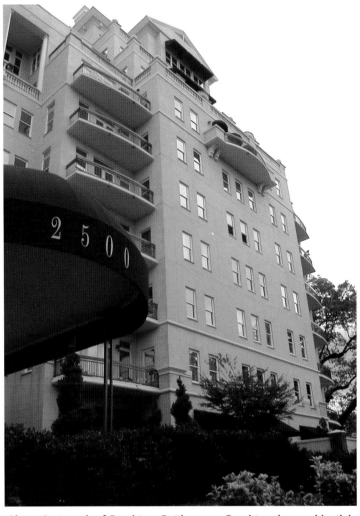

Above, Just north of Peachtree Battle, 2500 Peachtree is a residential complex located in an area of Buckhead called "The Park Avenue" of Atlanta. This prestigious property provides amenities that include valet parking, private elevator lobbies, concierge services, a fitness center, a club room, and much more. Photo by Jennifer Pack.

The Buckhead community should be extremely proud of its successful efforts to preserve a long-standing tradition of building a desirable community where families, neighborhoods, and businesses don't just co-exist—they thrive and support each other. The fruit of their dedicated efforts is borne out by the number of residents who are raised in Buckhead, leave for college, and return as adults to rear their own families in a place they proudly call "home."

—**Peggy Warner**
Principal
Christ the King School

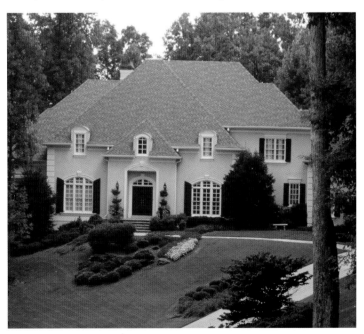

Above, One of the most distinguished addresses in Buckhead is discovered in the neighborhood of Mount Paran, where homes are designed to accommodate the superlative lifestyle that has positioned Buckhead at the pinnacle of gracious living. Photo by L.A. Popp.

At left and below, The Phoenix on Peachtree Road is a twenty-seven-floor luxury high-rise with sweeping skyline views, dramatic terraces, and outdoor public gardens. The Phoenix also features its own library and business center, a grand salon and media room, and a fitness center, swimming pool, and spa.
Photos by Jennifer Pack.

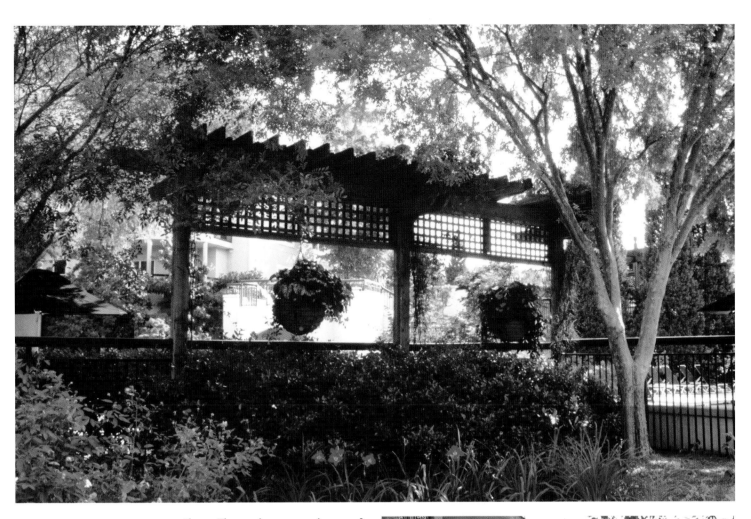

Above, The modern conveniences of apartment living in a natural setting surrounded by acres of lush greenery add to the appeal of Post Chastain on Roswell Road. Some of the complex's one- and two-bedroom units overlook a formal English Garden, while others provide breathtaking views of the Nancy Creek Nature Preserve.
Photo by L.A. Popp.

Above, Built in 1927, the Alhambra Apartment complex on Peachtree Road is listed in the National Register of Historic Places. Sixty-five single and multi-floor units offer residents affordable living with all the sophistication of a Buckhead lifestyle.
Photo by L.A. Popp.

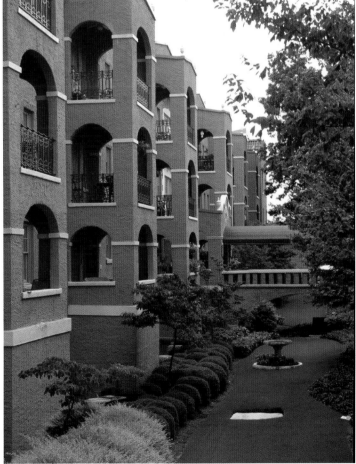

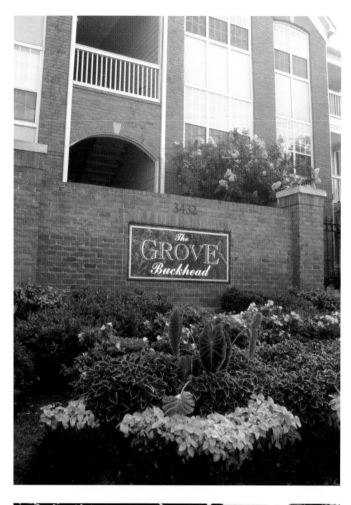

Above left, Located at the intersection of Piedmont Road, Buckhead Loop, and Carsen Lane, The Grove Buckhead is an apartment complex where young professionals and couples enjoy the dynamic business and social lifestyles that characterize Buckhead.

Bottom left, Located in the Mount Paran/Northside neighborhood of Buckhead, a gated mansion regally peeks through the trees above manicured grounds, giving passersby a view of the home's grand-scale design and opulence.

Above, Constructed in nineteenth-century American style, Alexandria Townhomes is a luxurious complex of forty-four classically styled residences ranging from twenty-six to thirty-eight hundred square feet. Located on Lenox Road, the units include oak floors, well-appointed kitchens, and alley-access garages among their many amenities. An added feature: Most of the townhomes have their own elevators.

Photos by L.A. Popp.

Above, Multi-level landscaping complements the innovative architectural design of this upscale residence, which is located on Mount Paran Road.
Photo by L.A. Popp.

At left, One of the advantages of living in Chastain Park is the opportunity to venture outdoors and enjoy the breathtaking scenery that surrounds this North Atlanta neighborhood.
Photo by Patrick Kelly.

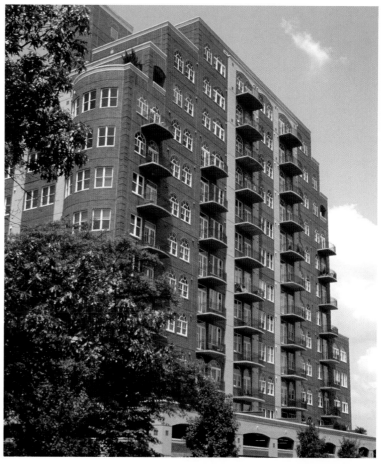

At right, Located in the heart of Buckhead, Mathieson Exchange Lofts is a sixteen-story, mid-rise complex with seven floors of well-appointed lofts and three floors of luxurious penthouses. Amenities include twenty-four-hour lobby attendance and controlled access, a swimming pool with a spa, a fitness center, and a spectacular rooftop clubhouse with a 1,280-square-foot terrace that provides beautiful views of Buckhead and beyond.

Below, Golden shades of autumn gently shroud this majestic home, which is located on West Paces Ferry Road. A circular driveway, garden sculptures, and architecturally unique door and window detailing are among the residence's distinctive features.

Photos by L.A. Popp.

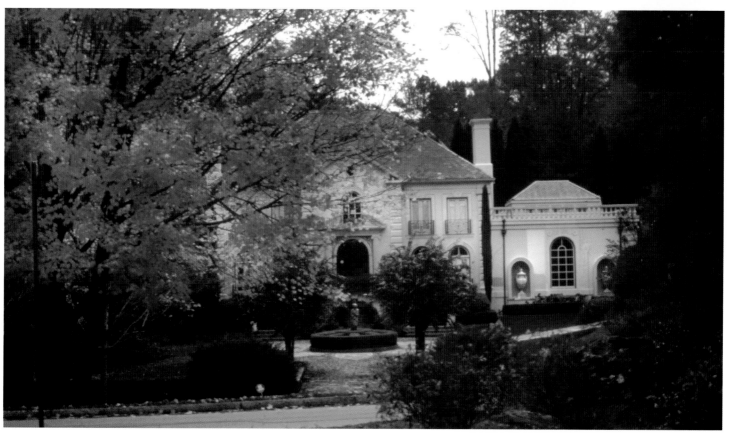

Above, Located in Peachtree Heights, which was listed on the National Register of Historic Places in 1980, this striking residence is one of approximately 400 homes in the neighborhood, many of which are classic or traditional in design. Photo by Jennifer Pack.

At right, While a diverse array of architectural styles are represented in Tuxedo Park, there is a unifying factor throughout the neighborhood: Large property lots abundant with trees and shrubs—which are one of Tuxedo Park's distinguishing characteristics—were developed in an effort to maintain the natural environment of this park-like section of Buckhead.

Photo by L.A. Popp.

Below, Once an area of Buckhead that was primarily hardwood forest, the well-manicured, residential neighborhood of Peachtree Heights—often called Peachtree Heights West—is also home to many of Buckhead's magnificent mansions that were designed by acclaimed architects Philip Trammell Shutze, Neel Reid, and Buck Crook.

Photo by Jennifer Pack.

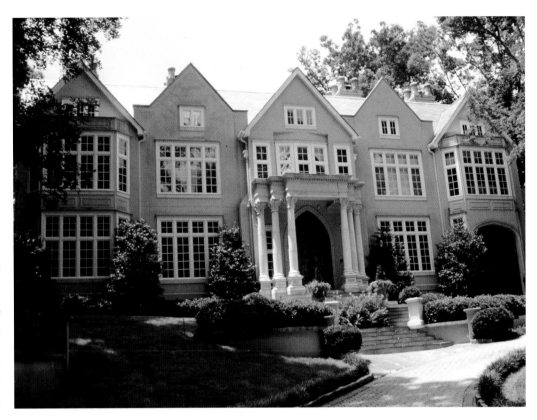

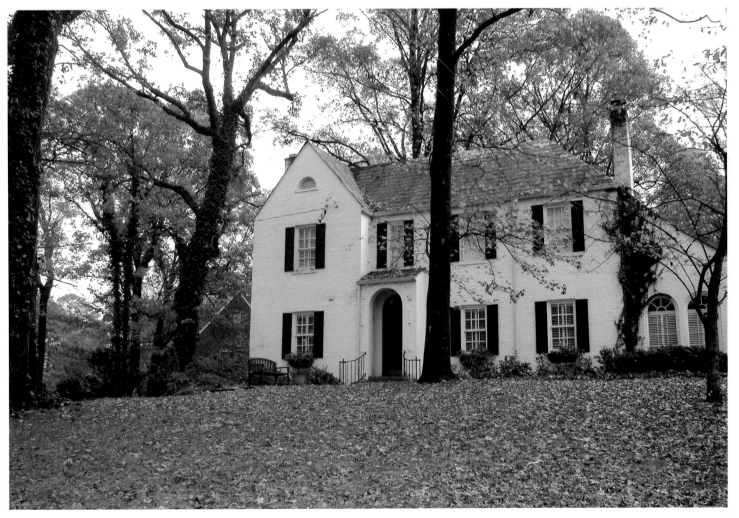

arts,

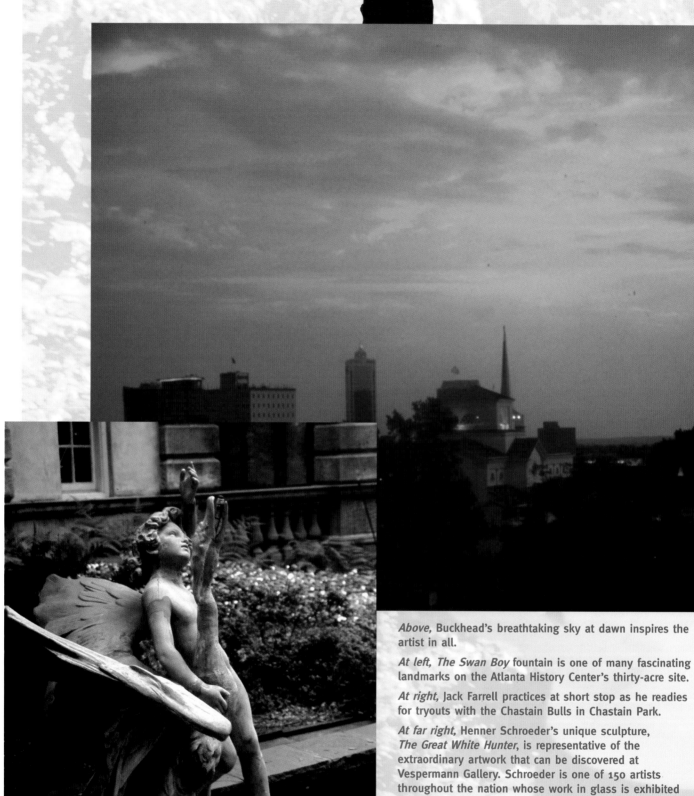

Above, Buckhead's breathtaking sky at dawn inspires the artist in all.

At left, The Swan Boy fountain is one of many fascinating landmarks on the Atlanta History Center's thirty-acre site.

At right, Jack Farrell practices at short stop as he readies for tryouts with the Chastain Bulls in Chastain Park.

At far right, Henner Schroeder's unique sculpture, *The Great White Hunter,* is representative of the extraordinary artwork that can be discovered at Vespermann Gallery. Schroeder is one of 150 artists throughout the nation whose work in glass is exhibited at the East Paces Ferry Road gallery.

Photos by L.A. Popp.

attractions
& recreation

Activities **abound in Buckhead, where everyone from** *fitness* **enthusiasts and** *history* **buffs to** *art* **connoisseurs and** *fun* **seekers can always find an** *endless* **array of pleasurable** *pastimes.*

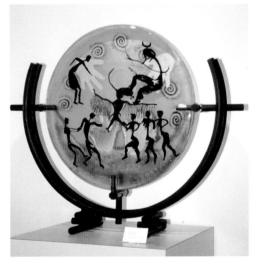

Things to See, Places to Be in Buckhead

Above, Eclectic collections of contemporary art are waiting to be discovered along Gallery Row in South Buckhead.

At left, A pristine interior provides a perfect backdrop to showcase the extraordinary paperweights, perfume bottles, jewelry, vases, sculptures, and other artistic pieces—all created from glass— at Vespermann Gallery.

Photos by L.A. Popp.

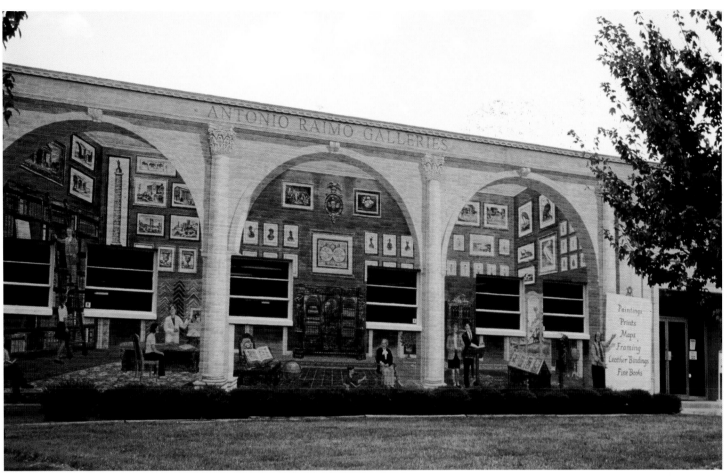

Above, A larger-than-life outdoor mural vividly depicting a colorful Italian arcade welcomes art lovers to Antonio Raimo Galleries on Miami Circle.

At right, In the heart of the Buckhead's business district at Tower Place, *The Kite Children,* sculpted by Gary Price in 1995, has quickly become a community treasure. Photos by L.A. Popp.

Buckhead's wealth extends far beyond the affluent neighborhoods and majestic mansions that are character-istic of this charming address in Atlanta. It is the generous offering of art, cultural, and recreational opportunities that makes this thriving community rich beyond compare.

For the connoisseur of fine arts, it would actually take weeks upon weeks to visit all of Buckhead's art galleries; there are nearly seventy-five in all. The community is home to Atlanta's thriving art scene, with galleries both large and small showcasing works created in every medium.

Folk art, fine art, decorative arts, paintings, drawings, photography, sculpture, glass, and pottery crafted by both emerging and nationally known artists are on display and for sale.

Several clusters of galleries have evolved, with design districts Miami Circle and Bennett Street leading the way in both number and diversity. Buckhead's Village district also boasts a strip of galleries, much like the area of Peachtree Street in South Buckhead known as "Sobu Row."

Galleries, however, aren't the only settings in which Buckhead's artistic tastes can be enjoyed. There are more than thirty pieces of sculpture on public display throughout the

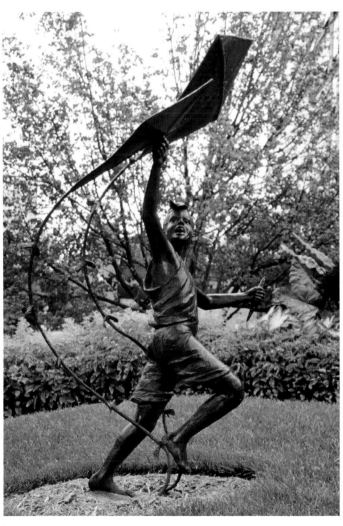

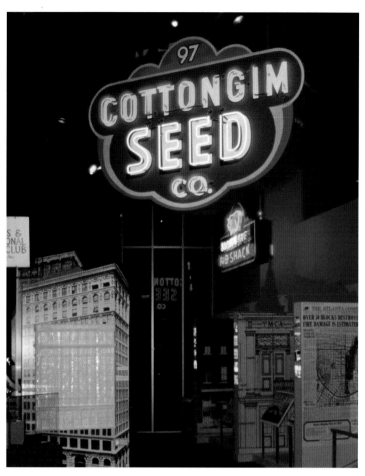

Above, Broad Street's Cottongim Seed Company was a part of the Atlanta commercial scene, circa 1890. The neon sign, pictured above, dates from the late 1930s and is now part of the Atlanta History Museum's exhibition, *Metropolitan Frontiers: Atlanta, 1835-2000.* Photo by L.A. Popp.

community. Many have become part of the landscape as visually arresting landmarks that illustrate various aspects of life in Buckhead.

Several renditions of Atlas reflect the area's strength and vitality, while *The Kite Children* at Tower Place poignantly reminds people of simpler, carefree times. In Buckhead Park, *The Storyteller* adds a whimsical and historical note to the heart of the community, and *The Great Fish*, a sixty-five-foot sculpture at the Atlanta Fish Market, is simply a great conversation piece.

Buckhead's churches and hospitals are also graced with an abundance of art that celebrates the human spirit and capacity for compassion.

Area history buffs and visitors new to the area will appreciate the retrospective on life in Atlanta waiting to be discovered at the Atlanta History Center, which offers a fascinating look at how the city's past has shaped its present. The sprawling complex includes the Swan House, the Tullie Smith Farm, and the Atlanta History Museum, as well as acres of gardens and an exhaustive library and archive collection.

The Swan House is often cited as a symbol of gracious Southern living in general and Buckhead's beauty and charm in particular. The home, which is listed on the National Register of Historic Places, was originally named for the swan motif extensively used as an artistic design element throughout the house's interior.

Built in 1928 by noted Atlanta architect Philip Trammell Shutze for Edward and Emily Inman, heirs to a post-Civil War cotton brokerage fortune, the home's design incorporates both Italian and English classical styles.

In 1966 the Atlanta Historical Society purchased the Swan House and most of its original antique furnishings. The house was opened to the public a year later, offering visitors a firsthand look at the life of an affluent family in Atlanta, circa 1930.

The Tullie Smith House was built by the Robert Smith family in the 1840s. The structure, described as a "plantation-plain" house, is also included on the National Register of Historic Places. Originally located on eight hundred acres of property east of Atlanta in what is now DeKalb County, the farm amazingly survived the city's fiery destruction by General Sherman in 1864.

The house and its outbuildings were moved to their current location at the Atlanta History Center beginning in the late 1960s.

A tour of the farm complex offers further evidence of Atlanta's rural past with its authentic blacksmith shop, detached kitchen, smokehouse, dairy, barn, and corncrib, which are all housed on the property.

Above, With thirty thousand square feet of exhibition space, the two-story Atlanta History Museum also features a 118-seat theater, a museum shop, classrooms, and The Coca-Cola Cafe. Award-winning collections, which represent the colorful history of Georgia, the South, and the United States, include fascinating objects dating from the early nineteenth century to the present. Photo by L.A. Popp.

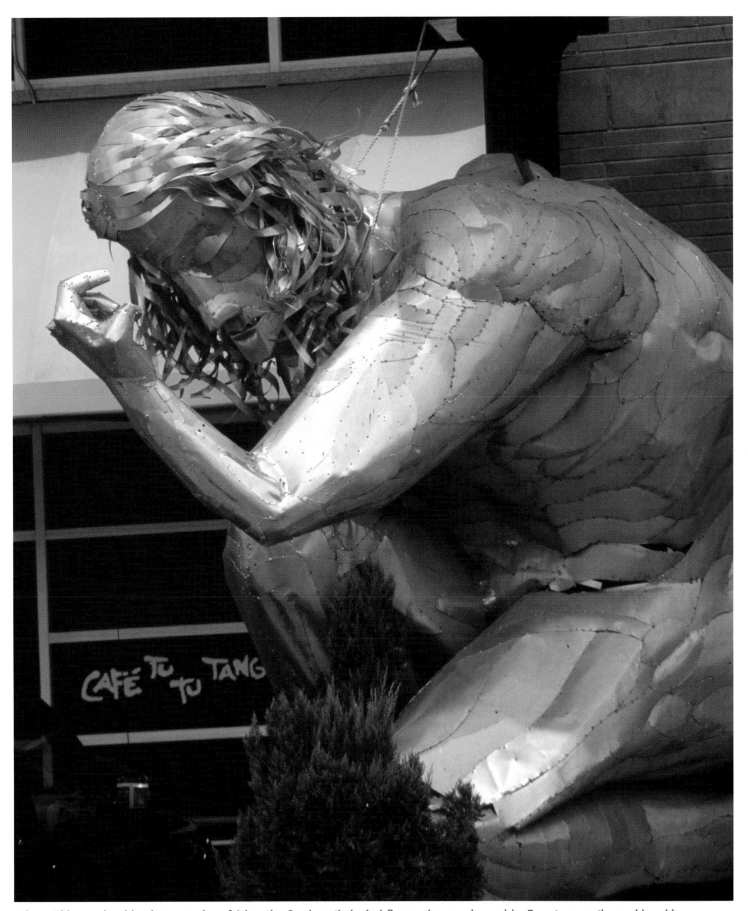

Above, This awe-inspiring interpretation of Atlas, the Greek mythological figure who was doomed by Zeus to carry the world on his shoulders, is one of three sculptures of the Titan god in Buckhead, all skillfully created by artist Randy Blain in 1999. Crafted from molded metal, the work of art is located outside Café Tu Tu Tango on Pharr Road. Photo by L.A. Popp.

Above, Designed by renowned Atlanta architect Philip Trammell Shutze, the Swan House gives visitors a glimpse of life in the early twentieth century. Listed on the National Register of Historic Places, the elegant mansion and its breathtaking gardens are considered Shutze's finest residential work. Photo by L.A. Popp.

Above, Thirty-three acres of spectacular gardens, woodlands, and nature trails give visitors to the Atlanta History Center's gardens an opportunity to explore nature while rediscovering the horticultural history of Atlanta and its surroundings. Photo by L.A. Popp.

Costumed tour guides at the Tullie Smith Farm provide descriptive details of daily life during the mid-1800s, adding another genuine element to this fascinating exhibit.

The Swan House and the Tullie Smith Farm are surrounded by thirty-three acres of beautiful gardens, woodlands, and nature trails, which colorfully illustrate the region's horticultural history. Winding paths lead from the Quarry Garden to the property's period gardens.

Well worth seeing is the garden where dozens of rhododendron species are abloom in an array of breathtaking colors.

Another historical perspective on life in Atlanta is available by visiting the Atlanta History Museum, located on West Paces Ferry Road. The museum houses permanent and transitory exhibits that recount the story of Atlanta, from early Indian settlements to contemporary events, such as the 1996 Olympics. From the emergence of railroads, the conflicts of the Civil War, and the era of Reconstruction to the literary publication and movie premiere of *Gone with the Wind* and the Civil Rights movement, Atlanta's triumphant and, at times, tragic history is chronicled in fascinating tableaus.

One of the most comprehensive collections of Civil War memorabilia and history is on permanent exhibition at the museum.

Turning Point: The American Civil War explores the full scope of what is commonly thought to be the most monumental event in the country's history. Authentic objects such as cannons, guns, uniforms, and flags bring to life the conditions that surrounded the war and took the lives of six hundred thousand Americans. Photos, personal stories, maps, and interactive stations further enhance each visitor's understanding of this epic conflict.

Other exhibits focus on the ways in which folk art has shaped lives. Examples of pottery, woodwork, basketry, weaving, quilting, and metalwork illustrate how these mediums, once central to the lives of Southerners, now offer insight into our social history.

Another popular exhibit recounts the story of homegrown golfing legend Robert Tyre "Bobby" Jones, Jr. *Down the Fairway with Bobby Jones* explores Georgia's involvement in the game, from course development and tournament play to the integration of public courses. Central to the exhibit is the story of the man considered to be the most important golfer in the sport's history. Photographs and personal artifacts tell the story of Jones's amazing career and his enduring impact on the game.

Atlanta's history can also be discovered throughout the community. More than seventy historical markers dot the landscape, many recounting the locale's significance during the Civil War.

The Governor's Mansion, located on West Paces Ferry Road, is another local structure of historic significance. Completed in January 1968, the Greek Revival-style mansion was designed by famed Georgia architect A. Thomas Bradbury. Its thirty rooms span twenty-four thousand square feet and include a sweeping entrance hall, drawing rooms, a library, a formal dining room, and the First Family's private living quarters. Furnished with nineteenth-century Neo-Classical furniture, paintings, and porcelain that complement the home's architectural design, the mansion is credited with having one of the finest collections of Federal Period furniture in the country.

The mansion's eighteen acres include an expansive front lawn, where the public gathers each December for the lighting of the Christmas tree. By law, the mansion belongs to the people of Georgia and is open to the public for tours.

The Cherokee Town and Country Club is another stunning structure situated on West Paces Ferry Road. In 1955 some of Buckhead's most affluent families agreed that a club for recreational and social activities was needed in close proximity to their homes. Together they leased a private, one-hundred acre estate featuring a limestone and stucco English Country-style home, with an option to buy the property for $200,000.

Today, the club continues to provide a haven for Buckhead and Atlanta's social and business elite.

Golf and tennis on the same world-class order can also be found in some of Buckhead's public facilities. Located off Northside Drive, the Bobby Jones Golf Course and the Bitsy Grant Tennis Center offer athletes an opportunity to pursue the sports excellence achieved by their legendary namesakes.

As a point of interest, Bitsy Grant Tennis Center has been named one of the top ten public centers in the country by *Tennis Magazine* and is home to the Georgia Tennis Hall of Fame.

Chastain Memorial Park attracts recreational and fitness enthusiasts from throughout the community to its challenging, eighteen-hole golf course, tennis courts, swimming pool, gym, baseball facilities, and horse stables.

In addition to horseback riding lessons, therapeutic instruction for developmentally disabled children is offered at the stables through a program supported by the Rotary Club of Buckhead.

As Buckhead residents are well aware, there's no need to visit a recreational facility to enjoy the outdoors. The community's abundance of picturesque neighborhoods and parks provide the perfect backdrop for a jog, a brisk walk, or a picnic.

There is no doubt that Buckhead's extensive array of cultural and recreational activities makes the opportunities for enjoyment endless and the prospect of boredom impossible.

When I grew up in Buckhead, it was a quiet, friendly village. We knew the shop owners, and they knew us. Buckhead is still a fun place to play, just more sophisticated. The soda fountains have now become some of the greatest restaurants in the world. Buckhead is truly a great place to live, work, and play!

—Dr. Ronald Goldstein
Senior Partner
Goldstein, Garber, Salama &
Beaudreau, LLC

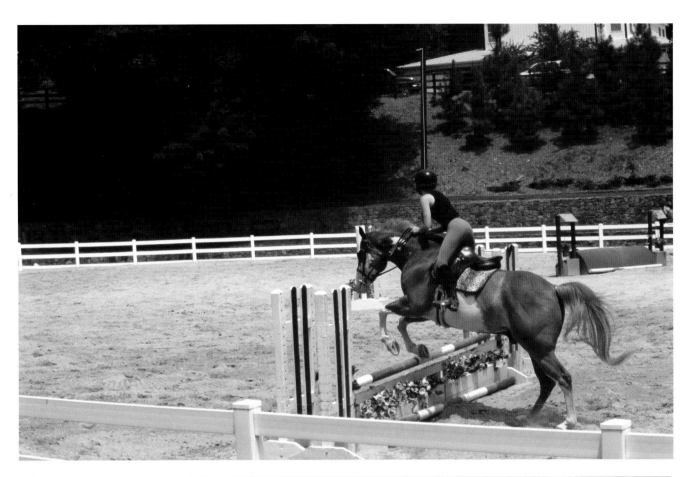

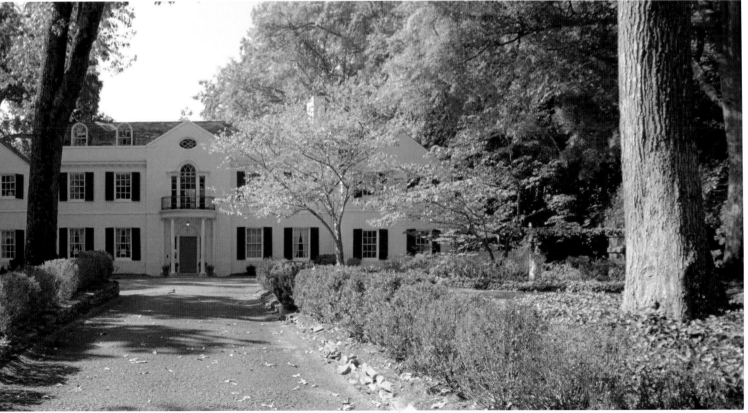

Top photo, Claudia D'Avanzo of Morningside, Georgia, demonstrates her equestrian skills atop her beloved horse, dell'Arte, at Chastain Horse Park. Founded by Amy C. Lance in 1997, the horse park occupies thirteen acres within Chastain Memorial Park. Photo by L.A. Popp.

Above, Built in 1929 by Philip Trammell Shutze, the Goodrum House is recognized as one of the nation's finest examples of English Regency architecture. Often called "The Peacock House" for the birds of brilliant plumage that once roamed the grounds, the house has served as the home of the Southern Center for International Studies, a nonprofit educational instiution and policy research center, since 1962.

Photo by Patrick Kelly.

Above, Georgia's golf legend lives on at the 18-hole, par-71 golf course on Woodward Way designed by and named for Atlanta's own Grand Slam winner, Bobby Jones. Photo by Patrick Kelly.

At left, Traditional flower, herb, and vegetable gardens are among the sites at the Tullie Smith Farm, an historical complex that includes a plantation-plain house built by the Robert Smith family in the 1840s, as well as a separate open-hearth kitchen, a smokehouse, a blacksmith shop, a double corncrib, a pioneer log cabin, and a barn. Photo by L.A. Popp.

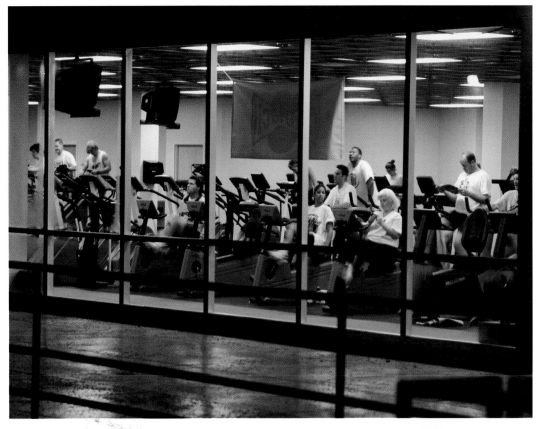

At right, With six workout clubs in Atlanta, including its location on Piedmont Road, Crunch Fitness brings state-of-the-art workout facilities to Buckhead.

Below, Built in 2000, the Carl E. Sanders Family YMCA features a multi-use gym with an indoor walking and running track.

Photos by Patrick Kelly.

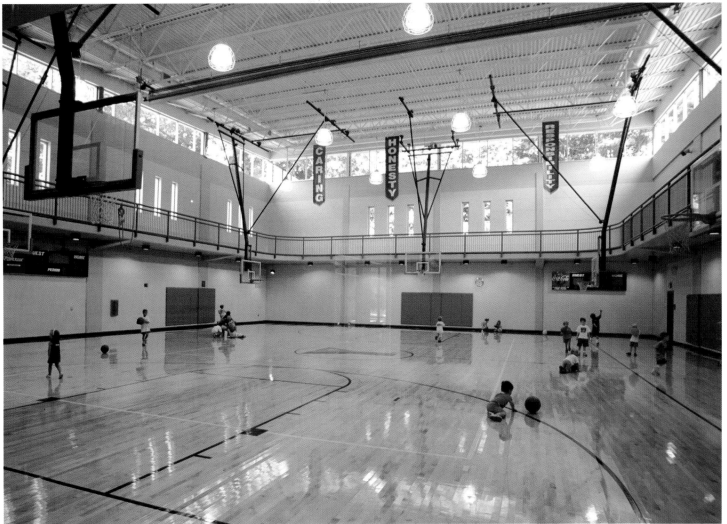

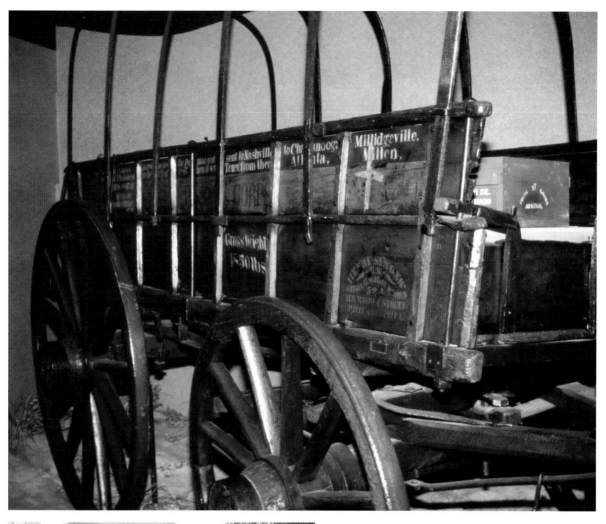

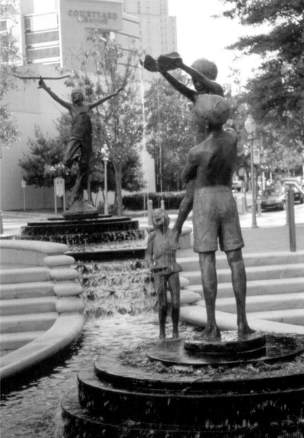

Above, As one of the last surviving examples of its kind now in existence, this Civil War wagon was used to carry supplies for Sherman's Union army as the troops advanced on Atlanta and during the March to the Sea. The wagon is part of the exhibition titled, *Turning Point: The American Civil War, 1861-1865* at the Atlanta History Museum.

At left, One of four sculptures on display by artist Gary Price in Tower Place Park, a one-acre public green space in the center of the Tower Place complex on Peachtree Road, *Wings* was created in 1998.

Photos by L.A. Popp.

At right, Created by Elbert Weinberg in 1972 and located on Peachtree Road, *Temptation of Eve* is the sculptor's interpretation of the Biblical story of Adam and Eve.

Photo by L.A. Popp.

Below, Buckhead residents have an unquenchable passion for dance, often attending performances staged by professional dance companies or recitals performed by the Atlanta Ballet Centre for Dance Education's tiniest ballerinas.

Photo by Kim Kinney, courtesy of the Atlanta Ballet Centre for Dance Education.

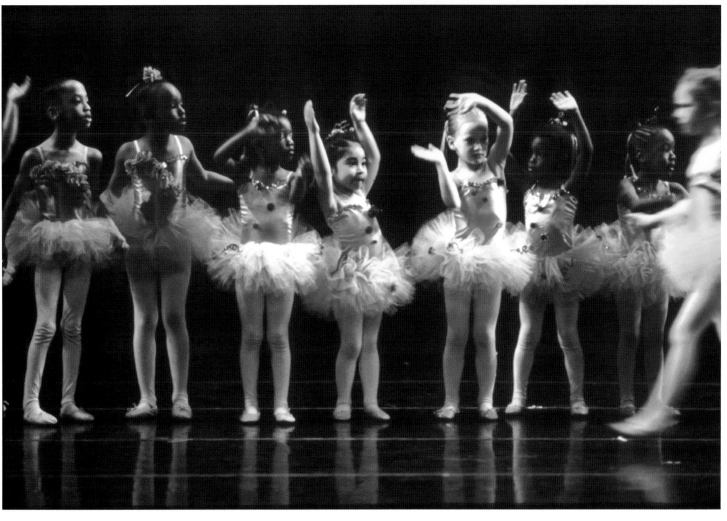

the business

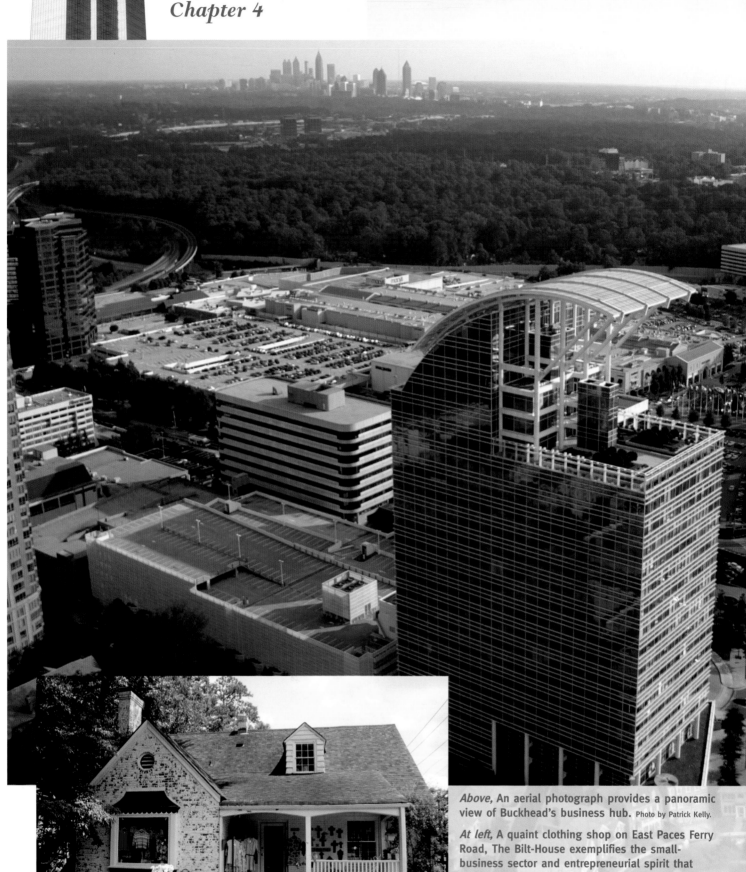

Above, An aerial photograph provides a panoramic view of Buckhead's business hub. Photo by Patrick Kelly.

At left, A quaint clothing shop on East Paces Ferry Road, The Bilt-House exemplifies the small-business sector and entrepreneurial spirit that prevails in Buckhead. Photo by L.A. Popp.

At right, A geometric, glass walkway at the Atlanta Financial Center serves as a gateway to one of Buckhead's most impressive corporate complexes on Peachtree Road. Photo by Patrick Kelly.

of enterprise

From *quaint* shops to *corporate* conglomerates, Buckhead is a *thriving* community of *entrepreneurship*, *industry*, and *commerce*.

Economic Perspectives on Buckhead's Growth & Success

Throughout Buckhead's history, fledgling entrepreneurs and industry giants alike have found inspiration and discovered success within the community's twenty-eight square miles. With excellent transportation, plentiful commercial real estate, a wealthy population, and active, engaged business districts, Buckhead has long been a prosperous community—financially, economically, and commercially.

It was, after all, working-class people who established the community, and folks have been employed here ever since.

Often described as an "edge city," Buckhead offers all of the amenities characteristic of a flourishing business and commercial district in a larger city, with the added advantages of sophisticated residential and retail environments.

In fact, the progressive growth of Buckhead's business district has given the area a skyline that rivals downtown Atlanta's, leading Sam Massell, president of the Buckhead Coalition, to predict that Buckhead may very well be destined to become the "downtown" of metro Atlanta.

Massell could be right on the money, because it's difficult to argue with the facts: Year after year, Atlanta's highest percentages in both population and employment growth emanate from Buckhead.

Throughout our nation's economic history, when much of the country has experienced the financial pinch of a recession, Buckhead still continued to experience boundless prosperity.

The phenomenal growth of business in Buckhead during the last decade can be credited to many factors but one, in particular, stands out: Georgia 400. The highway's expansion southward—past Lenox Square and under the Atlanta Financial Center—from I-285 to I-85 north of downtown Atlanta, opened up the proverbial floodgates. Suddenly Buckhead was easily accessible from the suburbs by commuters who previously had to navigate already crowded surface streets to get to their places of employment. With two Buckhead exits on the highway, the route was paved for new business development, along with the construction of additional single and multi-family housing units and retail centers.

Metropolitan Atlanta Rapid Transit Authority (MARTA) has also significantly contributed to Buckhead's business success. Its two rail lines, three rail stations, and seventeen bus lines facilitate travel into Buckhead for both workers and shoppers. Business travelers commuting from the airport to one of several convention hotels within walking distance of the stations also enjoy MARTA's convenience.

It was in the 1960s when modern-day Buckhead first began cutting its business teeth with the construction of several low- to mid-rise office buildings. But the community's first skyscraper, Tower Place—a twenty-nine-story building that was erected in 1974—set the stage for Buckhead's rise to business dominance.

Tower Place is still an impressive landmark, especially at night

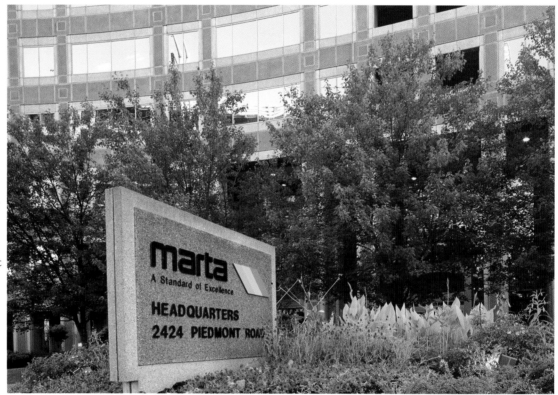

Above, Headquartered on Piedmont Road, Metropolitan Atlanta Rapid Transit Authority (MARTA) has had an indubitable impact on Buckhead's business success by facilitating travel into the community by both executives and shoppers via seventeen bus lines, two rail lines, and three rail stations. Photo by Patrick Kelly.

when its green, neon trim transforms the building into Buckhead's own Emerald City. But it now shares the skyline with many other impressive structures, including Monarch Tower, Buckhead Plaza, Pinnacle, and Resurgens Plaza, among others.

Buckhead's phenomenal growth has not been exclusively vertical. The landscape is dotted with sprawling, multi-building complexes, such as Piedmont Center and the Atlanta Financial Center. Many of the metro area's biggest employers are here and all told, there are 170 office buildings and nearly 17 million square feet of office space in Buckhead. And the good news is that it's nearly completely occupied.

Buckhead also has one of the lowest vacancy and highest

rental rates in the city. Those enviable statistics extend to housing, hotels, and other business outlets, as well. A diverse variety of fourteen hundred stores span almost eight million square feet of retail space and, again, more than 90 percent of this prime space is occupied.

While other geographical areas flounder, Buckhead flourishes. Perhaps that's because people make an effort to take advantage of Buckhead's bounty. It is estimated that 40 percent of the community's retail revenue is generated from people who live at least one hundred miles away.

Economic forecasters predict that Buckhead's upward business trends are likely to continue. Three hundred acres of prime real estate have already been zoned for other than single family residential developments. Nearly one hundred buildings spanning almost nineteen million square feet of office space, two million square feet of retail space, four thousand hotel rooms, and seventy-six hundred apartments and condominiums are also on the drawing board.

But Buckhead's business profile isn't just about quantity; it's also about quality. The top metro producers in a variety of industries have proudly made Buckhead their corporate home. Business leaders in advertising, architecture, commercial development, interior design, real estate, property management, public relations, broadcasting, dining, and stocks and bonds all have esteemed Buckhead addresses on their business cards.

According to data compiled by the Buckhead Coalition, Emory Marketing Association, Georgia State University, and the Buckhead Business Association, there are 1,207 total retail establishments—including 230 restaurants and bars and 360 specialty stores—in Buckhead. From necessities, such as automotive parts, books, clothing, computer supplies, prescription drugs, and groceries, to life's most luxurious amenities—antiques, art, flowers, gifts, and jewelry—there is always more in store for those who browse or buy in Buckhead.

Above, Prominence in Buckhead is an eighteen-floor commercial property that was completed in 1999. The Piedmont Road location provides views of downtown Atlanta's skyline from most floors. With 424,309 square feet, the structure boasts numerous amenities, including concierge and banking services, a fitness center, a conference facility, a deli/carry-out restaurant, dry cleaning and sundry shops, and an automobile detailing/maintenance center. Photo by L.A. Popp.

A sizable share of professional services—1,373 in all—have also "hung their shingles" along the gracious streets and amidst Buckhead's business districts. When searching for accountants, lawyers, physicians, dentists, Realtors, insurance agents, and a host of other professionals, there is an impressive directory of highly qualified experts from which to choose.

Those who are familiar with the community are well aware

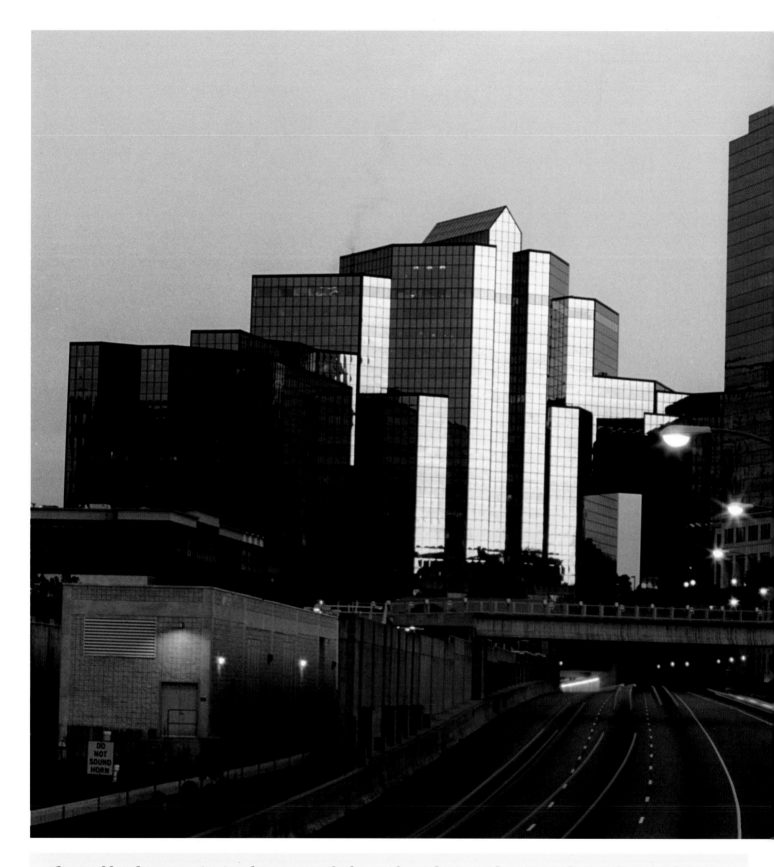

The Buckhead community is a large part of what makes Atlanta such a great place to live. With Lenox Square and Phipps Plaza, it is the unquestioned leader of shopping in Georgia and throughout the Southeast. With its many shops and restaurants, it is also the premier area of nightlife and culture for Atlanta's diverse population. Buckhead is a special area, and Wachovia will continue to remain committed to this fine community.

—Gary Thompson
Georgia State CEO, Wachovia Bank, N.A.

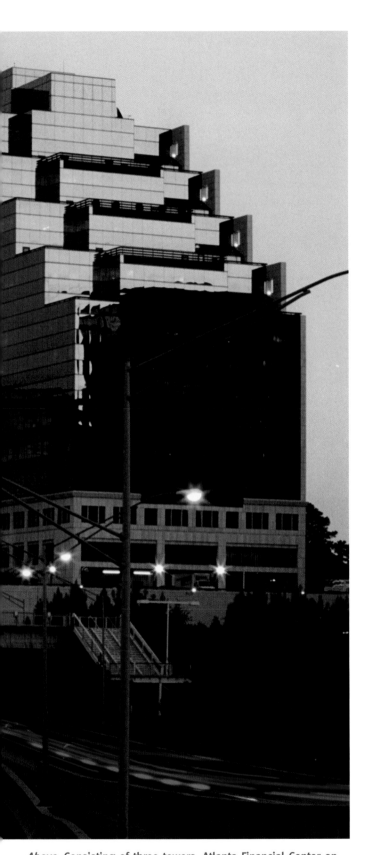

Above, Consisting of three towers, Atlanta Financial Center on Peachtree Road, NE, was originally constructed in 1983. With 887,290 square feet of prime commercial space, the center is home to corporate offices, as well as Buckhead Athletic Club, Atlanta Auto Spa, The University of Georgia Alumni Club, Silicon Valley Bank, Starbucks, and other prestigious businesses. Photo by Patrick Kelly.

that luxurious overnight accommodations also play a major part in both Buckhead's appeal and its economy, with more than five thousand hotel rooms in the community's two three-star hotels, three four-diamond hotels, one four-star hotel, and one of the state's two five-diamond hotels. According to PKF Consulting, hotel-room occupancy in July 2000 was an impressive 73 percent.

Although it has been identified by *Inc.* Magazine as the community with "the greatest concentration of small companies anywhere in the United States," Buckhead has also lured national and international conglomerates to its corporate landscape.

Large corporations with recognizable names that represent a diverse array of industries—BellSouth, Coca-Cola, Chubb Group Insurance, Dean Witter Reynolds, J. Walter Thompson, Kaiser Permanente, Merrill Lynch, Prudential Insurance, Target, Wachovia Bank, and others—have proudly added Buckhead to their rosters of national and/or international locations.

Worldwide leaders in the hospitality industry have not only capitalized on Buckhead's allure for tourists, but also its status as one of the premier business hubs in the Southeast. Crowne Plaza, Embassy Suites, Grand Hyatt, Ritz-Carlton, Sheraton, Swissôtel, and Wingate Inn have luxurious hotels with state-of-the-art conference facilities to lavishly accommodate overnight business travelers and vacationing guests within the community's perimeters. Marriott, in fact, has five hotels and inns in Buckhead's zip codes, all conveniently located near the community's major shopping centers.

Other industrialists have taken advantage of Buckhead's reputation as a retail profit center. Simon Property Group, an Indianapolis-based retail real estate firm known nationwide for its leading role in the development of America's highest quality retail properties, owns and manages not one, but two malls in Buckhead—Lenox Square and Phipps Plaza.

Other businesses have brought international recognition to Buckhead by making the community their headquarters.

The field of esthetic dentistry—or, in layman's terms, cosmetic dentistry—has been revolutionized by "Team Atlanta," a group of practitioners that has earned a global reputation for the innovative, unrivaled dental work performed in their West Paces Ferry Road offices. Dr. Ronald Goldstein, a lifelong native of Buckhead, is senior partner of Goldstein, Garber, Salama & Beaudreau, a practice that has attracted thousands of patients—including celebrities and sports figures—from around the world in search of the consummate smile.

Still other corporations use offices in Buckhead to establish global networks with their firms' locations in other parts of the world.

As Atlanta's largest professional services firm, the Buckhead office of PricewaterhouseCoopers is a principal link connecting

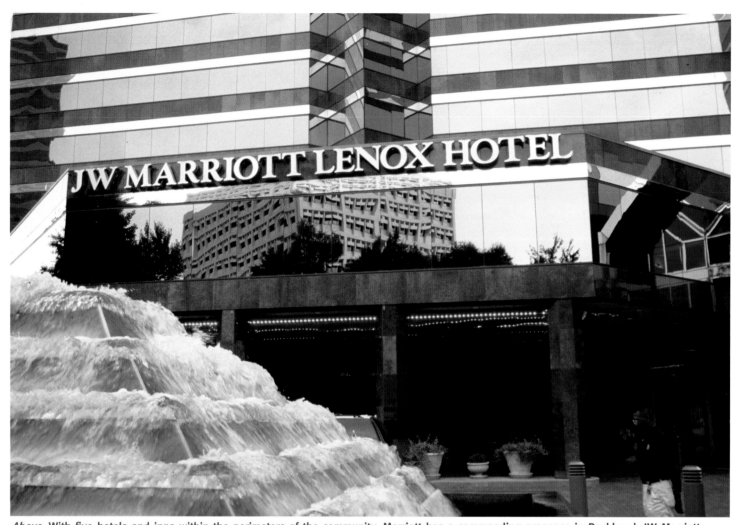

Above, With five hotels and inns within the perimeters of the community, Marriott has a commanding presence in Buckhead. JW Marriott Lenox Hotel, *pictured above*, is connected to Lenox Square and across the street from MARTA on Lenox Road. Featuring 371 guest rooms and 4 lavishly appointed suites, the luxury hotel has earned a four-diamond rating from AAA and a three-star rating from Mobil. Photo by L.A. Popp.

the corporation's 150,000 employees in more than 150 countries worldwide, providing a range of services to agencies, industries, organizations, and governments, on a local, national, and international level.

Buckhead is also the United States' headquarters of BCD Holdings, a multi-billion dollar company based in the Netherlands Antilles, with regional headquarters in Zeist, the Netherlands. Owned and established by John Fentener van Vlissingen, who resides in both Buckhead and the Netherlands, BCD Holdings is a global leader in the travel and financial services industries.

With operating companies in twelve countries in North and South America and Europe, BCD Holdings employs more than ninety-five hundred people worldwide.

For area residents, an abundance of employment opportunities is undoubtedly one of the perks of living in or near a community with such a prestigious corporate profile.

According to the *Buckhead Coalition Buckhead Guide Book*, there are seventy-five Buckhead-based companies with one hundred or more employees. Even more impressive is the fact that forty-three of these companies have two hundred or more employees on their payrolls.

The community's five major employers include IBM Corp., MARTA, and Piedmont Hospital, with approximately 8,400, 4,500, and 2,200 employees, respectively. Surprisingly, a local, yet nationally renowned dining dynasty—Buckhead Life Restaurant Group—ranks fourth, with about 1,400 employees. Blue Cross Blue Shield of Georgia holds the No. 5 position, with nearly 1,000 employees.

Another nationally renowned medical facility, Shepherd Center, is also one of Buckhead's top ten employers, with approximately 770 health care professionals and support personnel on staff.

Buckhead's commanding corporate presence offers distinct financial advantages, not only for the community, but also for its populace. Local residents enjoy lucrative employment opportunities that do not necessitate travel far from home, while the influx of commuters from beyond Buckhead's perimeters boosts revenue for local businesses and retailers.

What is the plausible impact of commuters on the community's economic health? In light of estimates that indicate that Buckhead's daytime population is approximately 135,000 people—a figure which is slightly more than double the community's residential population of 67,000—an opportunity for increased spending before, during, and after business hours undeniably exists.

With a retail base that, according to the Buckhead Coalition, grosses more than one billion dollars annually, shopping is incontestably far more than a popular pastime on the charming, shop-lined streets of Buckhead.

Of special interest is the fact that five of the community's forty-three employers with two hundred-plus employees are Buckhead's department stores. Rich's tops the list with 650 employees, while Macy's, Neiman Marcus, Parisian, Saks Fifth Avenue, and Lord & Taylor provide work for about 500, 450, 350, 270, and 200 employees, respectively.

Indeed, large-scale retail is also alive and well in Buckhead.

In addition to its corporate dominance, Buckhead has a unique cultural tapestry that has been enriched by the presence of consulates from seventeen nations around the globe. Responsible for representing the commercial interests of citizens of their native countries who are involved in business on America's financially fertile soil, the foreign consuls have planted roots in Buckhead, again because of the community's core positioning and reputation as one of the premier corporate centers in the Southeast.

Buckhead also has an unparalleled reputation for welcoming the self-starter. Entrepreneurs are encouraged in this prolific environment that has spawned several self-made millionaires. Small shops, boutiques, and businesses preserve the ambiance of Buckhead's humbler times, while co-existing with the community's commercial and retail giants.

While watchdog groups like the Buckhead Coalition keep a sharp eye on the development and direction of commercial growth, other area groups have taken a proactive stance to both safeguard and cultivate community business interests.

Comprised of businesses both big and small, the Buckhead Business Association has two principal objectives: the promotion of community well-being and the proliferation of networking opportunities among its professionals. The group began as a casual meeting of shopkeepers in 1951, and during the last half century, has evolved into a powerful mix of six hundred corporate and individual members.

YoungBucks, an affiliated group of business leaders in their twenties, thirties, and forties, effectively targets strategies to lead in the development of the ever-burgeoning market in Buckhead. The group, which meets monthly, is actively involved in a variety of hands-on community improvement projects.

In celebration of BCD Holdings' Silver Jubilee in the year 2000, international business magnate van Vlissingen, the company's founder and CEO, expressed this simple, yet compelling sentiment: "Building on the foundation of the past is important, but the future is even more exciting."

For the thriving business community of Buckhead, the promise of an exciting future—so vigilantly engineered by its earliest founders and so attentively implemented by its current activists—has arrived.

Above, Towering above Peachtree Road, NW, One Buckhead Plaza is a striking addition to Buckhead's skyline. Construction on the nineteen-floor, high-rise building was completed in 1988. Photo by L.A. Popp.

The business of enterprise is to serve not only the customer, but the entire community as well. It is unwise for a company to separate itself from the community it serves. Any successful business recognizes its responsibility to be profitable, but an exceptional company also bases its operating principles on what best serves the community as a whole.

—Lewis Glenn, President
Harry Norman, Realtors®

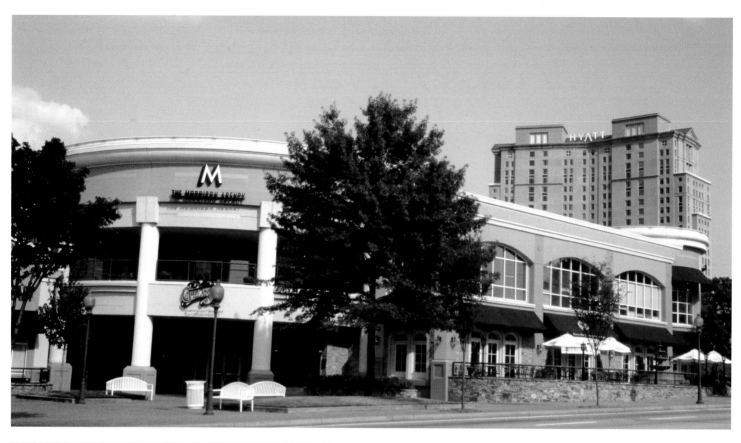

Above, Opportunities to pursue both business and pleasure abound on one of Buckhead's busiest boulevards: Piedmont Road. Originally named Plaster Bridge Road for Benjamin Plaster, one of the area's early settlers, the thoroughfare has become one of the community's most prestigious addresses.

Above, The Morrison Agency, brand-building advertising specialists, and Copelands, a Cajun eatery with three locations in metro Atlanta, are among the establishments that have found success at their doorsteps on Piedmont.

At left, One of Buckhead's four luxury hotels, Grand Hyatt Atlanta on Peachtree Road has an opulence that is only rivaled by its exceptional service. Constructed in 1990, the hotel—which has been rated among the country's top fifty hotels in the 1998 Zagat survey—has also earned a AAA four-diamond and a two-star Mobil rating.

Photos by L.A. Popp.

At right, As one of Buckhead's top thirty employers, Swissôtel is a world-class hotel located in a premier location: adjacent to Lenox Square. Luxurious accommodations include 349 guest rooms with one king or two double beds, a fitness center, and a spa with a pool.

Below, A relative newcomer in Buckhead's financial market, Piedmont Bank opened its doors in October 2001. Self-described as "a very progressive bank with a very classic philosophy," the financial institution provides a range of personalized and customized services for individuals, businesses, and merchants.

Photos by L.A. Popp.

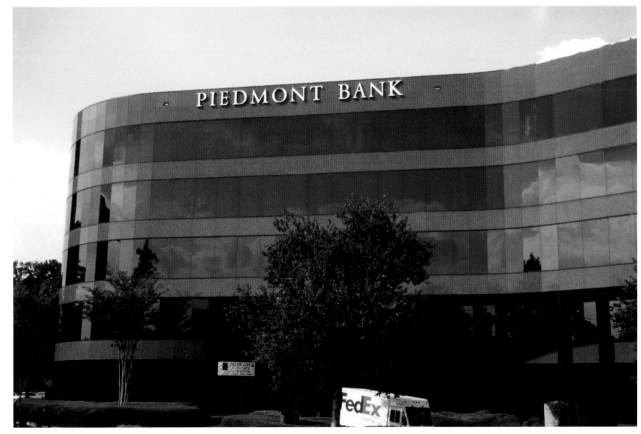

MATHIS
OF PIEDMON

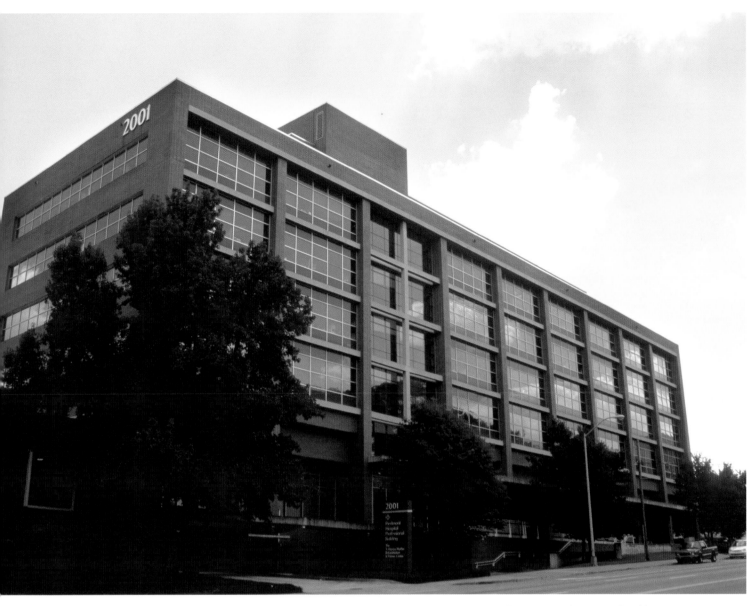

At left, Poised above the Georgia 400 connector, One Capital City Plaza is a Class A office building on Peachtree Road, with 410,128 square feet of rentable space. The seventeen-story structure serves as headquarters for Blue Cross Blue Shield of Georgia, which currently occupies two-thirds of the building.

Above, With six professional buildings situated on twenty-six acres along Peachtree Road, Piedmont Medical Center is one of Buckhead's greatest success stories. Founded as a ten-bed sanatorium in 1905, the community's leading healthcare facility is now a five hundred-bed, acute-care facility with a staff of more than eight hundred medical professionals. The medical center is nationally renowned for its unparalleled accomplishments in the fields of cardiovascular care, neuroscience, orthopaedics, and organ transplant.

Photos by L.A. Popp.

A true community is self-sufficient: Its residents and its businesses support each other, which enhances community life for everyone. As an integral part of Buckhead since the mid-1900s, Piedmont takes its responsibility as a good community "citizen" very seriously—we expect to continue serving the healthcare needs of our community for a long time to come.

–R. Timothy Stack
Chief Executive Officer
Piedmont Medical Center

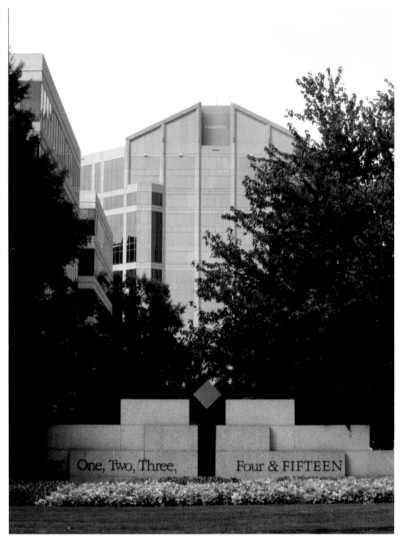

At left, When the preliminary upsurge in office space development began in Buckhead during the mid- to late-1970s, Piedmont Center was one of the community's first campus-style complexes. Occupying forty-five acres on Piedmont Road, the new corporate development included twelve buildings, with 1,600,000 square feet of commercial space. Two additional buildings—14 Piedmont Center and 15 Piedmont Center—were constructed in 1988 and 1998, respectively, adding 600,000 square feet of office space to the complex. Photo by L.A. Popp.

Below, With locations in twenty-two countries and supporting clients in thirty-one countries around the world, SYNAVANT maintains its corporate headquarters on Peachtree Road, NE. For more than thirty years, the company has partnered with pharmaceutical and healthcare companies to provide strategic solutions and services to its global clientele.
Photo by L.A. Popp.

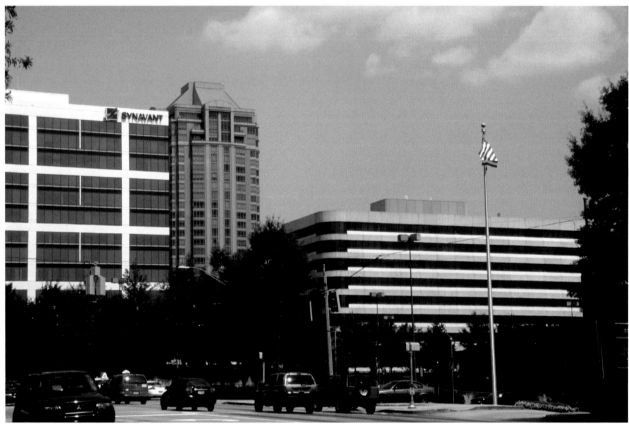

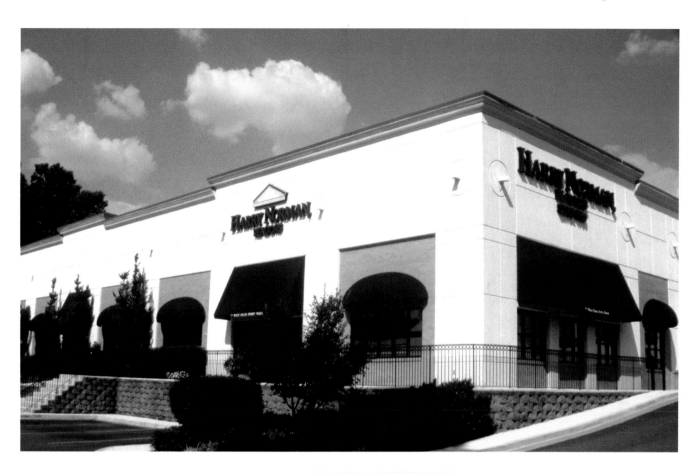

Above, As one of the community's leading residential realty firms, Harry Norman, Realtors® maintains a staff of nearly five hundred agents in six sales offices throughout the Buckhead region, including this location on West Paces Ferry Road.

At right, During the 1980s, approximately three million square feet of new office space became available in Buckhead. One of the inaugural high-rise developments was Monarch Plaza, a fifteen-story, modern structure with 386,000 square feet of prime office space. The plaza is located on Peachtree Road across from Lenox Square and south of Phipps Plaza.

Photos by L.A. Popp.

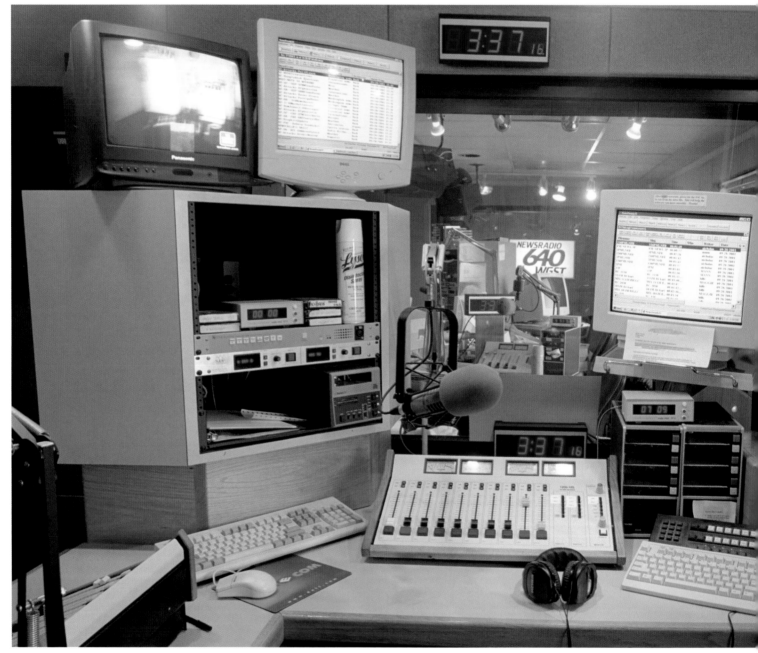

Above, As Buckhead's own AM radio station, Newsradio 640 WSGT is the community's resource for top local, national, and international news, as well as up-to-the-minute traffic and weather updates. Talk shows, contests, and local event promotions are also part of the station's regular programming. Area football fans tune in to hear pre-game coverage and live, play-by-play action of the Atlanta Falcons, with a post-game conference hosted by Head Coach Dan Reeves. Photo by Patrick Kelly.

Opposite page, top right, Located at 3500 Piedmont Road, Two Securities Center is a seven-floor office building constructed in 1982, during Buckhead's halcyon era of commercial development. As a free-standing building that is part of the Securities Center complex, the structure has 245,894 square feet of prime office space. Photo by L.A. Popp.

Opposite page, bottom right, With nineteen full-service branches in Atlanta, Fidelity National maintains a powerful presence on Piedmont Road, providing a wide range of banking, mortgage, and investment brokerage services to Buckhead residents. Photo by L.A. Popp.

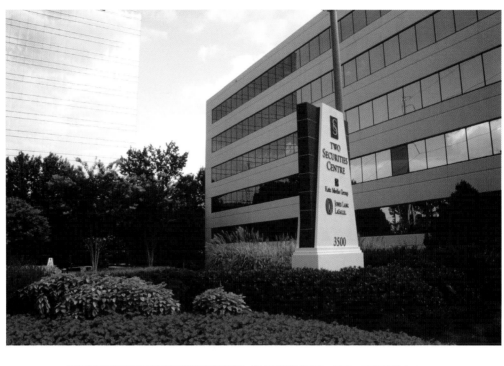

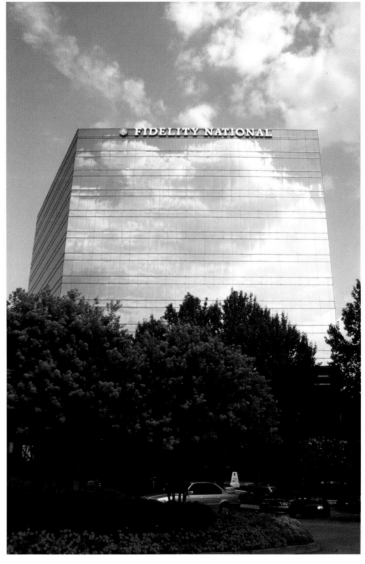

from ABCs

Above and at right, The Heiskell School was initially founded as a home-based preschool in 1949. Today the Northside Drive school provides a Christ-centered learning environment that lovingly fosters leadership skills and character development, while offering an academically challenging, content-rich curriculum to students in its preschool, elementary, and junior high programs.

At far right, Located on Peachtree Road, NE, American InterContinental University (AIU) - Buckhead is an integral part of a global educational community with campuses on three continents and a student body representing more than one hundred countries. With a career-oriented education as its focus, AIU offers undergraduate programs in international business, interior design, fashion, visual communication, and media production. Photos by L.A. Popp.

o MBAs

As a *community* devoted to the pursuit of learning, Buckhead *earns an* "A+" for its *exceptional* educational institutions, which rank among the *finest* in the nation.

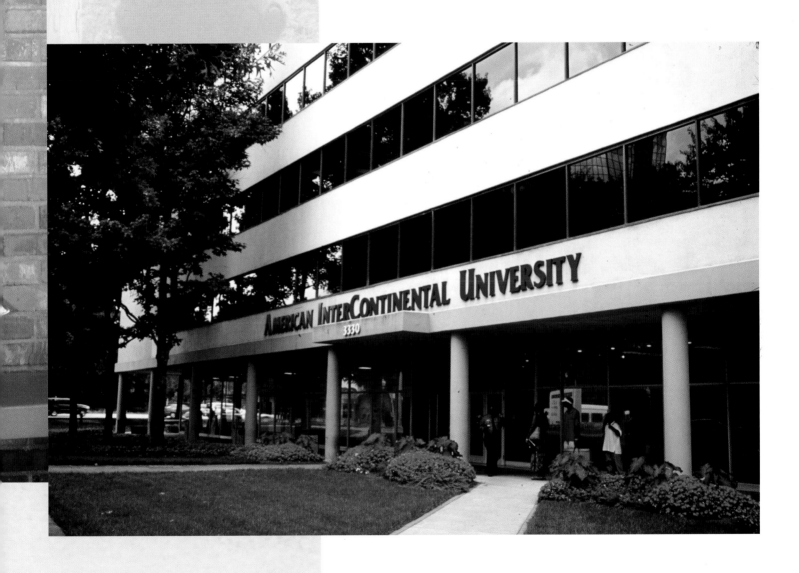

The Quest for a Quality Education in Buckhead

In Buckhead, a solid academic foundation for each and every resident has long been considered a key component in upholding the community's quality of life.

Access to a host of educational institutions that are ranked among the most prestigious in the nation give students of all ages who call Buckhead "home" an opportunity to prepare for futures filled with promise.

Little ones can get a head start on a lifelong learning experience at any of several area preschools and kindergartens. While many of the early-education programs are part of elementary and secondary private institutions, others are either branches of national chains or affiliated with Buckhead's many churches.

Summer day camps for Buckhead's youngest residents are also offered to ensure the learning process continues year-round.

While Buckhead has several public elementary schools, the community's middle school students attend Willis A. Sutton School near Chastain Park. Older teens enrolled in the public school system attend North Atlanta High School, which is renowned for an excellent performing arts program that has helped launch the careers of several notable celebrities.

It is, however, Buckhead's abundance of the metropolitan area's most highly acclaimed private schools that garners the most attention.

Many of the area's young Catholics begin their education at Christ the King School. With five hundred students in kindergarten through eighth grade, the school, which shares its campus with Cathedral of Christ the King on Peachtree Way, recently underwent a major construction and restoration project.

Founded in 1937, the school's first teachers were the Grey Nuns of the Sacred Heart, who were committed to providing a quality education in a Catholic environment. Today, the school continues this legacy by remaining faithful to its founding motto: "Building minds and souls for the future."

Consistently recognized as a National School of Excellence, Christ the King School focuses its instruction on allowing each student to advance at the pace most appropriate for his or her age, developmental stage, and ability.

Administrators and faculty at Christ the King believe that education is a cooperative collaboration between family, church, and community and that these factors will provide an opportunity for moral development and educational excellence in a supportive setting.

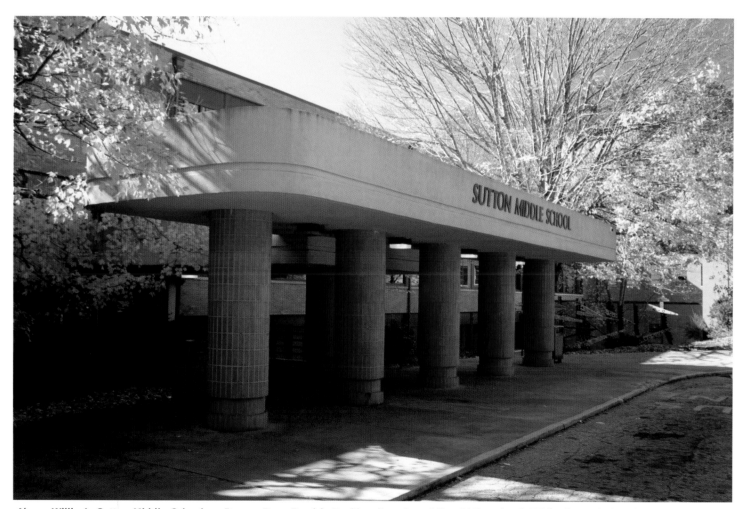

Above, Willis A. Sutton Middle School on Powers Ferry Road is Buckhead's only public middle school. While the majority of students at Sutton have previously attended one of the area's six elementary schools, others travel from throughout the city of Atlanta. With more than twenty countries represented by the student body, the school reflects the community's ever-increasing international diversity. Sutton is, in fact, one of a select number of middle schools in the country that offers Spanish, French, and Japanese. Photo by Patrick Kelly.

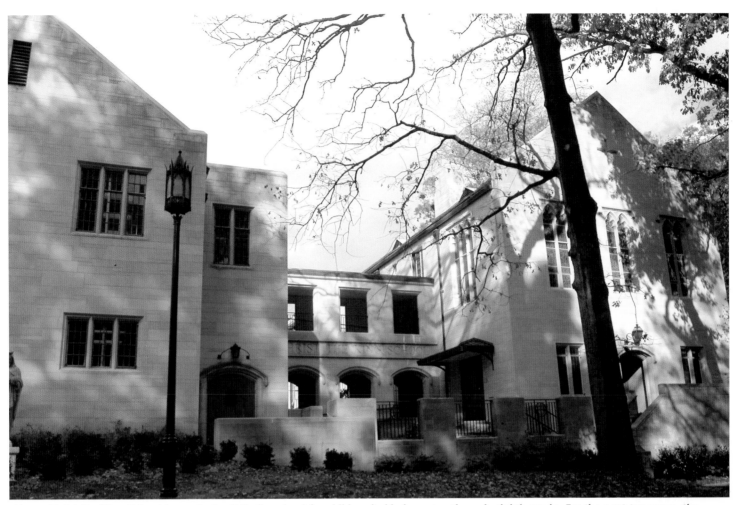

Above, Christ the King School is a private, Catholic school for children in kindergarten through eighth grade. For the past ten years, the school, which shares its campus with the Cathedral of Christ the King, has been recognized as a National School of Excellence.
Photo by Jennifer Pack.

Another institution dedicated to spiritual enrichment and educational advancement in the development of outstanding young adults is The Heiskell School. Located at Northside Drive and Moores Mill Road, the family-run Christian school started as a preschool in 1949, and through the years, expanded to include both elementary and junior high school programs.

With approximately 350 students from the local Atlanta area and the distant, foreign soils of Australia to Zimbabwe and many countries in-between, The Heiskell School provides an "academically challenging and spiritually dynamic atmosphere." Faculty members, who personally exemplify the Christian beliefs on which the school was founded, are charged with nurturing the development of academic, social, emotional, and spiritual values in a Christ-centered environment.

Also emphasizing the benefits of a multicultural, multilingual environment is the Atlanta International School. Located in the historic North Fulton High School building in Garden Hills, the school enjoys world-renowned success for its innovative four-year kindergarten through twelfth grade curriculum, which incorporates the rigorous International Baccalaureate (IB) program, an intensive, two-year program taken by juniors and seniors. Upon successful completion of the program, graduates receive a diploma from the Atlanta International School, as well as the internationally esteemed IB diploma, which opens doors to prestigious colleges and universities worldwide.

Situated on twenty-five acres among the stately mansions of West Paces Ferry Road is Pace Academy, an independent college preparatory school known for academic excellence. With 835 students, the school maintains a low student-to-teacher ratio to ensure personal contact with instructors and ample opportunity to explore extracurricular activities. The school's high level of commitment to the total student is evident in its dynamic athletic and fine arts programs.

According to Headmaster Mike Murphy, "Pace Academy offers the perfect balance of nurture and rigor, cooperation, and competition. We focus on the individual, while being concerned for the greater community."

The Galloway School in Chastain Park is housed in the historic Fulton County Alms House. Atlanta educator Elliott Galloway, who envisioned a school that emphasized solid academic performance, independence, and the joy of learning, founded the school in 1969. He believed that learning is natural,

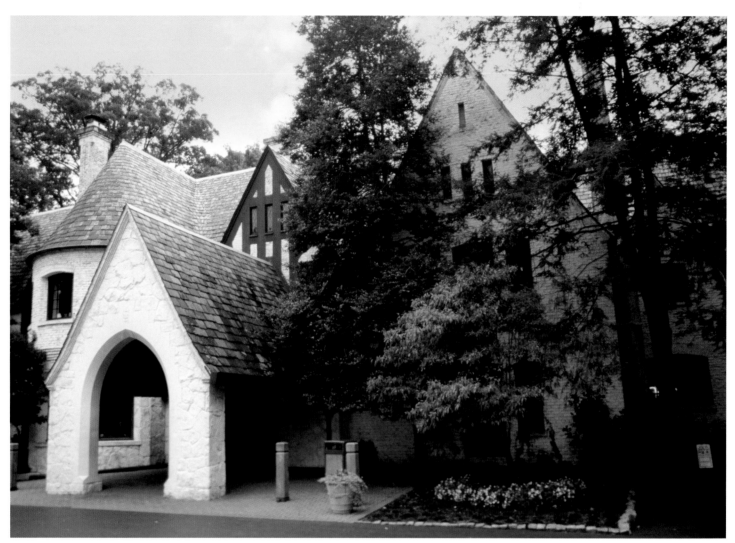

Above, Established in 1958, Pace Academy is an independent, college preparatory school for boys and girls in pre-first through twelfth grade. Located on West Paces Ferry Road, the school provides a challenging academic curriculum, complemented by numerous opportunities to excel in athletics and the arts. Photo by L.A. Popp.

The schools of Buckhead are a source of pride for our city, state, and region. The variety of schools, combined with outstanding reputations in academics, arts, and athletics, attract families from all over Greater Atlanta and attract businesses from around the world. It is well known that strong schools make good neighborhoods. The schools, churches, synagogues, other non-profits, and the businesses of Buckhead unite to make this a great place for people of all ages.

——**Mike Murphy**
Headmaster, Pace Academy

and if barriers are removed, a healthy educational environment results. The school's curriculum is designed to allow students to develop problem-solving skills in such an inspiring setting.

Nestled on the banks of the Chattahoochee River on Paces Ferry Road, the Lovett School is known for generating students who rank high in academic achievements, particularly in mathematics and foreign languages. As a college preparatory school, the Lovett School emphasizes the total education of each student.

Founded in 1951, Westminster School remains dedicated to its mission of developing the whole person for college and beyond by providing a top-notch educational experience. The school merged with the Washington Seminary in 1953 and is now located on the site of an old day camp, originally chosen because of its ideal distance from Atlanta's city life.

Rooted in the traditions and philosophy of Christian faith, Westminster School encourages its seventeen hundred students to develop personal religious beliefs and actively seeks and welcomes students of all racial, ethnic, religious, and economic backgrounds.

Westminster School is recognized not only for producing students who are among those with the highest SAT scores in the Southeast, but also for being among the secondary schools in this region of the country with an impressive number of National Merit Scholars.

Several institutions of higher learning have also brought educational prestige to Buckhead. American InterContinental University, situated across from the Atlanta Financial Center, is a leader in the fields of information technology, international business, interior design, media production, and visual communication.

Bauder College is nationally known for its programs in fashion merchandising and design, as well as interior and graphic designs. The college is located in Phipps Plaza, home of many couture shops where students can explore the mall to seek inspiration during their studies.

The Portfolio Center is an acclaimed school for creative arts located amidst Bennett Street's galleries and design centers. Students receive intensive training in art direction, Internet development, advertising copywriting, illustration, and photography.

Terry College of Business, located in the Atlanta Financial Center, is in the heart of Buckhead's business district. The part-time, executive MBA program is a branch of the University of

Above, Opened in 1951, Westminster School is an independent day school for boys and girls in pre-first grade (kindergarten) through high school. The school, which has been ranked No. 1 in the Southeast for SAT scores and National Merit Scholars, provides an impressive college preparatory education that is deeply rooted in the Christian faith. Photo by Patrick Kelly.

Georgia system and offers students an opportunity to pursue a post-graduate degree without interrupting their careers.

Those not looking for traditional degrees also have many options in Buckhead. There are several vocational and business schools in the community that offer training in esthetics, modeling, court reporting, business administration, tax preparation, insurance, computers, and several foreign languages.

The pursuit of learning needn't stop once a degree has been earned. Non-credit, continuing education classes that encourage the exploration of interests in dance, art, music, and drama are offered by the Atlanta Ballet Centre for Dance Education, Lee Harper Dance Studios, the Georgia Academy of Music, Ichiyo Arts Center, and the Professional Actors Studio.

Developing skills in test preparation and English as a second language are additional opportunities for learning that are offered by Kaplan Educational Center.

Indeed, acquiring knowledge can—and should—be a lifelong experience in Buckhead, where the consummate quality of schooling makes realizing educational aspirations an achievable goal at any age.

In the words of Albert Einstein, "The important thing is not to stop questioning. Curiosity has its own reason for existing."

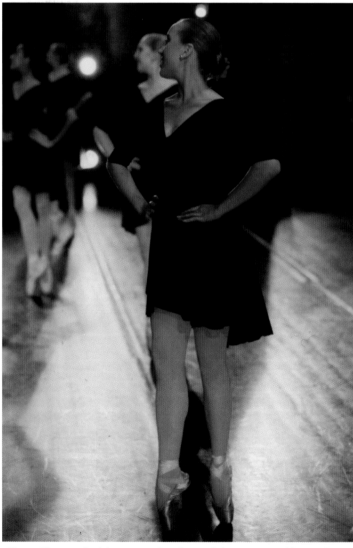

Above, The magical beauty and artistry of dance are waiting to be explored at the Atlanta Ballet Centre for Dance Education in the Chastain Square Shopping Center on Roswell Road. From hip hop, tap, Flamenco, and Pilates, to creative movement, modern, jazz, and ballet, classes for all ages, sizes, shapes, and levels of skill are offered. Photo by Kim Kenny, courtesy of the Atlanta Ballet Centre for Dance Education.

Above, As one of Buckhead's newest educational institutions, the Atlanta Girls' School, a private, nonsectarian college preparatory school for girls in sixth through twelfth grade, initially opened its doors in 2000. Two years later, the school moved from its temporary location in the classroom wing at Buckhead Baptist Church to its new home: the former site of Trinity School on Northside Parkway. Photo by Patrick Kelly.

At right, Ichiyo Art Center, located on East Paces Ferry Road, brings lessons from the Far East to the community of Buckhead. Classes in flower arranging, Japanese calligraphy, Japanese brush painting, book binding, and lamp making, as well as traditional tea ceremonies, can all be enjoyed in a pristine and equally peaceful setting. Photo courtesy of Ichiyo Arts Center.

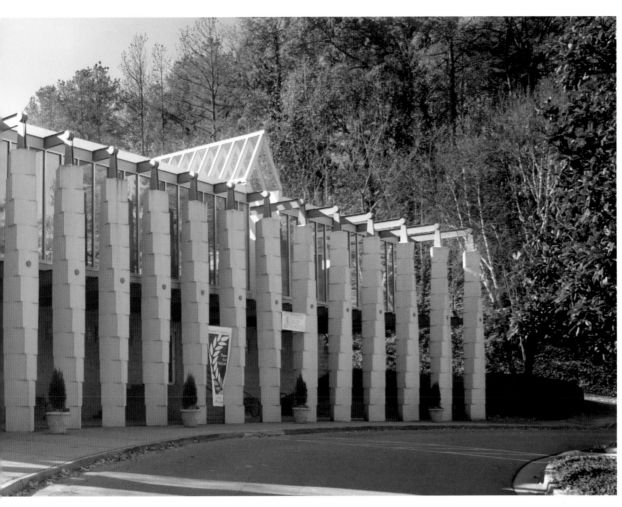

Above, Lee Harper has long been a recognized and respected name in Buckhead's dance community. Owner of a studio on East Shadow-lawn Avenue, Harper offers classes in basic skills, creative movement, pre-ballet, ballet, modern, jazz, and tap for children from three years of age to adult. The studio is also the home of a professional dance company, Lee Harper & Dancers, and a children's dance company, Dancers II. Both companies perform regularly with the Atlanta Symphony Orchestra.

Photo courtesy of Lee Harper Studios.

At left, Garden Hills Elementary School on Sheridan Drive, NE, provides a public elementary school setting for young Buckhead residents in kindergarten through fifth grade. Included on the National Register of Historic Places, the school building was designed by acclaimed Atlanta architect Philip Trammell Shutze.

Photo by L.A. Popp.

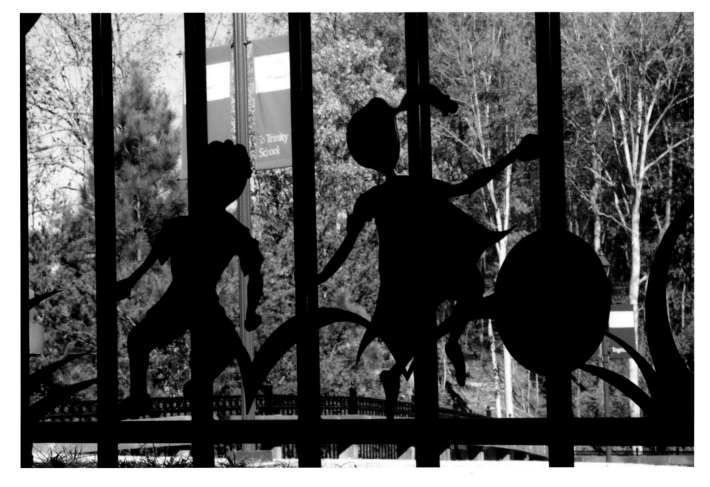

At right, Formerly the location of Peachtree Heights School, which opened in 1917 and was destroyed in a fire in 1949, 8 Peachtree Battle Avenue is now the address of E. Rivers Elementary School, a public elementary school for children in kindergarten through fifth grade. The new building was designed by Stevens & Wilkinson in 1949 and has been featured in *Time* magazine for its unique and innovative international style.
Photo by Jennifer Pack.

Below, One of Buckhead's three private elementary schools, Trinity is a nondenominational day school for preschoolers through sixth graders. Located on Northside Parkway, NW, the school's animated gates welcome children of all faiths, races, and cultures.
Photo by Patrick Kelly.

Above, The Portfolio Center, located amidst the galleries on Bennett Street, NW, in the heart of Buckhead's design district, offers a specialized, creative arts curriculum for students interested in pursuing careers in the fields of design and art direction, media architecture and Internet development, advertising and design writing, illustration, advertising art direction, and photography. Photo by Patrick Kelly.

At right, Home to one of the ten largest undergraduate programs in the nation, University of Georgia - Terry College of Business, located in the Financial Center South Tower on Peachtree Road, also offers one of the country's most selective MBA programs.

Photo by Terry Allen, courtesy of Terry College of Business.

Above, Serving more than eighteen hundred children and adults each year, the Atlanta Speech School on Northside Parkway, NW, is one of the oldest therapeutic educational centers in the Southeast. The school's mission is to help children and adults with speech, hearing, language, or learning disabilities to realize their full potential.

Photo courtesy of the Atlanta Speech School.

At left, inlingua Language Training Center on Lenox Road, NE, is an affiliate of inlingua International, the world's largest partnership of privately owned language centers, with more than three hundred locations around the globe. In addition to offering private and group language classes, the center provides intercultural and crosscultural communication training, as well as translation and interpreter services. Innovative study opportunities include instruction via telephone, daily E-mail lessons, and Internet videoconferencing. Students studying English can enjoy weekday instruction on the golf course with an experienced golfer!

Photo courtesy of inlingua Language Training Center.

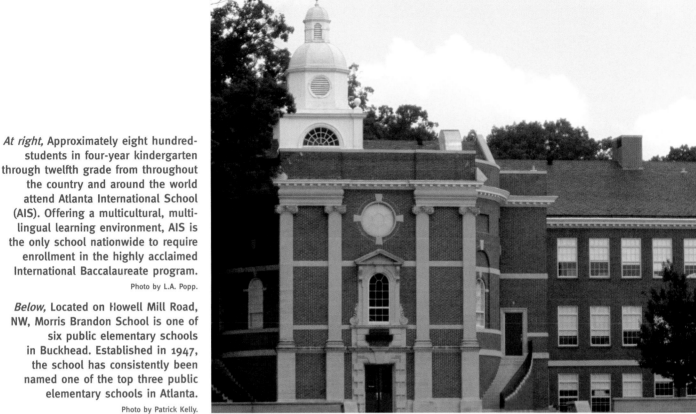

At right, Approximately eight hundred-students in four-year kindergarten through twelfth grade from throughout the country and around the world attend Atlanta International School (AIS). Offering a multicultural, multi-lingual learning environment, AIS is the only school nationwide to require enrollment in the highly acclaimed International Baccalaureate program.

Photo by L.A. Popp.

Below, Located on Howell Mill Road, NW, Morris Brandon School is one of six public elementary schools in Buckhead. Established in 1947, the school has consistently been named one of the top three public elementary schools in Atlanta.

Photo by Patrick Kelly.

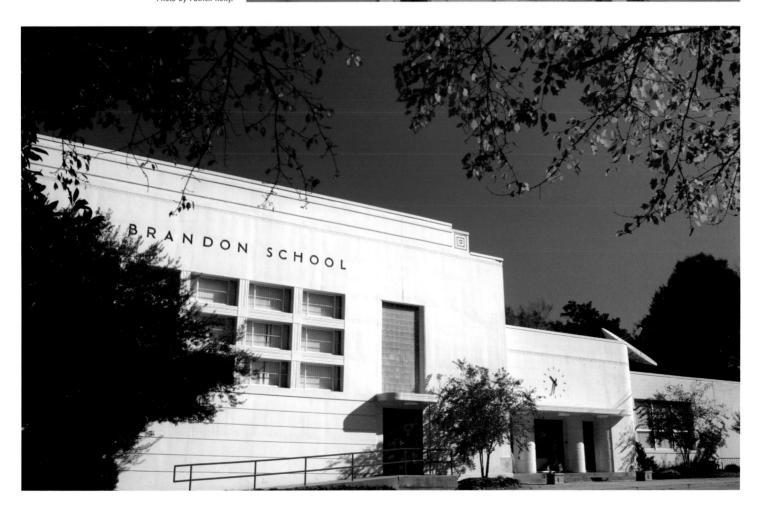

a people

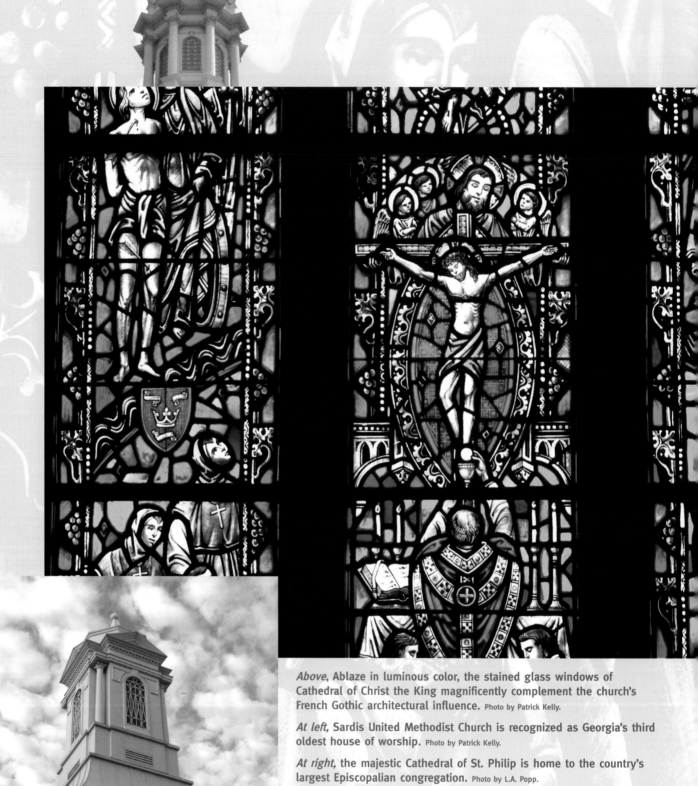

Above, Ablaze in luminous color, the stained glass windows of Cathedral of Christ the King magnificently complement the church's French Gothic architectural influence. Photo by Patrick Kelly.

At left, Sardis United Methodist Church is recognized as Georgia's third oldest house of worship. Photo by Patrick Kelly.

At right, the majestic Cathedral of St. Philip is home to the country's largest Episcopalian congregation. Photo by L.A. Popp.

of faith

Home to several of the country's largest *congregations*, Buckhead has a flourishing *spiritual* community that, time and time again, has proven to be an *inspiration* to one and all.

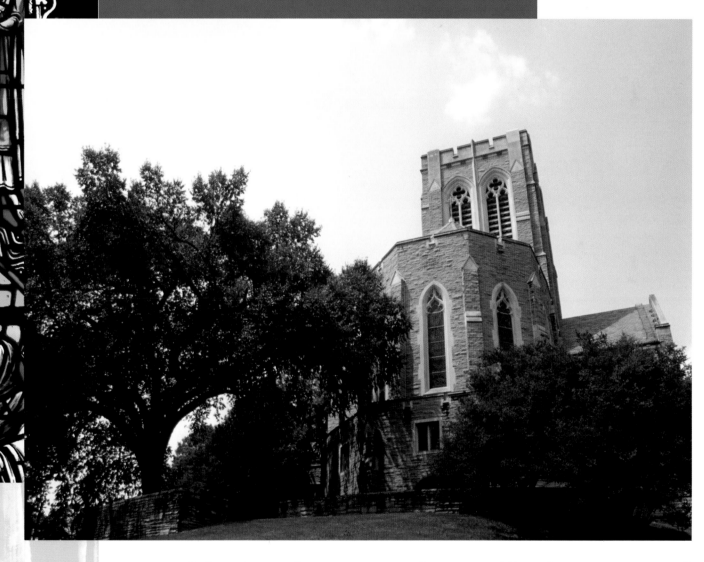

A Powerful Spiritual Presence Defines Buckhead's Heart & Soul

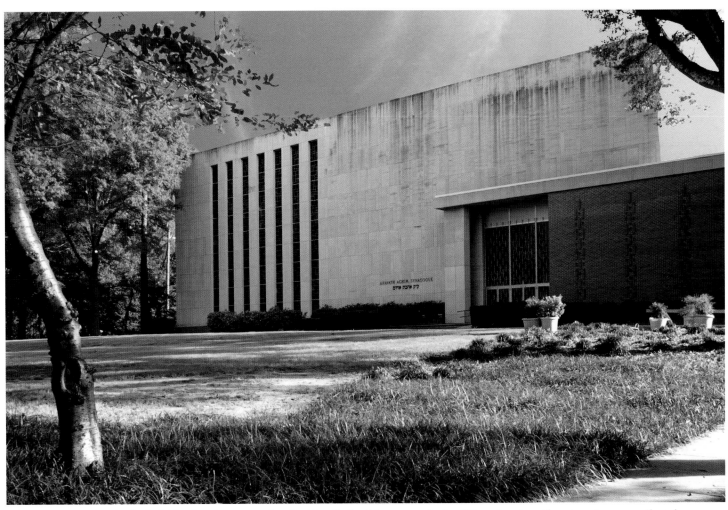

Above, Congregation Avahath Achim first began serving Buckhead's Jewish community in 1887, when less than twenty men gathered in a small room on Gilmer Street in downtown Atlanta. The cornerstone of the synagogue's current structure was laid in 1958. Today, the "Congregation of Brotherly Love" is the third largest conservative synagogue in the United States. Photo by Patrick Kelly.

The freedom to worship as one chooses is one of America's enduring liberties. In Buckhead that freedom is abundantly evident as several of the largest congregations in the country worship here.

But it's not only the number of churches or the size of their congregations that make the faith community in Buckhead so impressive. The houses of worship that welcome thousands of worshippers to north Atlanta are undeniably among the most beautiful and majestic ever to grace a city.

A choice of more than thirty different churches is available to followers of varied faiths. Most Christian denominations, including Seventh-Day Adventists, Christian Scientists, and Jehovah's Witnesses, have at least one house of worship in the area.

The nation's third largest conservative Jewish synagogue is located on Peachtree Battle Avenue. Congregation Ahavath Achim, which means "Congregation of Brotherly Love," first met in 1887 in a small room downtown. During the first half of the twentieth century, the congregation met in area homes until 1958, when the cornerstone of its current building was laid and construction on the synagogue began to accommodate the growing congregation.

More than one hundred years later, Ahavath Achim continues to serve the community's Jewish population.

Several of Buckhead's churches are more than just visually striking; they are rich in history, as well.

Sardis United Methodist Church, for example, was built in 1812 on Powers Ferry Road and is recognized as the third oldest house of worship in the state of Georgia. Because of missing documents, the exact date of its founding isn't known, but it is estimated that the church was established between 1812 and 1825. Many Buckhead pioneers, including Henry Irby and several members of his family, are buried in its cemetery.

Still other area churches are known for their architectural integrity, as well as their size and beauty.

Wieuca Road Baptist Church was established when the congregation of Second-Ponce de Leon Baptist Church foresaw the need for another congregation on Buckhead's north side. Land was purchased on Peachtree Road between Wieuca and Peachtree-Dunwoody Roads in 1947, and services were held in several different buildings until the current sanctuary was dedicated in 1971.

With more than eight thousand members, Roswell Road's Peachtree Presbyterian Church is the country's largest Presbyterian congregation. So many worshippers attend Sunday services that three continuously running shuttle buses are needed to transport churchgoers to the sanctuary from satellite parking lots.

The activity at the church isn't however, confined to Sundays. The parishioners at the church reach out to the community through its state-of-the-art fitness and family life center and its counseling center, which offers a myriad of services to members

Buckhead is a place with far more than average influence on the economics, the politics, and the character of our culture. Fortunately, such a place is filled with thriving faith communities. Perhaps more than any other force, the faith communities of Buckhead help to shape its character and integrity.

—Pastor David Sapp
Second-Ponce de Leon Baptist Church

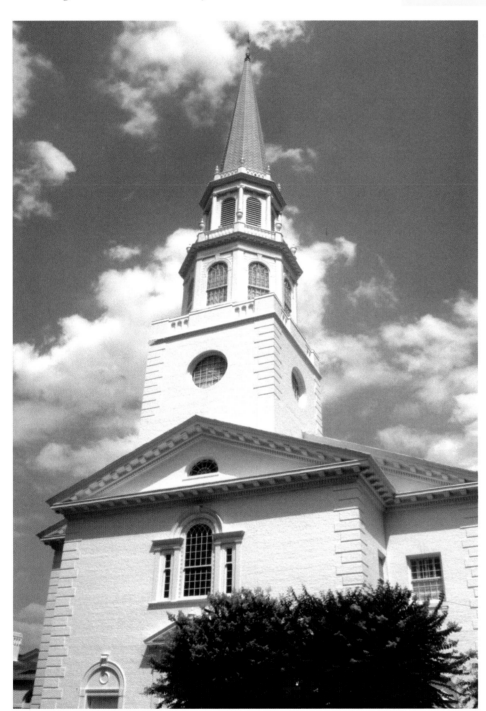

Above and at right, Second-Ponce de Leon Baptist Church was established in the early 1930s when the congregations of the Second Baptist and Ponce de Leon Avenue Baptist Churches merged to form one dynamic Chirstian community in Buckhead. Today, the church is acknowledged as one of the largest Southern Baptist congregations in the country. Photos by L.A. Popp.

and nonmembers alike. Every Saturday a group of dedicated church volunteers swing hammers and haul wood at an area Habitat for Humanity building site.

Peachtree Road United Methodist Church, located on Peachtree Road just south of Piedmont Road, has the third largest United Methodist congregation in the country. Despite humble beginnings in a small wooden structure in 1925, the church flourished and in the fall of 2002, dedicated its new sanctuary built to help serve the needs of its fifty-six hundred members.

Three of Buckhead's most awe-inspiring houses of worship stand clustered together on Peachtree Road, just north of East Wesley.

Cathedral of Christ the King was established in 1936 on four acres between East Wesley and Peachtree Way. Since 1956 the magnificent, French Gothic structure has served as the Catholic Cathedral of the Archdiocese for North Georgia.

The soaring steeple of the majestic Second-Ponce de Leon Baptist Church captures the attention of travelers along Peachtree Road. Established in the early 1930s, the church, with nearly thirty-five hundred members, is one of the country's largest Southern Baptist congregations. As people left the downtown Atlanta area and congregation size dwindled, two existing congregations, Second Baptist and Ponce de Leon Avenue Baptist, merged in Buckhead. The current sanctuary was completed in 1937.

In addition to its own family life center, a state-of-the-art recreational facility enjoyed by church members and area residents, the Second-Ponce de Leon Baptist Church sponsors an active outreach program.

"Out of our seats and into the streets" is the motto of Atlanta Community Ministries, an effort started by the Baptist church in 1995 to meet the human needs of others and reach out to those interested in the Christian faith. Although most are members of the congregation, the group's four hundred volunteers also come from other churches across the city. More than eighty-five thousand ministry contacts have been made to the homeless, students, cancer patients, prisoners, immigrants, and prayer groups since the program's inception.

With the largest Episcopalian congregation in the country, Cathedral of St. Philip traces its origins to 1846, when the church stood across from the capitol building downtown and had a congregation of five communicants. The church moved to its present Buckhead location in 1933, and its current stone structure was completed in 1962.

Although the community's houses of worship may represent a variety of different faiths, there is a unifying thread that exists among all believers: an enduring commitment to make Buckhead a better place to live.

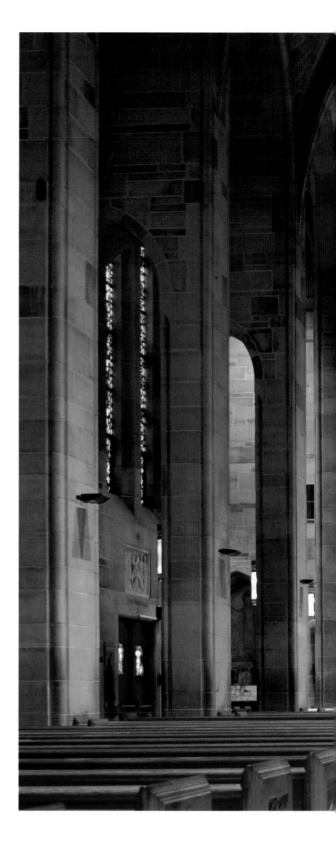

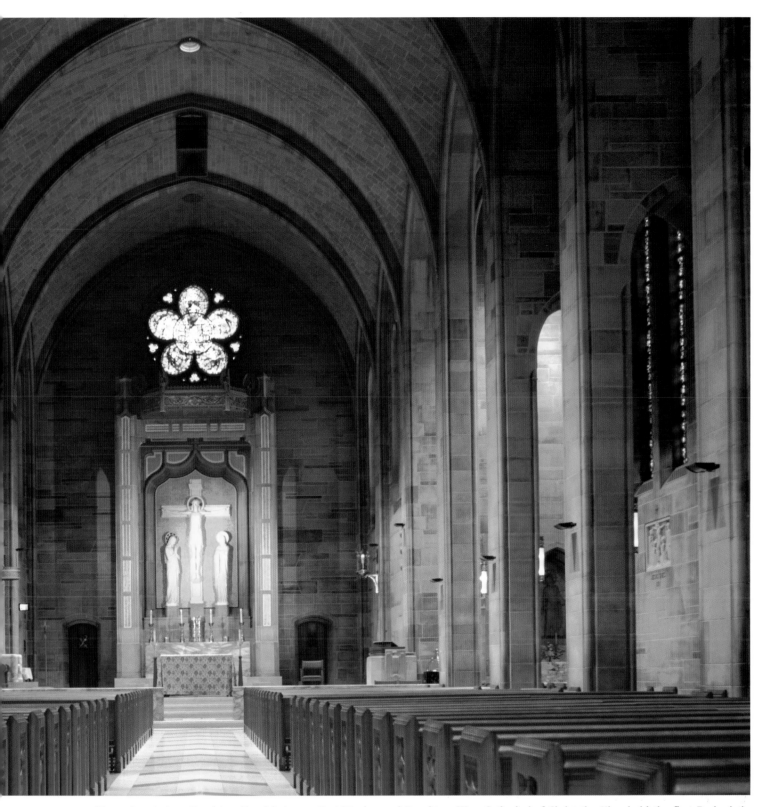

Above, Located on Peachtree Road between East Wesley and Peachtree Way, Cathedral of Christ the King held the first Eucharistic Celebration of Christ the King Parish on August 15, 1936. The cornerstone of the current sanctuary, *pictured above*, which seats more than seven hundred worshippers, was blessed and laid by Bishop O'Hara on October 31, 1937, the Feast of Christ the King.

Photo by Patrick Kelly.

At left, As the first Presbyterian house of worship in the Buckhead area, Covenant Presbyterian Church, with a membership of nearly five hundred parishioners, celebrated its seventy-fifth anniversary in 2001. Photo by Patrick Kelly.

Below, As one of the cornerstones of Buckhead's spiritual community, Cathedral of Christ the King has served as the Catholic Cathedral of the Archdiocese for North Georgia since 1957. Photo by Jennifer Pack.

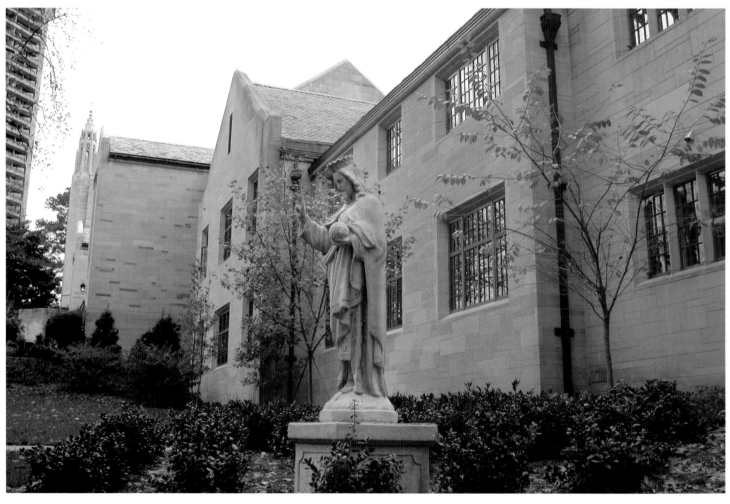

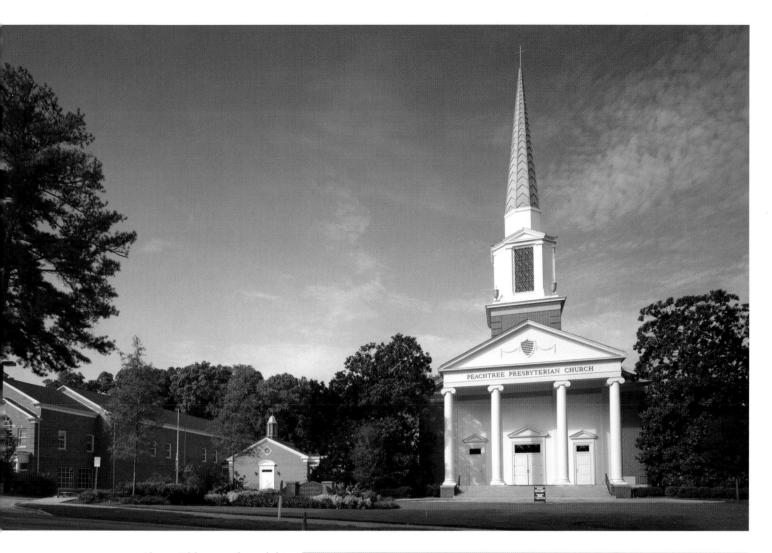

Above, With more than eight thousand parishioners, Peachtree Presbyterian Church has the largest Presbyterian congregation in the United States. Originally located in a gray granite building, circa 1926, on the corner of Peachtree Road and Mathieson Drive, the church moved to its current location on Roswell Road in 1960.
Photo by Patrick Kelly.

At Right, Pursuing its noble vision, "Giving the world hope in Christ," the evangelical congregation of Mt. Paran Church of God on Mt. Paran Road offers biblical teachings, Christ-centered worship, and people-oriented ministries to residents of metropolitan Atlanta.
Photo by L.A. Popp.

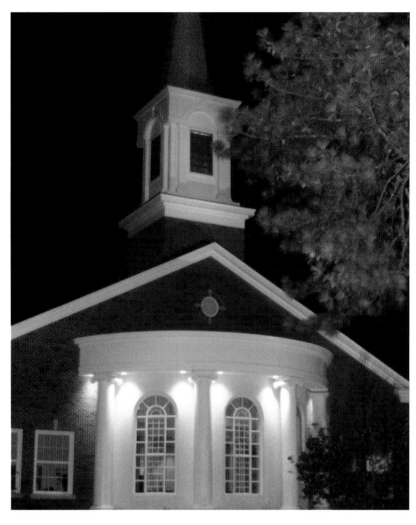

At left, With an intimate congregation of nearly one hundred members, Buckhead Baptist Church commemorated its seventy-fifth year of Christian service in 2002. The church family has made Roswell Road its spiritual home since 1960. The facility also serves as the house of worship for the Buckhead Community Fellowship and the Living Water Ministry. Photo by L.A. Popp.

Below, The Christian Scientist Reading Room, located on the corner of Peachtree Road and Stratford, is owned by the Second Church of Christ, Scientist, Atlanta. Parishioners and the public are welcome to enjoy the room's quiet setting as a library or study. Free access to books and other publications sold by The Christian Science Publishing Society—including the Pulitzer Prize-winning newspaper, the *Christian Science Monitor*—is available. The church, which is adjacent to the Reading Room on Peachtree Road, was founded in September 1920 and moved to its current location in 1948. Photo by Jennifer Pack.

At right, Wieuca Road Baptist Church, which is located on Peachtree Road, NE, is also considered one of the largest Southern Baptist congregations in the country. Photo by Jennifer Pack.

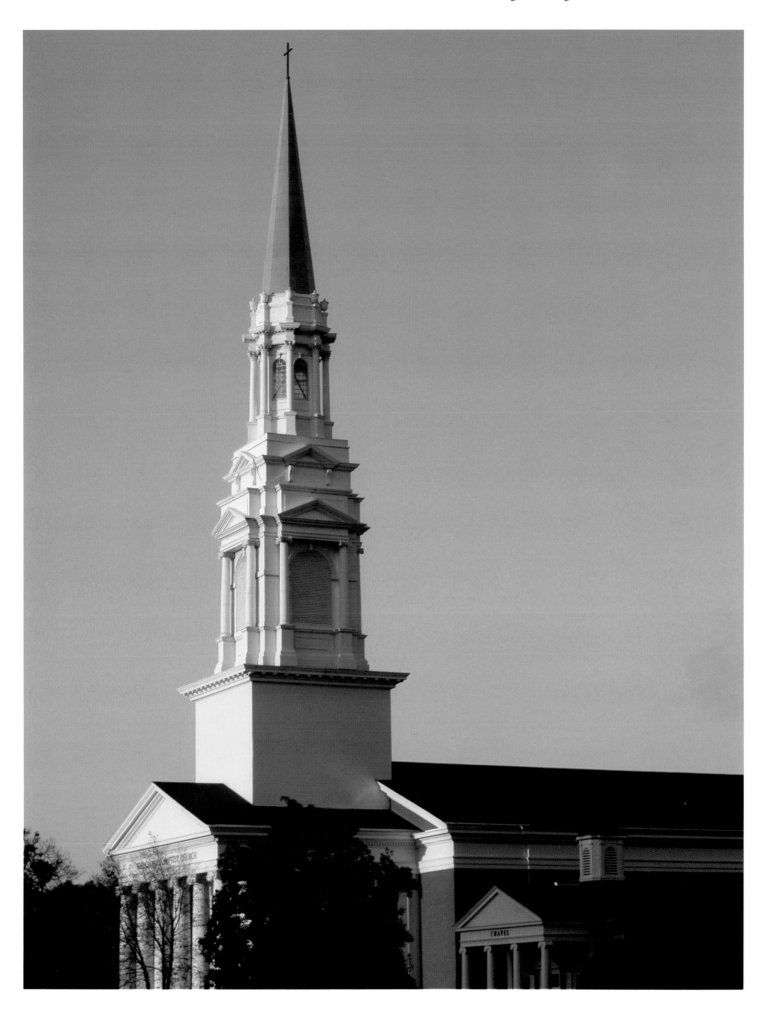

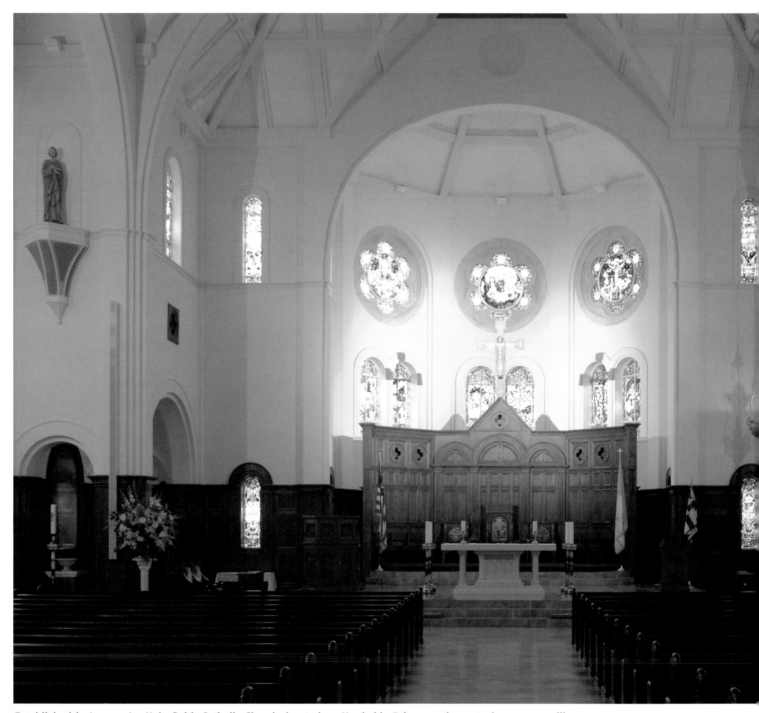

Established in June 1964, Holy Spirit Catholic Church, located on Northside Drive, continues to have a prevailing presence in Buckhead. Designed to symbolize solidity and strength, the exterior of the building, *pictured at right*, is an example of the nineteenth century Romanesque Revival period of architecture that was based on the Romanesque Period of the eleventh and twelfth centuries. The church's main interior, including the sanctuary, *pictured above*, is in the shape of the Latin Cross, with design elements that visually symbolize the Blessed Trinity. Photos by Patrick Kelly.

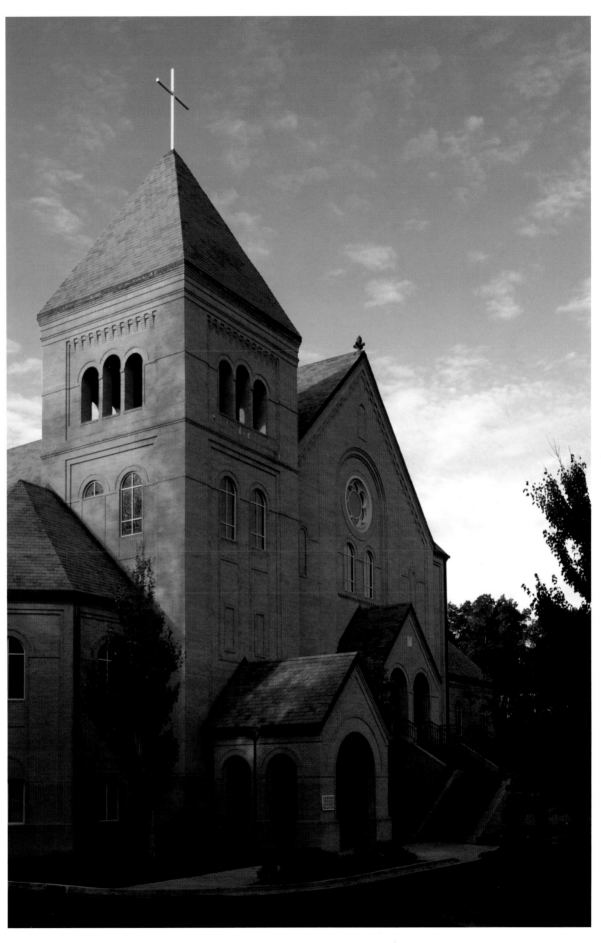

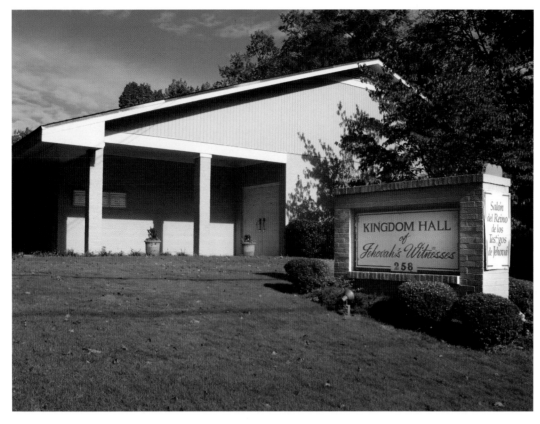

At left, With its own house of worship on Wieuca Road, NE, the Buckhead congregations of Jehovah's Witnesses holds weekly services in both English and Spanish.
Photo by Patrick Kelly.

Below, With the third largest United Methodist congregation in the country, Peachtree Road United Methodist Church dedicated a new sanctuary in 2002 to serve the church's fifty-six hundred members.
Photo by Jennifer Pack.

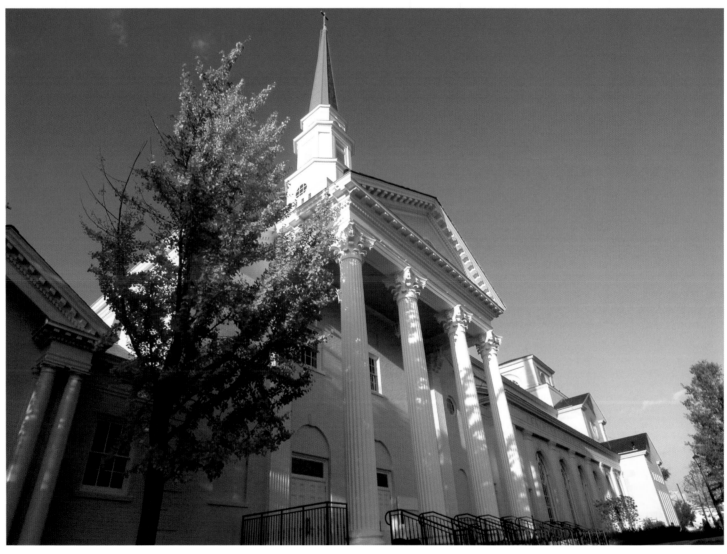

Above, On a brisk autumn day in Buckhead, the steeple of Wieuca Road Baptist Church pierces through pastel-colored clouds as it soars above another familiar Buckhead landmark— Phipps Plaza—on Peachtree Road.

Photo by Jennifer Pack.

At right, The modern Park Place apartment complex on Peachtree Road serves as a visually striking backdrop to the historic steeple of Second-Ponce de Leon Baptist Church, symbolizing the community's enduring spiritual presence that continues to transcend time.

Photo by L.A. Popp.

one hand,

Above, Two of the Easter Bunny's helpers enjoy the Atlanta Speech School's Easter Egg Hunt, held annually to raise money for the school's programs for children who are deaf or have hearing loss, as well as children with language and learning disabilities. Photo courtesy of Atlanta Speech School.

At right, At Shepherd Center, one of the nation's largest, not-for-profit specialty hospitals, more than eight hundred victims of catastrophic illnesses and injuries receive state-of-the-art medical care each year. Photo by L.A. Popp

Far right, Pano Karatassos, owner of Buckhead Life Restaurant Group, serves as Atlanta's chairperson for Share Our Strength's (SOS) Taste of the Nation fund-raiser. Held annually the elegant, black-tie gala has contributed nearly $4.5 million to the city's fight against hunger and poverty. Photo courtesy Buckhead Life Restaurant Group.

many hearts

Buckhead is undeniably a *community* of *friends* and *neighbors*, as evidenced by its prevailing *generosity* and a willingness to *reach out* to others in *need*.

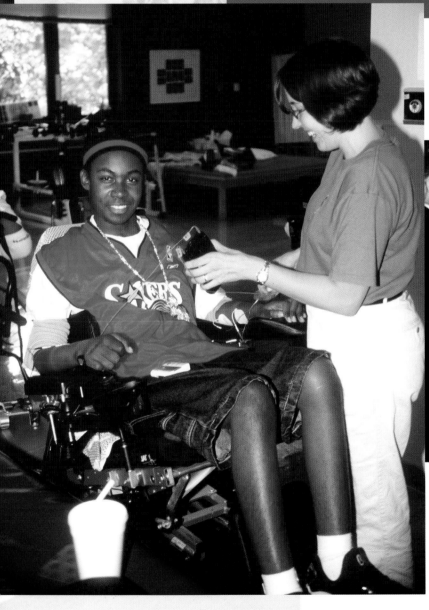

A Gift for Giving Becomes Buckhead

A community's spiritual commitment can't be measured solely by how many churches it has or how big and beautiful those houses of worship may be. Rather, an accurate gauge of a community's spirit and compassion can also be perceived by how its friends and neighbors care for each other, especially those who are sick or in need.

Buckhead's civic, religious, and private organizations have always been ready to generously help with their time, money, and love. Benefactors have created world-class treatment facilities, community programs, and an extensive variety of popular charity events, which raise millions of dollars annually to help others.

Above, In celebration of the tenth anniversary of the Americans with Disabilities (ADA) Act, the ADA torch was passed between employees, patients, and former patients of Shepherd Center, sponsors of the nationwide Spirit of ADA Torch Relay. Photo courtesy of Shepherd Center.

In communities throughout the United States, the local medical facilities are often among the first places where excellent care and heartfelt compassion can be discovered.

Two of the most well-known and respected medical facilities in the country have, in fact, made their home in Buckhead.

Since 1975 Shepherd Center has been a place of hope and new beginnings.

As one of the largest, private, not-for-profit specialty hospitals in the country, Shepherd Center treats more than eight hundred patients each year, providing state-of-the-art medical care for individuals suffering from catastrophic illnesses and injuries.

The center was born of necessity. In 1973 Alana and Harold Shepherd's son, James, was paralyzed in a bodysurfing accident in Brazil. After transporting their son back to the United States, the Shepherds became frustrated by the lack of specialty care available in the Southeast.

James spent months receiving care and undergoing rehabilitation in Denver, Colorado. Thankfully his paralysis was treatable, and James now walks with the assistance of leg braces and a cane.

Too many other accident victims, however, are not as fortunate, a realization that inspired the Shepherd family to develop a spinal cord injury center that would serve the eastern part of the country.

Above, In 2002 the American College of Physicians and the American Society of Internal Medicine awarded the prestigious Edward R. Loveland Memorial Award to the Shepherd Center for its "distinguished contributions to the health care field." Only one other Georgia-based organization has ever received the forty-year award. Photo by L.A. Popp.

The Shepherd Spinal Center opened in 1975 as a six-bed unit operating out of an Atlanta hospital. Moving to its own facility on Peachtree Road in 1982, the center continued setting the standard for catastrophic care through the 1990s by doubling its facilities with a $23 million addition. In 1995, the hospital's name was changed to the Shepherd Center.

Today Shepherd Center is one of the country's premier facilities for the care of people with spinal cord injuries, acquired brain injuries, multiple sclerosis, and other neurological disorders and urological problems. Its expanded services include outpatient programs and a residential rehabilitation center for patients with long-term, supported-living needs.

As a fervent advocate for the disabled community, Shepherd Center has taken an active role in state legislation, promoting the passage of stricter laws in Georgia that mandate the use of seat belts and motorcycle helmets and the imposition of DUI fines.

The center celebrated the tenth anniversary of the Americans with Disabilities Act (ADA) by sponsoring the nationwide Spirit of ADA Torch Relay.

Although the size and scope of Shepherd Center has changed since its inception, its mission remains the same: to return patients to the highest level of functioning possible, enabling them to continue their lives with hope, dignity, and independence.

Equally distinguished for its excellence in health care is Piedmont Hospital, a familiar landmark on Peachtree Road that has been an integral part of the city's landscape for nearly a century. As a not-for-profit health care facility, the hospital takes pride in providing the people of Atlanta with the highest quality of care while spearheading community-wide efforts to enhance the health and well being of residents of Buckhead and beyond.

Above, Equestrian Lauren McDevitt, a former patient of Shepherd Center, led the United States' wheelchair athletes into the stadium during the Opening Ceremonies of the Paralympics. The center led the 1990 bid effort for the games, helped gather the initial corporate support, and provided more than 120 skilled medical and sports volunteers to organize, judge, lead, and support the competition.
Photo courtesy of Sheperd Center.

Established by two dedicated doctors in 1905 as a ten-bed sanatorium, the hospital enjoys a reputation for medical excellence and unrivaled patient care. Today, the five hundred-bed facility employs twenty-five hundred caring individuals and is nationally recognized for its innovations in several fields, including ophthalmology, obstetrics, women's services, and microsurgery. Patients travel from locales throughout the country to take advantage of the medical staff's expertise in specialty procedures, such as open-heart surgery and kidney transplants.

In addition to providing specialized medical care, Shepherd Center also leads the way in serving the community.

As the sponsor of the Wheelchair Division of the annual Peachtree Road Race, the center attracts dozens of wheelchair athletes, both men and women, from around the world to compete in the 10K race each Fourth of July.

In 1996 the center was also one of the sponsors of the Atlanta Paralympic Games, an event in which disabled athletes competed on a world-class level in Olympic sports, capturing the attention of spectators and supporters around the globe.

Renowned for its outstanding orthopaedic and sports medicine programs, Piedmont Hospital's staff physicians in these disciplines also serve as the team doctors for Atlanta's professional sports teams—the Braves, the Falcons, and the Hawks.

The doctors and staff of Piedmont Hospital are repeatedly sought out to share their knowledge and experience. Medical students from several institutions of higher education, including

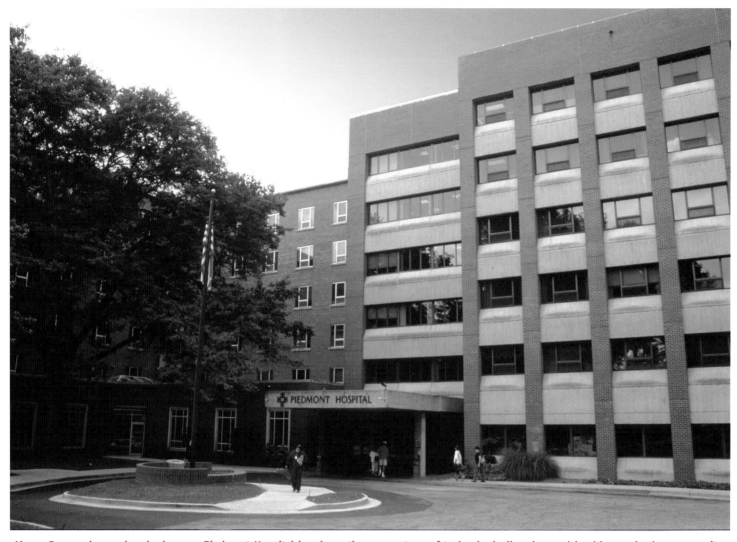

Above, For nearly one hundred years, Piedmont Hospital has been the cornerstone of technologically advanced health care in the community of Buckhead. An integral part of Piedmont Medical Center, the hospital has earned a nationwide reputation in various disciplines, including cardiovascular care, orthopaedics, women's services, and organ transplants. Photo by L.A. Popp.

Emory University and the Medical College of Georgia, rotate through various departments of the hospital as part of their educational training.

Believing that prevention and education are the foundation for healthy living, Piedmont Hospital offers a variety of service-based programs within the community, including support groups, educational seminars, immunization drives, parish nursing, and older adult services.

From its modest beginnings nearly one hundred years ago to its stature among medical facilities today, Piedmont Hospital has retained its vision of providing specialty care services while meeting the overall medical needs of the community in a professional and compassionate environment.

In Buckhead, tending to friends and neighbors in need extends beyond the community's medical facilities and places of worship, as other groups and organizations have been established and called to action, taking an aggressive stance in ensuring a better quality of life for all.

Although Buckhead boasts some of the most magnificent

mansions and homes in Atlanta, the community is not immune to the problem of homelessness.

In Fulton County, for example, 38 percent of children live in poverty, which places their families at risk of losing their homes.

In 1987 five Buckhead churches joined together to form the Buckhead Christian Ministry (BCM) in an effort to alleviate hunger and homelessness in the community by providing food, clothing, and financial assistance with rent and utilities.

Since its inception, BCM has increased its support to twenty-three churches and added a number of programs, including the Transitional Housing Program, which assists families in finding temporary shelter. The program also promotes a family's self-reliance through work with a case manager, who helps parents solve problems with finances and child care, while fostering each family member's emotional well-being.

BCM's selfless volunteers help more than 3,000 families a year.

Community-wide volunteer and fund-raising efforts also extend to individual Atlantans, who love to get together for a good

cause. Each year, nearly seven hundred thousand people come to Buckhead to participate in dozens of events benefiting a variety of groups, schools, and churches. From black-tie galas and art or antique auctions, to musicals and marathons, there's an almost never-ending supply of ways to have fun while raising money to help others.

Charity events are held throughout the year to provide financial support for a variety of organizations.

Annual events that raise funds for local causes include The High Museum Atlanta Wine Auction that is held at Lenox Square to benefit the High Museum of Art; The Decorators' Show House to benefit the Atlanta Symphony Orchestra; and The Cathedral Antiques Show at the Cathedral of St. Philip.

Buckhead residents generously support national causes, as well. Popular annual events include "Party with a Purpose" for the American Cancer Society at Lenox Square; the Crystal Ball at the Ritz-Carlton in support of the research and education efforts of the Arthritis Foundation; the nationally celebrated Dress for Success "Clean Your Closet Week" at Phipps Plaza; and the Cystic Fibrosis Foundation's Sixty-Five Roses Ball at Swissôtel.

Everyone benefits from several races, fun runs, and walks held each year to raise additional funds. Participants get great exercise while helping worthy causes during the Pace Race for Pace Academy; the Atlanta Speech School Fun Run; the MS Walk for the National Multiple Sclerosis Society; the Crohn's & Colitis Foundation's Walk-a-Thon, which is held in Chastain Park; and the Buckhead/Vinings Relay for Life and the Making Strides Against Breast Cancer Walk that both raise funds for the American Cancer Society.

The extra exercise may come in handy for those who attend "Taste of the Nation" at the Grand Hyatt Atlanta. Cuisine from the city's top chefs can be sampled under one roof at this epicurean extravaganza. A mainstay of the charity circuit, the event benefits the Atlanta Community Food Bank locally and is part of the nationwide "Share our Strength" effort that has raised more than $46 million dollars nationally since 1988.

Buckhead also helps feed the hungry on a very real basis every day. In 1987 Buckhead Life Restaurant Group's president, Pano Karatassos, teamed with the Atlanta Community Food Bank to start "Atlanta's Table," the country's first freshly prepared food program. Now more than two hundred metro Atlanta restaurants, hotels, cafeterias, convention centers, and caterers donate twenty-five thousand pounds of fresh food that would otherwise be thrown away to dozens of nonprofit, hunger-relief agencies each month.

It's inspiring to know that throughout the community of Buckhead, compassionate care and heartfelt concern for one and all is merely an outstretched hand away.

Buckhead has a great spirit of philanthropy and a long tradition of improving the health and welfare of those in its community and surrounding it. It is home to many great nonprofit organizations whose impact reaches far beyond Buckhead.

–Robert M. Bird
Partner
PricewaterhouseCoopers

Above, Recognized as one of the premier charity auctions of its kind in the country, the High Museum Atlanta Wine Auction is a three-day extravaganza held at Lenox Square. Premier wine tasting seminars, a gala dinner dance, a vintner's reception, a live auction, and food sumptuously prepared by Atlanta's finest chefs are among the annual festivities. All proceeds benefit the High Museum of Art, which has been cited by the American Institute of Architects as one of the "ten best works of American architecture in the 1980s." Since its inception in 1992, the wine auction has netted more than $4.5 million for the museum. Photo by Ray Swords Photography, courtesy of the High Museum of Art.

Above, As the world's largest 10K event, the Peachtree Road Race was first held in 1970 with approximately 110 competitors. Hosted by the Atlanta Track Club, the race—which has become one of Buckhead's favorite Fourth of July events—is a world-renowned competition attracting more than 50,000 runners each year.
Photo by Ross Henderson, courtesy of the Atlanta Track Club.

At left, Walkers gear up for PaceSetter Walk 2002, a 2.5 mile walk around Chastain Park to raise awareness and funds for the Crohn's & Colitis Foundation of America.
Photo courtesy of Crohn's & Colitis Foundation.

At right, Each spring Pace Academy students, faculty, and parents take their mark alongside community residents to compete in the annual Pace Race. Proceeds from the 5K event benefit the Pace Academy Booster Club, an active group that raises money to support arts and academics at the school.
Photo courtesy of Pace Academy.

At left, For more than fifteen years, the Cystic Fibrosis Foundation's Sixty-Five Roses Ball has been a much-anticipated, black-tie dinner dance held annually to raise funds to find a cure for cystic fibrosis, a disease that afflicts thirty thousand Americans. With strong corporate support and an impressive number of returning sponsors and patrons, the event—which also includes both a silent and a live auction—is one of Buckhead's most successful and equally sophisticated events. Photo courtesy of the Cystic Fibrosis Foundation.

Below, One of the premier fundraisers in Buckhead—and throughout the Southeast—is the annual Decorators' Show House, hosted by Atlanta Sympony Associates. Interior and landscape designers use their skills to expertly transform the rooms and grounds of a selected property that is then opened to the public for tours. The site of the 1979 and 2003 event, *pictured below*: The Rhodes-Robinson House, a West Paces Ferry Road landmark that was built by Neel Reid and completed by Philip Trammell Shutze in 1929. All proceeds benefit the Atlanta Symphony Orchestra.

Photo courtesy of Atlanta Symphony Associates.

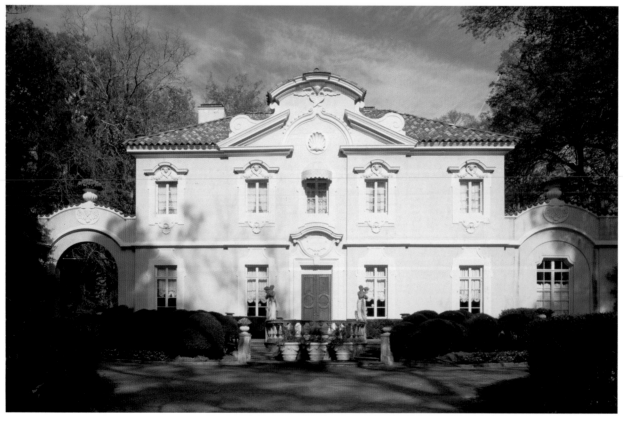

With more than one million people afflicted by arthritis in the state of Georgia, fund-raising efforts to support research to find a cure for the nation's No. 1 crippler are ongoing. Hosted by the state's chapter of the Arthritis Foundation, the Crystal Ball is one of Buckhead's most prestigious charity events, held annually at the Ritz-Carlton to raise money to fund research initiatives and provide information to improve the quality of life of arthritis sufferers nationwide.

Pictured above, Mrs. Jane Dean and Mrs. J. Lucian Smith are among the attendees of the 2002 Crystal Ball.

At right, Young residents from Buckhead and beyond gather to enjoy the Crystal Ball's black-tie festivities and support a worthy cause. *Back row, from left to right:* Ronald Miller, Abigail Foster, and Alyson Calder. *Front row, from left to right:* Dylan and Madison Thomas, John Woody, Samantha Price, and Chelsea Trout.

Photos courtesy of the Arthritis Foundation.

Above, Attracting more than eight thousand attendees each year, the Cathedral Antiques Show is an annual, five-day event sponsored by The Episcopal Church Women of the Cathedral of St. Philip to benefit a selected nonprofit organization in the Atlanta community. Acclaimed as one of the most successful events of its kind in the Southeast, the antique show features eighteenth- and nineteenth-century art, antiques, linens, jewelry, silver, porcelain, and other pieces presented by more than thirty prestigious American and European dealers. Other highlights of the event include guest speakers, educational presentations, personal antique appraisals, a tearoom lunch, late-afternoon tea service, and a tour of four exquisite homes in North Atlanta. Through the hard work of more than three hundred unpaid volunteers, the Cathedral Antiques Show has raised $1.5 million for area charities within the past eight years. Photo by Sister Moore.

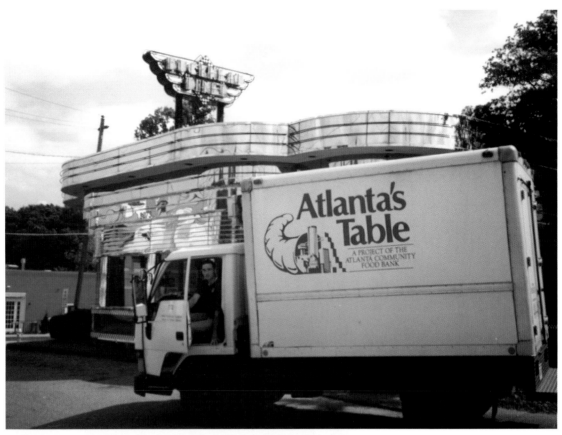

Above and at left, To help feed the area's hungry, more than two hundred metro Atlanta restaurants, cafeterias, hotels, convention centers, and caterers donate twenty-five thousand pounds of fresh food to nonprofit, hunger-relief agencies each month in a program known as "Atlanta's Table." Established in 1987, the country's first freshly prepared food program began as a joint venture between Pano Karatassos, president of the Buckhead Life Restaurant Group, and the Atlanta Community Food Bank.

Photos courtesy of Buckhead Life Restaurant Group.

Above and at left,
Throughout Buckhead, the phrase "Pub Crawl" has become synonymous with "party." And what a party it is when revelers gather to drink, eat, and be merry as they tour the town's taverns to raise funds in support of a worthy cause. In addition to the annual Buckhead Art Crawl sponsored by the Buckhead Business Association and YoungBucks, the community has also participated in a six-city pub crawl to raise awareness of breast cancer and support nationwide research efforts.
Photos by Patrick Kelly.

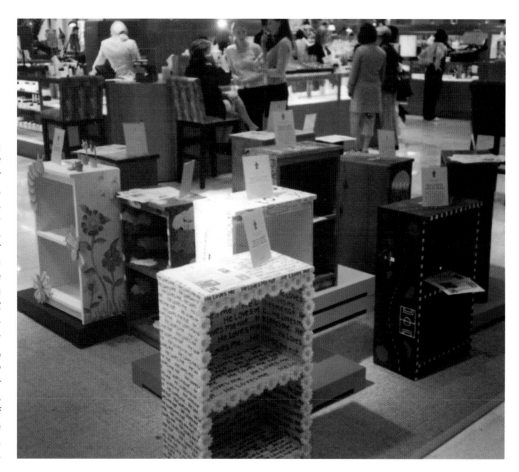

At right, The Children's Museum of Atlanta's annual family fund-raiser, "Making a Case for Reading," features storytelling, the creation of pop-up books, and a silent auction of book-cases decorated by musicians, sports celebrities, and other notables. Held at the Monarch Court in Phipps Plaza, the proceeds of the auction support the ongoing work of the museum.

Photo courtesy of Phipps Plaza.

Below, Always ready to tee off to support a worthy cause, area golfers register for the 10th Annual Crohn's & Colitis Foundation of America Golf Classic at the renowned Atlanta Athletic Club.

Photo courtesy of Crohn's & Colitis Foundation.

treasures

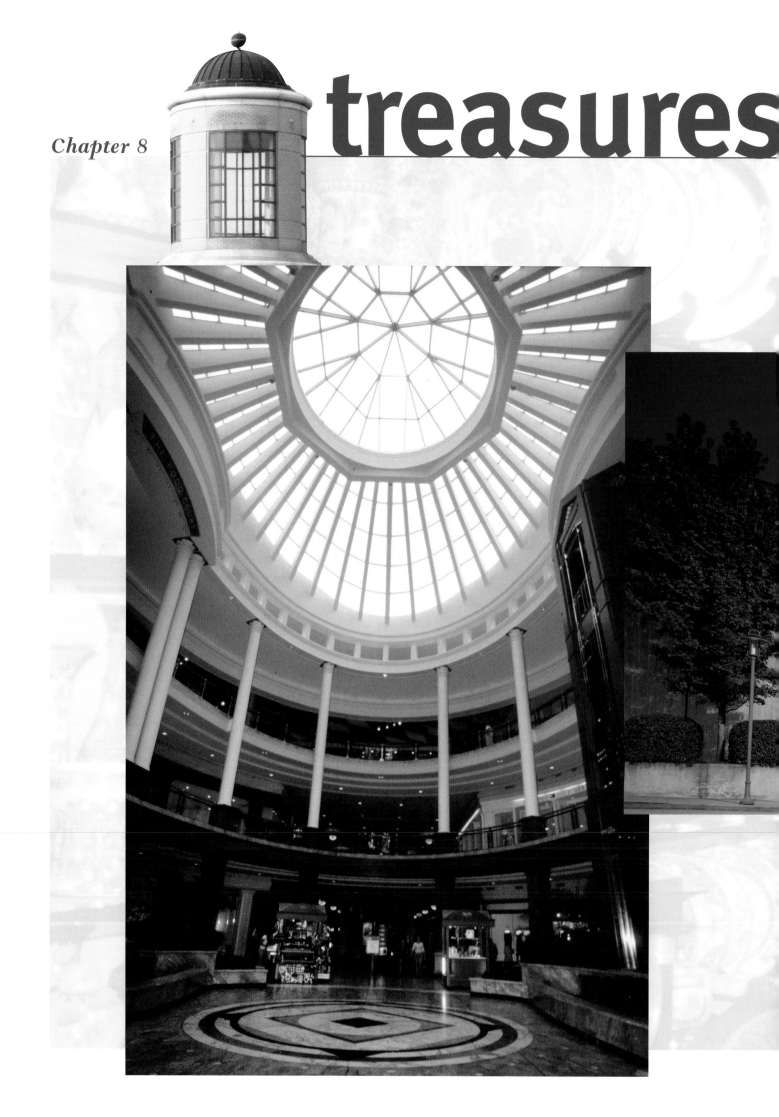

& pleasures

Attracting *patrons* from throughout the *South*, Buckhead's *premier* retail venues make this *community* a frequent and favored *destination* on the map of those in search of the *finer* things in *life*.

From quaint and quirky to high-end and haute couture—it's all waiting to be discovered in Buckhead's every nook and cranny, where a colorful ambiance and picturesque charm makes shopping an idyllic pastime. *At left,* Phipps Plaza. *Above,* Neiman Marcus. *At right,* The Bilt-House.

Photo of Neiman Marcus by Patrick Kelly; other photos by L.A. Popp.

Both Browsers & Buyers Discover 'Paradise' in Buckhead

At a time when only six malls were in existence nationwide, the opening of Lenox Square in 1959 brought a brand new shopping experience to the community of Buckhead and the southeastern United States. With 1.5 million square feet of retail space, the mall, *pictured above*, is now one of Buckhead's most popular and prestigious landmarks. Photos by L.A. Popp.

While Buckhead offers the best of many of life's pleasures, there is one venue in which the community truly excels: shopping. Nowhere in the Southeast can consumers discover a more concentrated and varied assortment of retail establishments.

Any dialogue about shopping in Buckhead must begin with the "grand dame" of malls—Lenox Square—whose history is closely linked with that of the community's own development.

Since Buckhead's establishment in 1838, its social life, like most other communities throughout the United States, was centered around the downtown area, which was usually comprised of government and business offices, as well as merchants, retailers, and cafés. But as American life changed with the migration of the masses to the suburbs, so changed the societal needs of community residents.

An astute businessman saw the exodus as an opportunity to introduce a new shopping concept in the city of Atlanta. In 1959, after one year of construction at the corner of Lenox and

Peachtree Roads, Edward Noble transformed traditional shopping patterns by opening Lenox Square, the region's first shopping center.

At an initial building cost of $15 million, Lenox Square was constructed as an open-air mall with fifty-two stores anchored by Rich's and Davison's department stores. The mall's emergence as the place for residents of Buckhead and beyond to shop heralded the beginning of the area's ascent to prominence.

After more than forty years and several renovations, the enclosed mall is now the premier retail destination in the Southeast—the Super Bowl and World Series of shopping rolled into one. The four-level, 1.5 million square-foot mall, which is now anchored by Rich's, Macy's, and Neiman Marcus, features 230 specialty stores, kiosks, and eateries. Many of the mall's retail tenants are, in fact, exclusive to the Atlanta area.

Lenox Square also offers some of the city's finest white-linen restaurants, an exhaustive selection of choices in its food court, and a six-screen movie complex.

Above, More than 200,000 people congregate each Fourth of July in Lenox Square's parking lot to celebrate Independence Day while watching the largest firework displays in the Southeast. For those who prefer to enjoy the festivities from the comfort of home, the community-wide event is telecast live each year.
Photo courtesy of Lenox Square.

Above, Lenox Square's open architectural design makes dining in the food court especially enjoyable as the sun filters through the skylights that are an intricate design element in the mall's steel-beamed ceiling.
Photo by L.A. Popp.

Above, Reminiscent of the grand ballrooms of the most magnificent mansions ever built, Phipps Plaza has more than one hundred specialty stores and three prestigious anchors—Saks Fifth Avenue, Parisian, and Lord & Taylor. Photo by L.A. Popp.

But it's not just the endless variety of shops and restaurants that make Lenox Square a popular destination for visitors and a vital part of the lives of area residents. This shopper's nirvana is also an integral part of the community. Several of the city's most beloved seasonal traditions take place here.

As the sun comes up each Fourth of July morning, fifty-five thousand runners of all ages, shapes, and sizes gather at the corner of Lenox and Peachtree Roads—outside the front entrance of the mall—at the starting line of the Peachtree Road Race. From its humble beginnings more than thirty years ago with several hundred runners, the Peachtree Road Race has grown into the world's largest 10K race, attracting elite athletes from around the world. They run the course down Peachtree Street and cross the finish line in Piedmont Park, long before the last of the thousands and thousands of daily runners even lace up their athletic shoes. The coveted finishers' T-shirts and the widespread camaraderie are what keep the faithful coming back year after year.

Later on that same night, thousands more Atlantans, many sporting their newly won race T-shirts, gather once again in the parking lot of Lenox Square to watch the annual Independence Day fireworks celebration. The "ooh-and-aah" factor is contagious as one of the largest pyrotechnic displays in the Southeast delights young and old alike.

Lenox Square is also home to Rich's Great Tree. In November a giant fir is cut in North Georgia, transported to Buckhead, and hoisted up to the corner of Rich's roof, where dozens of workers spend weeks decorating it with basketball-sized ornaments and miles of lights. Then on Thanksgiving night, thousands of Atlantans gather their families and friends and head over to Lenox Square to enjoy a program of religious and seasonal music as they await the magical moment when the switch is thrown, the Great Tree is illuminated, and the lights shine as bright beacons in the Buckhead sky, welcoming the beginning of the holiday season.

Adjacent to MARTA and surrounded by world-class hotels, motels, and office buildings, Lenox Square is within easy walking distance of several other fine Buckhead shopping destinations.

Just across the street is Phipps Plaza. Built in the early 1970s, Phipps gave Atlantans a sophisticated sampling of haute couture with anchors Saks Fifth Avenue and Lord & Taylor. Completely

Christened Buckhead's "grand dame of decorating," designer Jane Marsden transformed an unsightly property bordering Peachtree Creek into a gallery showcase at 2300 Peachtree Road, *above*, in 1987. The elegant complex, with its pronounced European plaza aesthetics, features some of Buckhead's most exquisite period and estate jewelry, fine art, porcelains, furniture, and antiques—all under one roof.
Photo by Patrick Kelly.

renovated in the early 1990s with the addition of the flagship store of its newest anchor, Parisian, Phipps Plaza still enjoys an unparalleled reputation for high-end shopping. The mall also boasts a fourteen-screen movie theatre and several fine restaurants.

The community of Buckhead also offers many alternatives to the mall experience. Several pockets of unique shopping opportunities flourish throughout in the area.

North of the Roswell-Peachtree split on Roswell Road is an area known as the Buckhead West Village. The streets are lined with quaint shops brimming with unique clothing and home-decorating accessories.

With an interesting array of shops and restaurants, Peachtree Battle Shopping Center is home to what may be Atlanta's only remaining bona fide variety store.

Other areas worth a stop include Brookwood Square and Lenox Marketplace, which features a two-story Target with a separate escalator for shopping carts and a seventy-foot climbing wall at Galyan's sporting goods store.

The last few decades have also seen the emergence of several distinct designer areas specializing in unique home furnishings and antiques.

Miami Circle, located off Piedmont Road, consists of nearly eighty businesses devoted to all aspects of interior design. In the early 1980s, the area was still completely industrial, but a few innovative individuals, lured by the economic appeal of afford-able square footage, set up antique shops in several of the area's warehouses. The product range in the district now runs the gamut from designer quality art, rugs, and architectural elements, to marble, porcelain, and lighting, all available to the public.

A tired shopper can get a relaxing manicure or a new haircut at Stan Milton Salon, then head to the end of Miami Circle for the fun and tapas always waiting at Eclipse di Luna restaurant.

Off Peachtree Road, south of Peachtree Creek, is Bennett Street, where another creative and eclectic collection of quaint stores that evolved from a warehouse district is waiting to be discovered. In the mid-1970s, forward-thinking gallery owners set up shop on the former country road. Now the area is chock-full of shops teeming with unique treasures for home and garden, as well as art galleries, artists' studios, and restaurants.

Visitors to Bennett Street will also find The Portfolio Center, a creative arts college, and IMAGE Film and Video Center.

So little time...so many shops and stores. Indeed, Buckhead affords both the dedicated shopper and the casual browser virtually anything and everything.

More than just a neighborhood, Buckhead is a way of life...and for many residents and businesses, the true heart of Atlanta. What once began with a general store and tavern, Buckhead has blossomed into Atlanta's crossroads—gently merging a community steeped in tradition and rich in history with a thriving business environ-ment. From the site of the city's oldest annual Independence Day celebration at Lenox Square, to hosting families shopping and visiting the "true" Santa at Phipps Plaza, each holiday season, we are proud to call Buckhead "home."

—Helen Burns
Regional Vice President
Simon Property Group
Lenox Square and Phipps Plaza

ve left, Rich's Department Store in Lenox Square hosts the annual lighting of Rich's Great Tree each year on Thanksgiving night. It is estimated t more than two hundred thousand attendees make this jubilant celebration—which is made all the merrier with live entertainment by top-name sicians—a part of their family's holiday tradition each year. Photo courtesy of Rich's Department Store.

ve right, another breathtaking view of the spectacular Fourth of July fireworks display that lights up the night over Lenox Square.
courtesy of Lenox Square.

At left, C Lighting on East Paces Ferry Road provides an "illuminating" experience for shoppers looking for innovative ways to brighten their living environments with traditional and contemporary lighting systems.

Below, Since earning *Atlanta Magazine*'s rating for "Best Perennial Inspiration" in 1999 and "Best Garden Gifts" in 2000, patrons of Buckhead's West Village have clamored to Boxwoods Gardens & Gifts located on East Andrews Drive. Boxwoods is abloom with all things beautiful— antiques and art, gifts and gardening accessories, plants and planters.

Photos by L.A. Popp.

Above, Located on Peachtree Road, NE, Melissa Sweet Bridal Collection features the exclusive wedding and evening gown collections of one of the nation's top bridal designers, Melissa Sweet. A graduate of Bauder Fashion College in Atlanta, Sweet operates salons in Denver, New York, and Atlanta. Her designs are also featured in boutiques and salons throughout the United States and in Canada.

Photo by Jennifer Pack.

At right, Established in 1991, Now & Again, located in Andrews Square, is a consignment shop that blends the past and the present in a charming setting. In addition to art, antiques, and finer furnishings, the shoppe sells gifts and decorative accessories, as well as traditional and unusual period pieces from artists, auctions, estate sales, and gift markets throughout the Southeast, New York, North Carolina, and Europe.

Photo by L.A. Popp.

Above, Buckhead is home to some of the most prestigious luxury vehicle dealerships in the region. Land Rover Buckhead on East Paces Ferry Road offers a unique setting for its display of SUVs in a modern showroom facility set amidst a unique, rock-formation landscape.

At left, A chrome jaguar sits atop the dealership sign, glistening in the bright, blue skies over Buckhead, inviting area residents to visit the luxury car showroom on Piedmont Road.

Photos by L.A. Popp.

At right, For more than thirty years, Brookhaven Buckhead Flowers has created breathtaking floral arrangements for metropolitan Atlanta residents. The full-service florist, located on Peachtree Road, NE, specializes in wedding arrangements ranging from traditional to contemporary—yet always elegant—in design.

Below, Peachtree Battle Shopping Center, located on Peachtree Road, is a frequent stop for Buckhead residents. The multi-level mini-mall is anchored by Talbot's, Publix, Chapter 11, Kings, Bank of America, and Ace Hardware.

Photos by L.A. Popp.

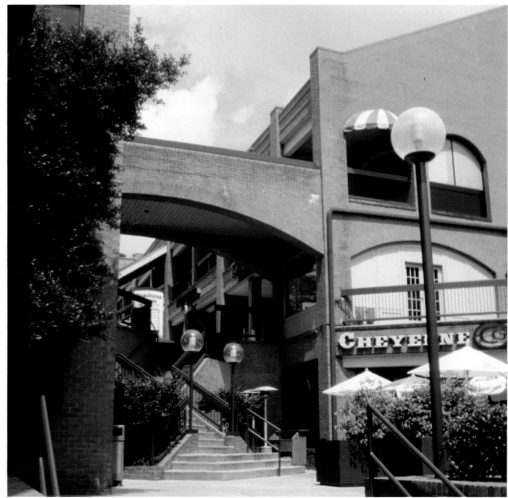

At *left*, Jane J. Marsden Interiors & Antiques lures collectors in search of English and Continental antiques and accessories to the filled-to-the-rafters, two-story shop located at 2300 Peachtree Road.

At *right*, Saks Fifth Avenue is just one of the many sophisticated stores that clearly defines Phipps Plaza as a premier shopping destination in Buckhead.

Below, Anchored by Kroger, Fountain Oaks on Roswell Road is a bi-level shopping center featuring an array of fitness centers, eateries, and retail stores. The Gym at Buckhead, GNC, and Gymboree are among the mall's notable tenants.

Photos by L.A. Popp.

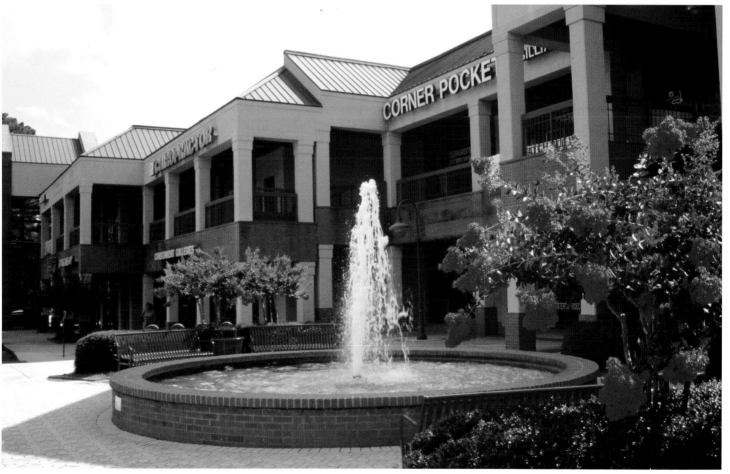

Above and at right, The Bilt-House on East Paces Ferry Road in Buckhead's East Village offers a brightly-colored potpourri of clothing, collectibles, linens, bedding, and furniture.

Bottom right, Peridot Distinctive Gifts has converted the old house it occupies on East Paces Ferry Road into a shopper's "treasure chest." Offering an array of delightful, out-of-the ordinary gifts, each room, with its own theme, is filled from floor to ceiling with lovely items for the kitchen, bath, garden, newborns, and more, bringing buyers back time and time again to discover and explore each nook and cranny.

Photos by L.A. Popp.

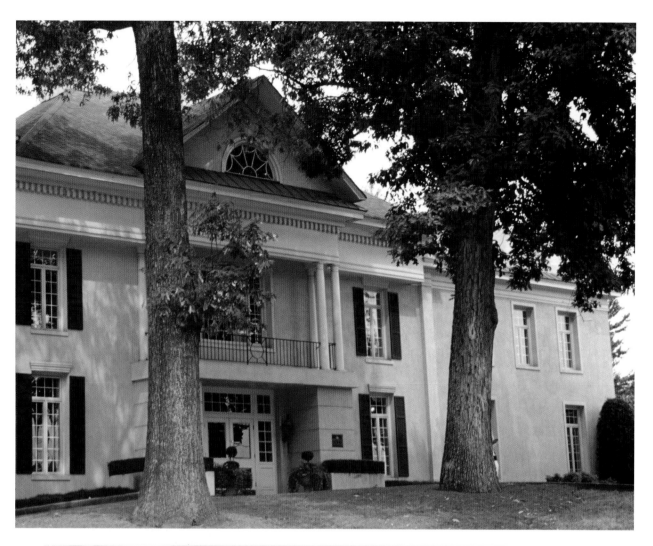

Above, Beverly Hall Furniture Galleries has been "making Atlanta beautiful, one home at a time" since 1945. Claiming the largest selection of traditional and contemporary classic furniture in the South, the Piedmont Road gallery is one of three locations in metro Atlanta. Photo by L.A. Popp.

At left, Classic French traditions in the most exquisite home decor are the "pièce de résistance" at Pierre Deux - French Country. As one of nine stores nationwide, the Miami Circle shoppe features the finest furnishings, linens, fabric, and wallpaper reminiscent of France's enduring heritage of luxurious quality and exceptional beauty. Photo by Jennifer Pack.

Named for Miami Window Co., a popular tenant of the area in years gone by, Miami Circle has been aptly described as "one of Atlanta's liveliest design and decorating scenes." Since the 1970s, when the street's development as a design district first began, the cul-de-sac has flourished with seventy unique shops. *At right and below*, Design Place, located at 715 Miami Circle, is an eclectic emporium of quaint stores that sell everything from rare antiques, vintage chandeliers, oil paintings, and mirrors, to fine rugs, frames, and sophisticated Bose sound systems.

Photos by Jennifer Pack.

Chapter 9

dining

Above, An evening at the Capital Grille—renowned for its dry aged steaks, chops, and fresh seafood—is the perfect way to unwind after a bustling day of business or pleasure in Buckhead. Photo by L.A. Popp.

At left, Michael Bolton croons under the stars at one of Chastain Park's legendary summer concerts. Photo by L.A. Popp.

Above right, The Atlanta Pub Crawl to raise breast cancer awareness and money for research brought area residents together to tour the town's taverns and share a toast to good health. Photo by Patrick Kelly.

Far right, Even the most discerning palate will find the delectable dishes at Chops—one of Buckhead Life Restaurant Group's popular eateries—delightful and delicious day and night. Photo courtesy of Buckhead Life Restaurant Group.

Bottom right, The streets sparkle with a spectacular display of lights as cars travel to and from their favorite Buckhead destinations. Photo by Patrick Kelly.

& nightlife

Around the *table* and under the *stars*, there's always a whole lot *cookin'* for those *lookin'* for good *fun* and great *food* in Buckhead.

Four-Star Flavor & First-Rate Entertainment Make Buckhead a Favorite Destination

If providing the consummate shopping experience is one of Buckhead's fortés, its gastronomic pleasures that tantalize the hungry—who can always find exactly what they are craving among the community's staggering variety of eateries—vie for equal eminence.

Food, however, is just one of the offerings on the menu in many of these world-class establishments; fun, drama, and special moments add an unparalleled zest to Buckhead's culinary flavor.

Often referred to as "the dining room of Georgia," Buckhead offers more than two hundred restaurants with something for every appetite and wallet. From a slice of pizza served al fresco to filet mignon prepared to perfection in a white-linen, five-star dining room, each palate is always satisfied.

Buckhead's restaurants are popular, too; the top six metro area revenue producers are all located here. Just look for the crowds at The Cheesecake Factory, Maggiano's Little Italy, Atlanta Fish Market, Chops, Bones, and ESPN Zone.

Buckhead also has some of the most romantic, unique, and eclectic restaurants in the country.

At Dante's Down the Hatch, diners dip into fondue while listening to live jazz on the deck of an eighteenth-century sailing ship and wharf.

The Dining Room at the Ritz-Carlton offers one of the most appetizing experiences possible. Winner of several of the culinary world's most prestigious awards, the restaurant is a favorite locale for celebrating special occasions.

Another award winner is Seeger's, the brainchild of former Ritz-Carlton chef Gunter Seeger. The restaurant's eclectic menu changes daily according to the whim of Chef Gunter.

The list of delicious choices is almost endless, but one company in particular typifies the consistency, longevity, and innovation that have positioned Buckhead's restaurants on the culinary map. The Buckhead Life Restaurant Group owns many of the areas most celebrated and best-loved restaurants. Three of the top six money earners in the city—Atlanta Fish Market, Chops, and Bluepointe—are all Buckhead Life properties. The group's first restaurant, Pano's and Paul's, opened in 1979 and was named for its founders, Pano Karatassos and Paul Albrecht. The two met in

Above, Dante's Down the Hatch offers an unforgettable evening of food and fantasy as diners enjoy an array of mouthwatering fondue dishes amidst eighteenth century artifacts, including a three-masted sailing ship, antiques, and live alligators in the moat that surrounds the vessel. In the foreground, Dante, the owner, serves guests, Mario Younes and Jenny Price of Atlanta. Photo by L.A. Popp.

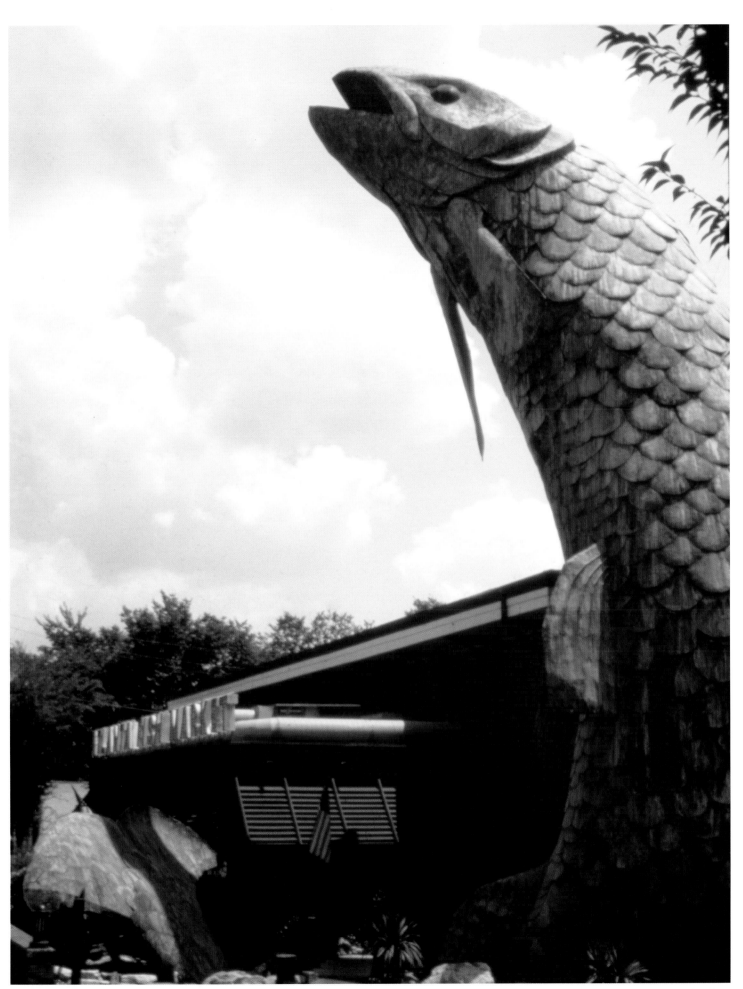

Above, *The Great Fish*, created by sculptors Martin Dawe and Randy Blain in 1995, has become a legendary landmark of great proportion for those visiting the Atlanta Fish Market on Pharr Road. Consistently rated "Atlanta's Best Seafood Restaurant," the eatery is one of the nationally acclaimed restaurants owned by the Buckhead Life Restaurant Group. Photo by L.A. Popp.

an eatery in Washington, D.C., where Pano ran the dining room and Paul oversaw the creative doings in the kitchen. Admiring each other's talents, they decided to strike out on their own. The pair's commitment to quality earned the restaurateurs accolades for elevating Atlanta's dining standards to what they are today.

Pano has since moved on to create his own culinary empire in and around the community of Buckhead, with twelve restaurants, a European-style bakery, a private club, and a private-event facility. All types of cuisine receive his personal touch—from steaks and seafood to Southwestern, Italian, American, and Continental fare. Pano has, indeed, made an indelible impression on Buckhead's culinary landscape.

After an evening of fine dining, it's time to check out another of Buckhead's celebrated attributes: its nonstop nightlife.

New Orleans has the French Quarter; Atlanta has the Village.

Dozens of nightclubs and bars line the streets in the area known as the East Village near Bolling Way and Buckhead Avenue. The proliferation of party spots has kept pace with the growth of Atlanta's young adult population, and on warm weekends, the streets are teeming with so many revelers, it's like Mardi Gras North.

But it wasn't always so. In the late '70s, there were a handful of bars dotting Peachtree Street. Harrison's, Good Ol Days, Carlos McGee's, and Aunt Charley's were popular night stops that have all since issued their "last call." But as the '80s dawned, so did a new day for Buckhead nightlife.

Ron Hudspeth, former *Atlanta Journal* columnist and dedicated chronicler of Buckhead life, pinpoints the birth of modern-day Buckhead to the time when George Rohrig moved his little Peachtree Café sandwich shop across East Paces Ferry to a larger building and converted it into a restaurant and bar that instantly became the place to be. Rohrig followed up with several other successful restaurants and bars, opening the doors for dozens of entrepreneurs whose mantra through the years has been, "If you party, they will come."

On a more sedate but no less entertaining note, nothing

Above, Located on Peachtree Road in Buckhead, The Cheesecake Factory is famous for its homemade, melt-in-your-mouth cheesecakes in a sinful variety of thirty-five decadent flavors, from banana cream to pumpkin. But the savviest patrons don't just visit the factory for sweets: There are more than two hundred tantalizing selections, including an enticing array of pastas and pizza, salads, sandwiches, steaks, and seafood, on the menu, that make it difficult—if not impossible—to leave room for dessert. Photo by L.A. Popp.

Above, As the newest addition to the Buckhead Life Restaurant Group's culinary empire, Kyma opened its doors in 2001. Both the food and the décor at the Peachtree Road dining establishment are authentically Greek by design, blending classic Mediterranean tastes—influenced by the Midas touch of owner Pano Karatassos—served in a modern and most dramatic ambiance, complete with astrological Greek symbols and twinkling stars in the restaurant's central ceiling. Photo courtesy of Buckhead Life Restaurant Group.

typifies the good life like an evening under the stars at Chastain Park Amphitheater. Nestled in a natural setting, the outdoor arena sets the standard for summer entertainment. And although music is the main draw, Atlantans make the most of the venue's liberal policy regarding food and libations. Concertgoers regularly spread out tablecloths, complete with silver, candelabras, flowers, and champagne, to accompany their meals, which are, more often than not, catered, gourmet fare. Others keep it casual with beer, wine, and snacks. Two summer concert series attract artists as diverse as Michael Bolton and R.E.M., the Gipsy Kings and James Taylor, and B.B. King and the B52's.

Another popular music venue is located right in the heart of Buckhead. The Coca-Cola Roxy Theater brings the best of local, regional, and national acts to the city, offering audiences a comfortable setting in which to enjoy the show. Housed in a converted movie theatre with a landmark marquee, the Roxy stages an up-close, intimate experience not available in larger halls.

The theatre's lobby also boasts an impressive private collection of music and entertainment memorabilia. Most of the mementos belong to legendary concert promoter Alex Cooley, who is credited with converting the theatre into a live music hall. Cooley and Peter Conlon head up Concert Southern Promotions, which owns or operates four venues around Atlanta, including the Coca-Cola Roxy Theater and Chastain Park Amphitheater. With offices located adjacent to the Roxy, the company is also responsible for arranging most of the major musical talents that headline in Atlanta each year.

Buckhead's dining and nightlife options certainly have changed since a buck's head was mounted on a post outside Henry Irby's tavern nearly two hundred years ago.

But now, as in days gone by, food, drink, song, and—most importantly—satisfying the customer's appetite for a fun-filled night on the town are still what it's all about when the sun sets in Buckhead.

Buckhead superbly brings together the classic traditions of the past and exciting concepts for the future. It unites strength and stability with fun and vibrancy. That is why we chose to position our restaurants throughout the Buckhead community. In fact, we named our company in that very spirit—the Buckhead Life Restaurant Group—showcasing the character and energy that we strive daily to exemplify.

—I. Pano Karatassos
President/Owner
Buckhead Life Restaurant Group

At left, The marquee of the Coca-Cola Roxy Theater on Roswell Road lights up the night with a colorful neon display, serving as a beacon to all who visit Buckhead to enjoy the Village's nonstop nightlife.

Above, Occupying an old, two-story house that was once a fine porcelain shop, the Steamhouse Lounge on Bolling Way serves a scrumptious selection of shellfish dishes and an unrivaled lobster bisque, which has been voted "Atlanta's Best."

Photos by Patrick Kelly.

At right, Lori Rua of Atlanta (at left) and Shaddai Flewallen of Buckhead, enjoy a cup of java and spirited conversation at Starbucks on Piedmont Road.

Photo by L.A. Popp.

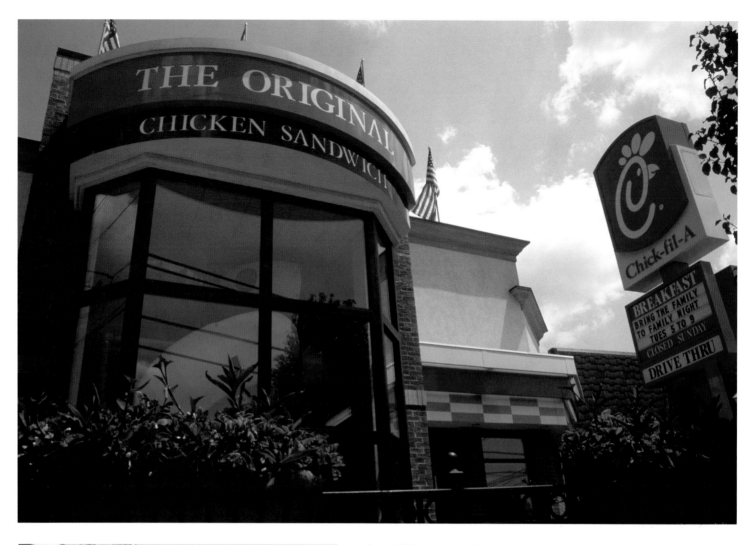

Above, With locations throughout Atlanta and the nation, Chick-Fil-A is a favorite fast-food establishment, as well as a generous patron of charities in Buckhead and beyond. Photo by L.A. Popp.

At left, Amidst authentic artifacts, patrons of Annie's Thai Castle enjoy bona fide flavors of a distant land. The Roswell Road restaurant occupies a refurbished house that offers an intimate, indoor ambiance. Alfresco dining can also be enjoyed on the patio in warmer weather. Photo by Patrick Kelly.

At right, Maggiano's Little Italy, located on Peachtree Road, expertly blends a taste of the old world with the new, creating superb Italian cuisine that is both traditional and contemporary. A must-have from the menu: the homemade goods from Maggiano's Bakery; they are simply "magnifico." Photo by L.A. Popp.

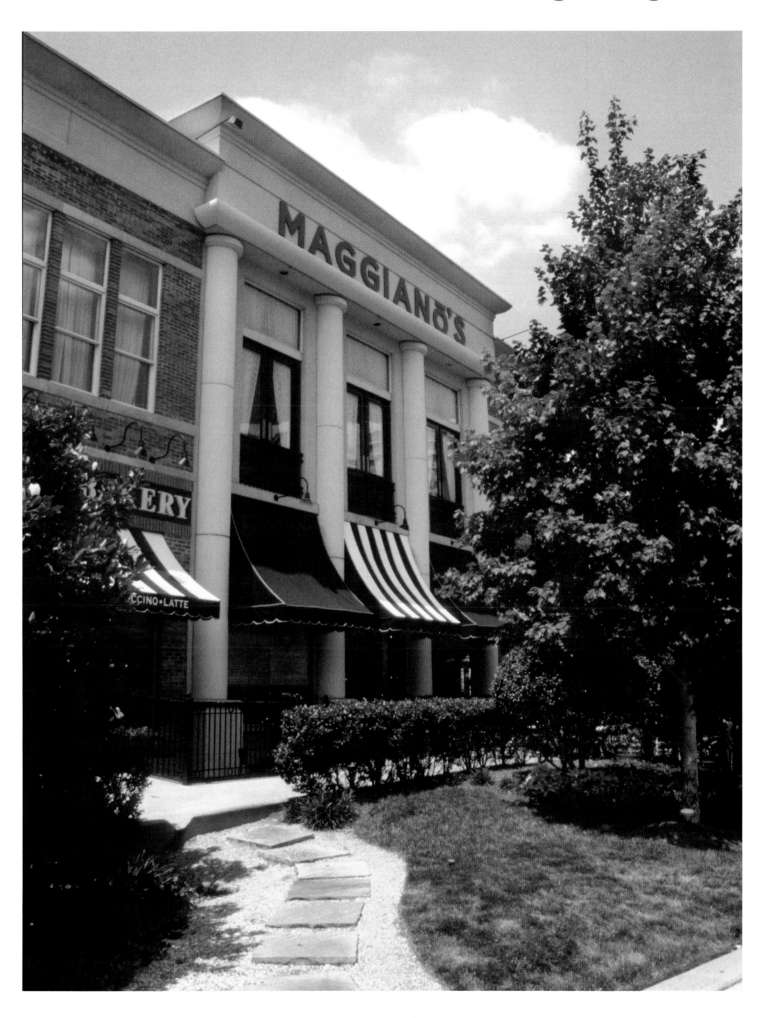

At left, Playing billiards is a popular pastime in the "pool hall" at the Buckhead Saloon. Photo by Patrick Kelly.

Below, It's a foot-stompin', hand-clappin', good ol' time at Coyote Ugly, where employees give new meaning to the phrase, "bar hopping." Located on East Paces Ferry Road, it's a popular place to stop in for a spell and kick up your heels to knee-slappin', country-and-western tunes. Photos by L.A. Popp.

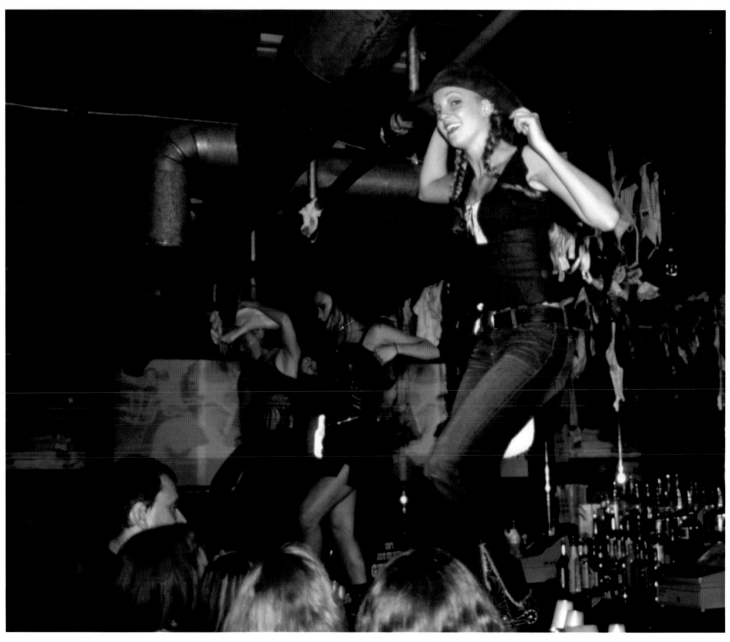

At top, One Buckhead Plaza serves as headquarters for several world-class businesses, a wide variety of retail shops, and two culinary delights of the Buckhead Life Restaurant Group—NAVA and Chops.

Photo by L.A. Popp.

Above, for the finest Southwestern dining experience this side of the Mississippi, NAVA presents intriguing fare that is authentic in color, flavor, and texture and deep-down-South delicious.

Photo courtesy of the Buckhead Life Restaurant Group.

At right, Young Chandler Vought of Atlanta enjoys the sights, sounds, and scenery at One Buckhead Plaza.

Photo by L.A. Popp.

Above, The Landmark Diner, located at the crossroads of Roswell and Piedmont, welcomes travelers with an inviting warmth and one of the region's most diversified menus. Here is where locals and travelers also kick back, dance, and revel in an evening of nonstop entertainment at the diner's always-hoppin' nightclub, Johnny's Sidedoor.

At left, The Buckhead Diner, located on Piedmont Road, serves an eclectic selection of discerning dishes that transcends traditional diner food. Day and night, this Buckhead Life Restaurant Group establishment is a favored—and flavorful—destination for one and all.

At right, It's a year-round Mardi Gras at Mako's on Peachtree Road, one of the Village's hottest spots that sports a genuine New Orleans theme, complete with beads, juggling, and fire breathing. With wall-to-wall crowds, the dance floor pulsates with loud music, while funseekers take turns floating above the crowd on a swing suspended from the ceiling. Party on!

Photos by L.A. Popp

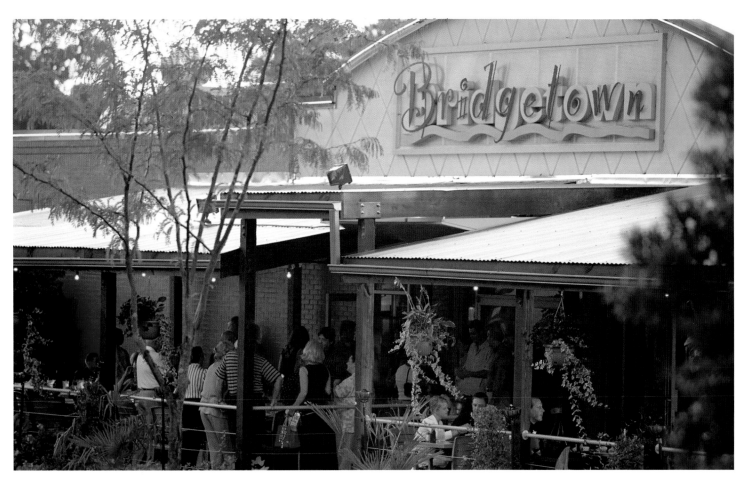

Above, For those seeking a culinary adventure, Bridgetown Grill, located on Piedmont Road, serves an exotic assortment of Cajun, Caribbean, and Southwestern specialities, including Coconut Shrimp, Conch Fritters, Mango Pork, Jamaican Burritos, and a Buckhead favorite–Black & White Bean Soup.

At left and at right, The spirit of America endures at R. Thomas' Deluxe Grill on Peachtree Street, where whimsical statues of Uncle Sam and Lady Liberty greet patrons who stop to savor a delightful meal.

Photos by L.A. Popp.

Above, On weekends, it's a rip-roarin' good ol' time as the Wild West comes alive at the Buckhead Saloon on Peachtree Road, NE. A popular club for area singles, the saloon is often packed to the gills, and for good reason: There's usually no cover charge to jump and jive to the live, acoustic music.
Photo by Patrick Kelly.

At left, Good friends and great pizza—both can be found at Metropolitan Pizza, one of Buckhead's favorite gathering places in the hub of the nightclub district on Bolling Way.
Photos by L.A. Popp.

Above, With ignited performances by fire-breathing and fire-twirling bartenders, the excitement is always sizzling at Mako's.

At right, On Peachtree Road, NW, fun is a guaranteed "slam dunk" for young and old alike at ESPN Zone, Buckhead's premier sports bar that champions good food and great entertainment. Not to be missed: the amazing interactive arcade with a second-floor basketball court, as well as a host of other equally challenging games and attractions.

Photos by L.A. Popp.

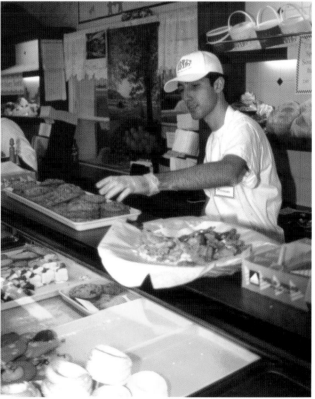

At left, Voted Citysearch's "Best Sports Bar" in 2000 and nominated each year since, Three Dollar Cafe on Peachtree Road, NW, offers an extensive selection of domestic and imported beers and some of the tastiest wings in the Village.

Photo by L.A. Popp.

Above, AMC Buckhead Backlot Cinema & Cafe, located in the Tower Walk Shopping Center, offers film lovers of all ages a colorful setting in which to enjoy a meal, a brew, and the company of family and friends while watching a first-run Hollywood blockbuster.

Photo by Patrick Kelly.

At right, Arjomadi of Henri's Bakery tempts patrons with freshly baked Coconut Cherry Cookies. The Irby Avenue bakery is a favorite stop for Buckhead residents with a consuming passion for pastries.

Photo by L.A. Popp.

Above, With three locations on Northside Parkway and Lenox and Peachtree Roads, Houston's Restaurant combines a unique, American culinary adventure with warm-hearted camaraderie that makes evenings out a delightful experience for both the palate and the soul.

At left, Originally established outside Dallas, Texas, Fogo De Chao brings the best in Brazilian fare to Buckhead. Billed as a "meat-eater's delight," the Piedmont Road establishment is also a trendy steakhouse, with a choice selection of prime cuts of beef. An epic salad bar with freshly made mozzarella, smoked salmon, tabbouleh, and more leaves little chance that patrons will walk away hungry.

Photos by Patrick Kelly.

At right, Located on Peachtree Road at the Crowne Plaza Atlanta Buckhead, Milan serves breakfast, lunch, dinner, and cocktails in a charming and colorful Mediterranean-style bistro setting. An outdoor patio, complete with soulful jazz and a waterfall, is a favorite spot to gather when Buckhead's skies are their bluest.

Photo by L.A. Popp.

Below, Housed in a beautifully transformed horse barn across from Chastain Park, Horseradish Grill on Powers Ferry Road, NW, serves up down-home favorites, cooked and seasoned with an elegant flair. Two outdoor areas—one for dining, the other for socializing—have earned the eatery its status as Buckhead's "neighborhood barn & grill."

Photo by Patrick Kelly.

Summertime, and the music is always magical at the annual concert series in scenic Chastain Park. *At top and center,* A perennial '60s favorite—The Temptations—still has what it takes to keep crowds singing in their seats and dancing in the aisles. Here, the "Emperors of Soul" harmonize to classics such as "Just My Imagination" and "My Girl." *Bottom left,* The ultimate seduction: Michael Bolton woos concert-goers with his soulful rendition of "When A Man Loves a Woman." *At right,* Buckhead residents dine under and amidst the stars at a summer concert of top musical performers. Photos by L.A. Popp.

blueprint

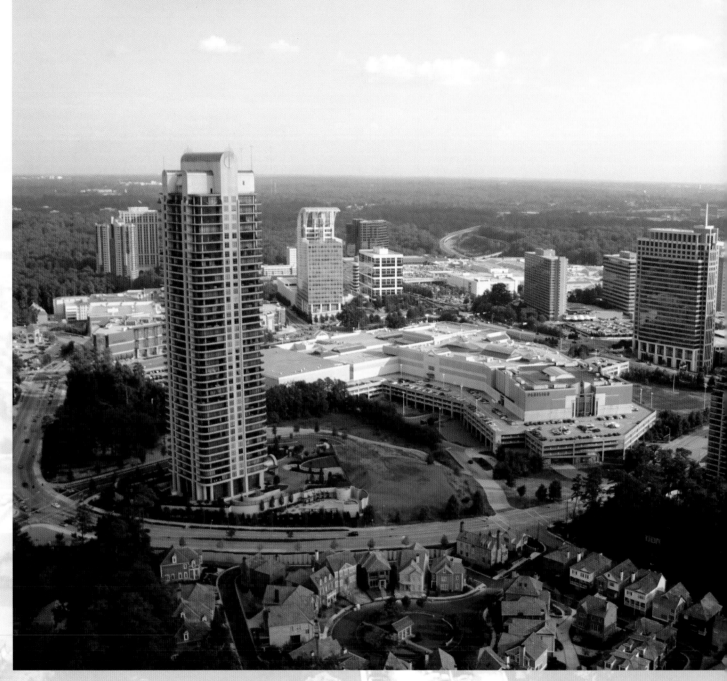

Above, An aerial view of Buckhead illustrates why enthusiasts speculate that the community is destined to become the downtown of metro Atlanta. Pictured in the foreground: Park Avenue Condominiums, a 486-foot high-rise that is, in fact, Buckhead's tallest building, as well as the tallest residential building in Atlanta. Photo by Patrick Kelly.

At right, Located in the Tower Place complex, Tower Place Park is a one-acre public green space complete with statues, fountains, and benches. The Peachtree Road park exemplifies the environmental design concepts proposed for locations throughout the community to enhance Buckhead's overall beauty and image, while improving public safety. Enjoying an afternoon in the park are, *from left to right*, Allison Oliver of Atlanta and Kim Hull of Chamblee. Photo by L.A. Popp.

for the future

Community *leaders* have laid the *foundation* for a promising *future* through exhaustive *research*, strategic *planning*, and sound *recommendations* for measured *growth* and *development*.

Synchronizing Progress With Environmental Protection

During the past several decades, Buckhead has clearly experienced unprecedented growth and development. These measures of success, however, may be quite costly if left unchecked. Rampant traffic congestion, unmonitored population growth, and indiscriminate expansion could eventually erode the quality of life that has positioned Buckhead at the pinnacle of upscale, outstanding communities in the Southeast.

Of course, Buckhead's leaders are well aware of the hazards of uncontrolled growth and have taken preemptive steps to maintain the character of the community they are proud to call "home."

Exhaustive ecological and demographic research has led to the development of "The Buckhead Blueprint," a detailed forecast for the community's future. Commissioned and funded by the Buckhead Coalition, Inc. at an expense of an estimated quarter million dollars, this comprehensive study focuses on two fundamental goals: to formulate specific guidelines for growth and development within the community and to propose recommendations for the future.

The plan highlights eight areas of community concern:

Conservation—Acknowledging that one of Buckhead's greatest assets is its residential neighborhoods, the study has earmarked the control and restriction of unbridled commercial development in established residential areas as a priority. It has been noted, however, that mixed-use development in specified areas may be extremely beneficial in the promotion of a pedestrian-friendly environment.

Market Trends—To maintain and enhance Buckhead's economic strength as an unrivaled place to live, work, and shop, the study suggests maintaining and/or increasing the community's retail market share by making the area more attractive to shoppers with additional parking and improved security.

Transportation—Without a doubt, traffic is the number one complaint in most metropolitan areas, and Buckhead is certainly no exception. Recommendations for controlling congestion on community byways calls for a series of improvements to existing infrastructures rather than expanding the current road system. Reducing daytime traffic by providing increased mobility within Buckhead, improving connections between existing thoroughfares, and improving signal systems to facilitate the traffic flow are all options that are being undertaken.

Community Growth—The recommendation is to establish "special districts" within Buckhead to better define the unique qualities of its diverse neighborhoods. Proposed districts include the Village, Piedmont-Lenox, Peachtree, Lindbergh-Piedmont, Roswell-Wieuca, Interstate, and Heritage.

Community Design—Extensive use of commons, parks, and streetscapes to link specific areas of Buckhead are the cornerstone of the proposed environmental design.

Planners believe the rejuvenation and ongoing maintenance of existing parks, as well as the development of new greenspaces, plazas, gateways, and medians, will not only significantly enhance the community's image, but also provide a safer environment. Another possibility is the addition of more pedestrian streetscapes, which will encourage area residents and visitors to bypass road use and rediscover the pleasure—and health benefits—of traveling by foot.

Public Safety—While statistics indicate that Buckhead has one the lowest crime rates in the city of Atlanta, there is a prevailing perception that crime is a critical issue that must be addressed.

Several measures that would increase safety and improve Buckhead's overall image have been proposed. Community policing, which would broaden law enforcement's mandate beyond criminal activity to include increased interaction with individuals, has been cited as an important step to minimizing crime. Other steps include moving the Zone 2 precinct headquarters to a more centralized location, increasing the number of foot patrol officers, and improving street lighting throughout the community.

To exemplify its commitment to public safety, Buckhead was the first community in the country to install Emergency 9-1-1 Cellular Telephone Call Boxes. The phones, which are posted in various locations, provide immediate communication with police, fire, and medical personnel.

Environment—Residents and visitors alike agree that one of Buckhead's most attractive attributes is its native beauty. Eliminating the visual clutter of billboards and utility poles, promoting recycling and litter control in public areas, cleaning up

Above, The Buckhead skyline is a captivating blend of both corporate and residential properties. *In the foreground,* Alliance Center, completed in September 2001, is a twenty-story "Class A" office building on Lenox Road that features a health club, a conference center, a sandwich shop, dry cleaning and sundry shops, an automobile detailer, and covered parking.
Photo by Patrick Kelly.

Peachtree and Nancy Creeks, and expanding pedestrian and bicycle greenways are among the recommendations that will ensure that the integrity of Buckhead's natural surroundings and scenic landscapes are safeguarded for years to come.

Implementation—Creating a comprehensive community plan, even one of this scope and magnitude, is relatively easy compared to the daunting task of implementing its recommendations.

Yet for Buckhead's residents, leaders, and government officials who have always worked productively and cooperatively as advocates of progress without compromising the ethics or ideals that are inherent to the community, anything—and everything—is possible.

Already considered the jewel of Atlanta, the future of Buckhead has never been more brilliant. Built upon a strong foundation of vibrant neighborhoods, business and civic leadership, and true community, Buckhead has come together to meet the challenges of a new century. With new initiatives such as the transformation of the Peachtree corridor into a pedestrian-oriented boulevard, Buckhead will maintain its focus on quality of life as it continues to grow and prosper.

—**David Allman**
President, Regent Partners

Grand Hyatt Atlanta is located in the heart of Buckhead, Atlanta's most prestigious and fashionable area. With its distinctive nightlife, restaurants, and shopping, Buckhead is an ideal setting for the business traveler. We are excited to be a part of the new initiatives and ongoing transformation of Buckhead. Along with the Buckhead area, Grand Hyatt Atlanta will focus on growth and prosperity within the community.

—**Michele Oberst**
Director of Sales
Grand Hyatt Atlanta

Above, Community-wide efforts to visually enhance Buckhead's streets and surrounding landscapes include improvement to the area near the Lindbergh MARTA Station, pictured as it was until recently. Widening of walkways and extensive planting of trees and shrubbery are among the recommendations that have been proposed to create a pedestrian-friendly environment in which to work, live, and play.

Photo courtesy of Buckhead Coalition; rendering courtesy of Edaw, Inc.

In early 1999 the Buckhead Coalition established the Buckhead Community Improvement District (CID), an area of major hotel, office, and retail developments that have agreed to self-imposed taxes for mobility improvements. Approximately $2 million, which is leveraged with grants from other governmental entities, are paid into the program annually by these properties. One of the CID's first projects, which is ongoing, targets upgrades to a portion of Peachtree. Improvements, which are illustrated in the rendering *above*, include a landscaped median, wider sidewalks, tree canopies, and custom-designed signage, lights, and furniture.

Rendering courtesy of Buckhead Coalition.

Depicting the major office-corridor portion of the Buckhead business core, the map *at right* illustrates Peachtree from Shadowlawn to Peachtree Dunwoody; Piedmont from Peachtree to Habersham; and Lenox (Loop) from Piedmont to East Paces Ferry.

Map courtesy of Buckhead Coalition.

Buckhead - CID

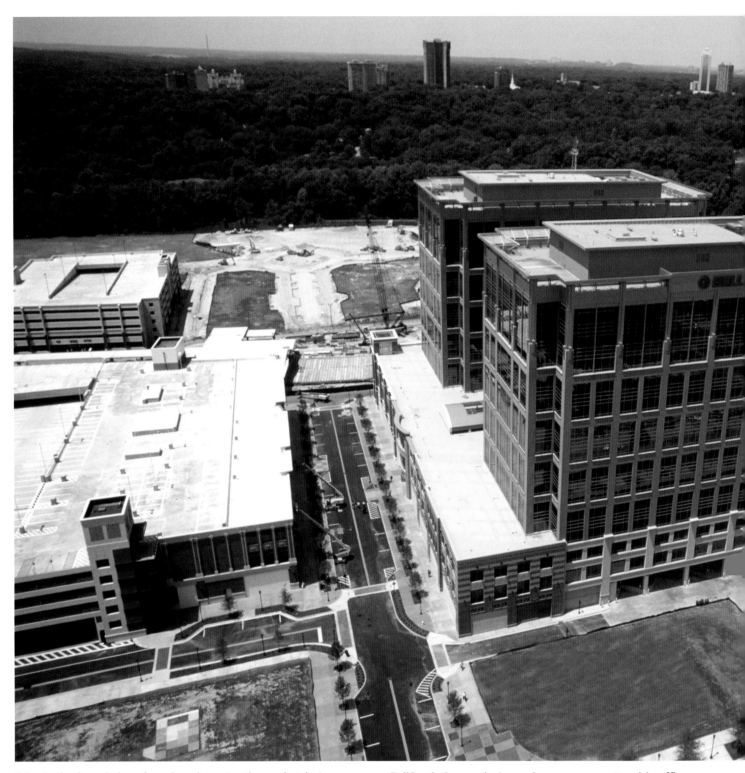

Prior to the formulation of a colossal construction project in January 1999, BellSouth Corporation's employees were scattered in offices throughout the city of Atlanta. The project, which was called the Atlanta Metro Plan, included the development of three large business centers totalling more than three million square feet. The goals of the plan were two-fold: to consolidate BellSouth's fragmented offices and to effectively address the city's traffic congestion and transportation issues by locating the business centers along MARTA's rail lines at the Lenox, Lindbergh, and North Avenue stations to encourage employees to commute to work via mass transit. Adjacent to the Lindbergh MARTA station, the first stage of the BellSouth campus on Piedmont Road, *pictured above*, was completed in late 2002. The mixed-use development includes corporate offices, housing, and a variety of retail venues. Photo by Patrick Kelly.

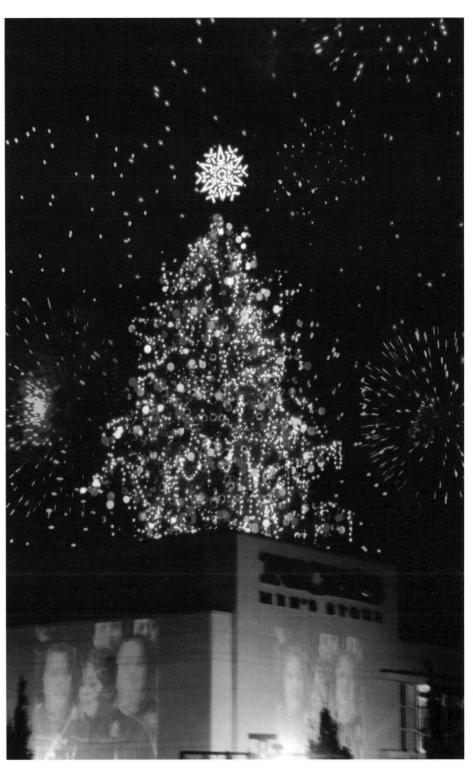

Above, While local improvement groups prudently seek ways to maintain and improve Buckhead's quality of life, community traditions, such as the lighting of Rich's Great Tree at Lenox Square each Thanksgiving, will continue to be celebrated and revered by generations to come. Photo courtesy of Rich's Department Store.

Above, Streetscape additions and improvements throughout Buckhead have been recommended, enabling community improvement groups to achieve a specific goal: to encourage residents and visitors to spend more time on the sidewalks, less time in their vehicles on busy streets. Rendering courtesy of Edaw, Inc.

In today's competitive business environment, brand equity can be a huge asset more important than ever. Like Carter's, the Buckhead brand has come to mean something extraordinary to Atlantans and visitors alike, through consistent attention to its core values: a great environment, great people, and continual growth and innovation. And, like Carter's, Buckhead's blueprint for the future is not to rest on its success, but to build on it.

—Fred Rowan
Chairman, President & CEO
William Carter Company

partners in progress

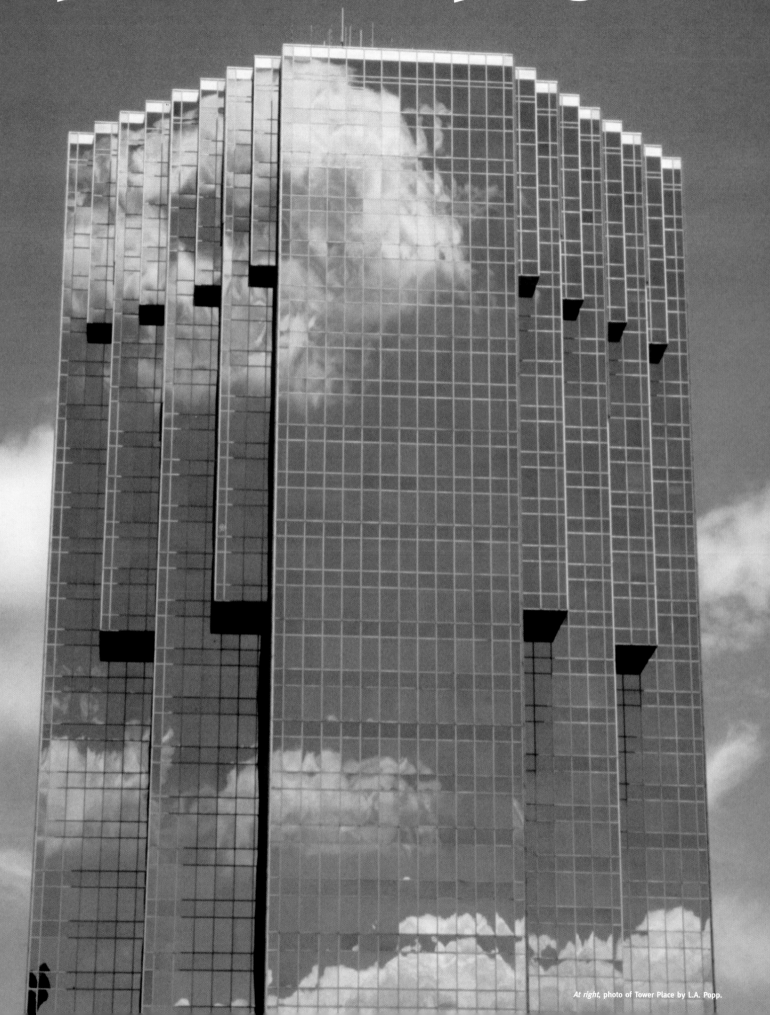

At right, photo of Tower Place by L.A. Popp.

BCD Holdings

Recognizing a tremendous, "untapped" potential in international travel services in the mid-1980s, BCD Holdings soon became an industry leader worldwide with the acquisition and expansion of three national travel companies. Photo courtesy of BCD Holdings.

The year 1975 marked a momentous milestone in Atlanta's corporate community, when a young Dutch investment banker traveled to Georgia and, inspired by the capital's growth potential, decided to plant roots and build a business.

BCD Holdings N.V. was launched; an international empire was crafted; a determined man—John Arthur Fentener van Vlissingen—was soon to become sovereign of his destiny.

With a worldwide focus on the travel and financial services industries, BCD Holdings is a Dutch, family-owned

BCD Employees

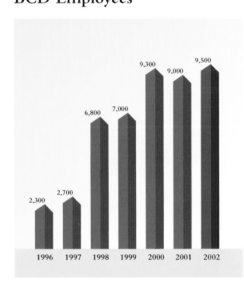

business that has its United States' headquarters in Buckhead. BCD is the second largest privately held company in Atlanta with two southeastern financial services companies, three national travel companies, and an affiliation with an upscale community bank in Buckhead.

While Atlanta is home to the company's United States' headquarters, BCD Holdings has operating companies in eleven countries in North and South America and Europe.

Through the diligence and devotion of its 9,500-plus employees, BCD Holdings achieves multi-billion dollar revenues each year.

Van Vlissingen has made an indelible impact in the industries he champions. Named one of the world's top twenty-five most influential travel executives for the year 2000 by *Business Travel News*, he serves as chairman of Business Travel International, the world's largest alliance of business travel management companies. Van Vlissingen is also co-founder of Noro-Moseley Partners, a leading venture capital firm in the Southeast.

Astute business savvy is most certainly a family

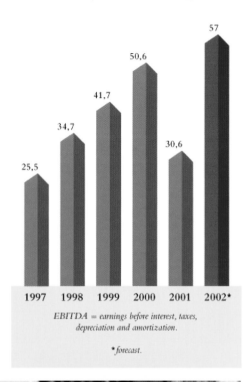

BCD Financial Results
in EBITDA (in millions US$)

EBITDA = earnings before interest, taxes, depreciation and amortization.

*forecast.

John A. Fentener van Vlissingen, chairman of BCD Holdings.
Photo courtesy of BCD Holdings.

LIFE AND DEATH UNDER THE PHARAOH
Egyptian Art from the National Museum of Antiquities in Leiden, The Netherla

In the year 2000, BCD Holdings sponsored a year-long Egyptian art exhibition at the Fernbank Museum. Photo courtesy of BCD Holdings.

legacy. Van Vlissingen is also a board member of SHV Holdings, the largest privately owned company in the Netherlands. The company has been in the family for eight generations and is still controlled by the van Vlissingen family.

Through the years, van Vlissingen has made it his business to reciprocate the generosity his companies have enjoyed by supporting the arts and sponsoring fundraising efforts in the communities the company serves.

"A company can only really progress if it feels close to the community," states van Vlissingen. "…I believe every businessman should be aware of that duty."

In celebration of the company's tenth

BCD

Paran Place • Suite 207
2060 Mount Paran Road, NW
Atlanta, GA 30327
404.264.1000

anniversary in 1995, BCD Holdings sponsored *Masterpieces of the Dutch Golden Age*, an exhibition in Atlanta's High Museum of Art, attracting more than eighty-five thousand visitors in one-and-a-half months.

In 1996, BCD Holdings was the official travel services sponsor of the Centennial Olympics in Atlanta.

Four years later, the company also sponsored a year-long, Egyptian art exhibition at the Fernbank Museum. The exhibit, *Life and Death Under the Pharaohs*, was a collection of ancient artifacts on loan from the National Museum of Antiquities in Leiden, the Netherlands, that was enjoyed by more than 250,000 visitors.

With global connections and enduring community ties, BCD Holdings has, indeed, brought power, prestige, and prosperity to the city of Atlanta.

Danny Hood, president of WorldTravel BTI. Photo courtesy of WorldTravel BTI.

Travel Services

The mid-1980s was a banner period for BCD Holdings, when the company diversified into travel services to target a fragmented and virtually untapped Ameri-

Mike Buckman, CEO of WorldTravel BTI. Photo courtesy of WorldTravel BTI.

can market with tremendous potential.

In 1987 van Vlissingen purchased WorldTravel Advisors, one of Atlanta's largest travel agencies with fourteen locations and annual earnings of $50 million. Renamed **WorldTravel BTI** after the company's merger with BTI Americas

WorldTravel International Sales Volume (in millions US$)

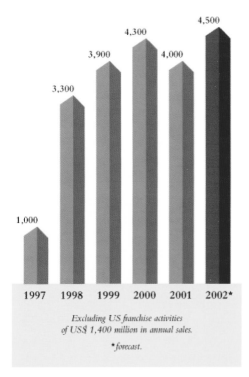

Excluding US franchise activities of US$ 1,400 million in annual sales.

**forecast.*

in 1998, the Atlanta-based firm is now one of the top three corporate travel management companies in the United States with multi-billion dollar earnings annually.

WorldTravel BTI's fifteen hundred locations in the United States are staffed by fifty-two hundred employees, who provide expert assistance in the management of corporate travel programs for thousands of the world's most prestigious companies. WorldTravel BTI provides cost savings and innovative, travel-management solutions tailored to its clients' local and global travel needs.

WorldTravel BTI incorporates best-of-breed technologies, flexible and visionary solutions, and excellent customer service to create a unique approach. The company works with its clients in developing a customized travel program and incorporates its proprietary technology and leading third-party technology.

WorldTravel BTI is recognized for its forward-thinking approach to corporate travel, becoming the first company to offer an online self-service reservation tool. The company has led the industry by being the first to institute an e-ticket tracking system and a low-cost e-fulfillment reservation center.

Recognized as the third largest United States-based corporate travel management company, WorldTravel BTI is the nation's ninth largest leisure travel supplier and ranks among the top five meetings and incentive travel providers throughout the country.

With the acquisition of **Park 'N Fly** in 1988, BCD Holdings expanded its travel services to include off-site parking at major airports in the United States. The company boasts nearly twenty-two thousand parking spaces in thirteen locations nationwide, including three facilities serving Hartsfield Atlanta International Airport.

Designed for both business and leisure travelers, customers are transported to the airport terminal with expedient "car-to-curb" service. Upon their return, arriving passengers are safely shuttled to Park 'N Fly's gated, well-lit lots.

In keeping with the company's "no-wait" policy, shuttles depart to and from terminals and parking lots every three to five minutes.

Additional amenities include luggage handling, complimentary newspapers, and emergency vehicle assistance.

In 1988, BCD Holdings expanded its travel services to include off-site parking. Park 'N Fly is now available at thirteen locations nationwide, with three facilities in Atlanta. Photo courtesy of Park 'N Fly.

Substantial savings on airport parking costs and Park 'N Fly rates can be earned through corporate membership in the company's "Corporate Advantage Program," while free parking credits are awarded to travelers enrolled in the company's "Frequent Parker Bonus Program."

With six hundred employees nationwide, Park 'N Fly has become the world's largest service of its kind, accommodating more than two million vehicles annually.

BCD Holdings' third venture into travel services was the 1990 purchase of Travel Technologies Group (TTG), a Dallas-based travel technology developer. TTG was combined with

Based in Atlanta, WorldTravel BTI is one of the top three corporate travel management companies in the United States. Photo courtesy of BCD Holdings.

Frederick D. Clemente, president and CEO of Park 'N Fly. Photo courtesy of BCD Holdings.

Trip Davis, president and CEO of TRX, Inc.
Photo courtesy of TRX, Inc.

Online Fulfillment Services—a company established in 1995 to support the operational requirements of online travel companies—and International Software Products—acquired in 1999—and rebranded as **TRX, Inc.** in the year 2000. TRX has grown into the leading provider of transaction processing solutions to the global travel industry.

TRX Online Ticket Fulfillment
(x 1000)

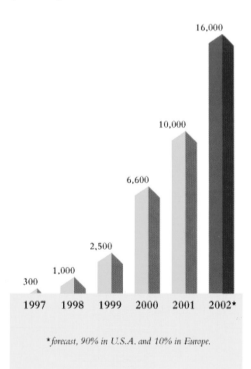

forecast, 90% in U.S.A. and 10% in Europe.

With more than fourteen hundred employees in ten American and European cities, TRX serves airlines, hotels, travel agencies—both online and offline—global distribution systems, and major corporations in sixty countries worldwide.

From the initial online reservation and quality control process, to the culmination of ticketing, accounting, management reporting, and data consolidation, TRX provides streamlined and sophisticated online booking and reservation processing technologies, processing an average of 60 tickets a minute, 24 hours a day, 365 days a year.

In 2001 TRX provided automated transaction processing and quality control support for twenty million travel transactions, representing nearly $10 billion in airline sales. The company expects to grow to thirty-two million transactions, representing nearly $16 billion in airline sales, in 2002.

**1055 Lenox Park Boulevard
Suite 420
Atlanta, GA 30319
404.841.6600
www.worldtravel.com**

**Paran Place, Suite 207
2060 Mount Paran Road, NW
Atlanta, GA 30327
404.264.1000
www.pnf.com**

**6 West Druid Hills Drive
Atlanta, GA 30329
404.929.6100
www.trx.com**

BCD Holdings involvement in the travel services industry includes serving as a major shareholder and managing partner of Business Travel International (BTI), the leading association of travel management companies in the world. The association collectively realizes $15 billion dollars in global sales annually through its sixty-six partner companies operating in eighty-seven countries around the globe.

Financial Services

During its first fourteen years in operation, BCD Holdings established a powerful presence in the city of Atlanta by focusing its efforts in the field of financial services.

When BCD Holdings was first established in 1975, the company served in an advisory capacity for European real estate investors pursuing investments in office buildings and large shopping centers both in the "New South" and on the California coast.

Prior to the company's inception, European investors were primarily targeting New York real estate acquisitions; they were unaware of the potential for development in the South, despite the

G.K. Johnson, vice president of Noro G.K. Development and, *at right,* John Sexton, president and CEO of Noro Management.
Photo courtesy of Noro Management.

locations worldwide: Atlanta, Georgia, Curaçao, Netherlands Antilles, and Zeist, the Netherlands.

As the company flourished, Noro Management's reputation as an international firm with expertise in asset management was recognized by investors in the United States and Europe. Noro Realty Management Inc., a sister company of Noro Management, specializes in managing mid-size retail centers and commercial offices across the Southeast.

With the same entrepreneurial spirit that capitalized on the lucrative opportunities that existed in the real estate market in the Southeast during the mid-1970s,

fact that property values in both Georgia and California had plummeted in the early- to mid-1970s.

Exceptional real estate at affordable costs: The door to opportunity was, indeed, wide open for foreign investors.

Enter a group of twelve private investors, whose first acquisition—the National Data Building in Atlanta—heralded the

Top left and above, Smyrna Market Village is a new, vibrant work, live, and play development in the heart of Smyrna. Photo courtesy of Noro Management.

Primary Capital, a leader in multi-family lending in the Southeast and one of Freddie Mac's Program Plus Seller/Servicers, recently provided Freddie Mac financing for the Heights at Cheshire Bridge in Atlanta.
Photo courtesy of Primary Capital.

establishment of several Noro real estate investment funds that focused exclusively on commercial development in the South and on the West Coast.

As BCD Holdings' oldest operating company, the firm, which is now called **Noro Management**, has more than twenty-five years of real estate investment experience in the United States. The company maintains corporate offices in three

Noro Management began to pursue its own real estate development and investment interests, while partnering with other firms to develop and manage a wide range of real estate and venture capital funds.

Partnerships in commercial property projects have included the Galleria office towers and Lindbergh Plaza shopping mall in Atlanta; Valley View shopping mall in Roanoke, Virginia; the Warner Theatre

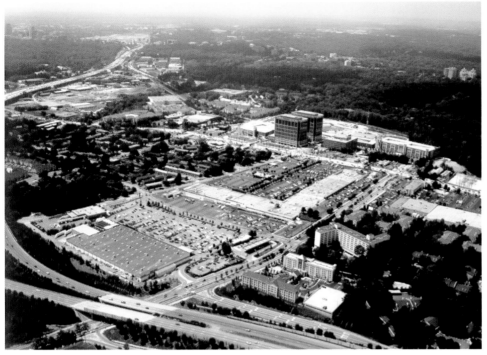

The revitalization of Lindbergh Plaza will help Atlanta reach its goals for smart growth.
Photo courtesy of Noro Management.

Since its inception in 1975, BCD Holdings has had a dynamic presence in international financial services, earning a reputation for unrivaled expertise in asset management by European and American investors. Photo courtesy of BCD Holdings.

Building in Washington, D.C.; and Wilshire Palisades in Santa Monica, California.

In 2000 the company experienced dynamic growth by acquiring Merchants Management, an Atlanta-based property management company that specialized in leasing and managing retail centers throughout the Southeast. Through the acquisition, Noro Management expanded its services to include in-house leasing for new and existing shopping center tenants.

Dorey's Retail Guide—a leading resource for commercial real estate information in Georgia—has recognized Noro Management as one of the top seven companies in Atlanta that provides third-party property management services.

While the company currently manages properties in six states, Noro Management continues to target the southeastern United States, and particularly the metropolitan Atlanta area, as its primary market.

In 1986 van Vlissingen purchased HomeBanc and built the largest community bank and residential mortgage lender in Georgia. The bank was sold in 1994 to a large regional competitor at a time when banking was thought to be going national.

That same year, BCD Holdings channeled its unparalleled expertise in financial services and real estate in a new direction

104 Interstate North Parkway East, SE
Atlanta, GA 30339
678.589.9500
www.noromanagement.com

Primary Capital
Paran Place • Suite 101
2060 Mount Paran Road, NW
Atlanta, GA 30327
404.365.9300
www.primarycapital.com

Primary Capital's Construction Lending Group provides interim financing to many of Atlanta's leading residential developers and homebuilders. Photo courtesy of Primary Capital.

by establishing a commercial mortgage bank. **Primary Capital**, a diverse real estate services company with over $1.1 billion in business closed annually, expertly handles every real estate lending need.

Headquartered in Atlanta, the firm offers an all-inclusive array of commercial and residential mortgage services—from income property finance, commercial brokerage services, and equity investing, to construction lending and residential mortgage lending.

As one of only thirty-three authorized Freddie Mac Program Plus Seller/Servicer lenders nationwide, Primary Capital's

William B. Pendleton, president and CEO of Primary Capital and CornerstoneBank. Photo courtesy of Primary Capital.

Income Property Finance Division expertly structures innovative credit facilities for multi-family, retail, office, and industrial properties.

Mortgage financing, refinancing options, and home equity loans are arranged for first-time and experienced homebuyers through Primary Capital's mortgage division. Ranked among Atlanta's top ten residential mortgage companies, Primary Capital delivers its innovative products through high technology channels to its customers.

In 1998 Primary Capital Realty Group was established as the brokerage arm of the company for the purchase and sale of multi-family properties. A wholly owned subsidiary of Primary Capital, the group quickly became a top-volume producer in Atlanta's apartment business.

Primary Capital also provides interim financing to homebuilders and residential developers through its Construction Lending Group. Acquisition and

development loans, equity financing, and builder lines of credit for residential construction loans are also available for area builders and developers.

Servicing a portfolio of $750 million a year, technology-driven servicing and state-of-the-art loan monitoring systems ensure that Primary Capital always provides timely, efficient, and accurate management of all financial records.

A staff of approximately seventy-

Primary Capital's Mortgage Division is a leading residential mortgage lender in Atlanta and the Southeast, delivering competitive mortgage products through several alternative delivery channels. Photo courtesy of Primary Capital.

Handling financing for retail and industrial properties, as well as multi-family, Primary Capital recently financed several Publix-anchored retail deals. Photo courtesy of Primary Capital.

mid-sized entrepreneurial businesses. CornerstoneBank strives to serve the private banking needs of professionals and executives in the Atlanta area. With a specialty in real estate lending, the bank's lenders know and understand their customers' businesses and, most importantly, all loan decisions are made locally.

While CornerstoneBank may be Buckhead's newest bank on the block, its affiliation with Primary Capital and BCD Holdings creates an omnipresent fiscal strength and security that far surpasses any other bank in the region.

The executive team of Primary Capital includes, *from left to right,* Faron G. Thompson, managing director of the Income Property Finance Group; Ron E. Cameron, vice president of Primary Capital Realty; William B. Pendleton, president of Primary Capital; George S. Phelps, chief operations officer of Residential Mortgage Lending; and K. Tucker Perkins, senior vice president of Construction Lending. Photo courtesy of Primary Capital.

five experienced banking and lending professionals enables Primary Capital to maintain a viable presence in metro Atlanta while the company continues its expansion in the Southeast.

With the 2001 opening of its affiliate, CornerstoneBank, Primary Capital offers customers a unique vantage point: access to a direct lending source.

CornerstoneBank

With the rise of community banking and guided by HomeBanc's entrepreneurial management team, **CornerstoneBank** was founded in 2001. Providing "Banking the way it used to be," CornerstoneBank prides itself on being a high-touch, high-service community bank.

CornerstoneBank was formed on strong relationships within the Atlanta business community, including an investment from van Vlissingen, who saw the benefit of having other community leaders involved. Located in Atlanta at the intersection of Mt. Paran Road and Northside Parkway off I-75, CornerstoneBank believes the hallmark of a great organization is its

ability to provide highly personalized service to its customers. It focuses on delivering a new level of service and establishing a personal banking relationship.

A local power lender, the bank focuses on providing flexible lending services and creative deposit products to small- and

CornerstoneBank
2060 Mount Paran Road, NW
Suite 100
Atlanta, GA 30327
404.601.1250
www.cornerstonebankga.com

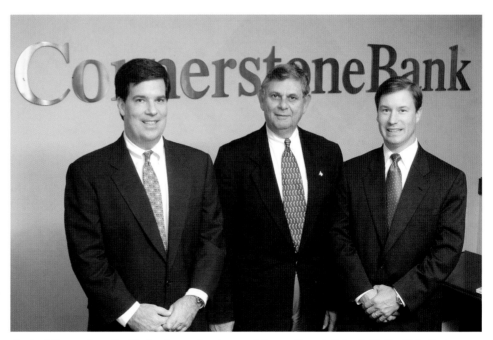

Part of CornerstoneBank's business development team. *From left to right,* David L. Fentress, senior vice president and senior lending officer; Albert D. Maslia, founder of Social Expressions and CornerstoneBank board member; and John F. Hall, senior vice president and chief credit officer. Photo courtesy of CornerstoneBank.

Buckhead Coalition

Mention the name "Buckhead" in the great city of Atlanta and most residents—and many of the community's visitors—will smile with recognition and point in the direction of the most beautiful and distinguished neighborhood ever to grace fine Georgian earth. They'll describe the elegant, historical residences; the distinguished houses of worship; the art galleries; the restaurants; the hotels, theaters, and museums; the excellent schools; and the unprecedented culture, commerce, and aesthetic sophistication that draw people with taste and an appreciation of life's finest to its tree-lined streets every day.

Of course, the lifestyle here didn't become this idyllic by accident. Among the many civic, governmental, and nonprofit organizations that have long worked to create and maintain the marvels of this district, one—the Buckhead Coalition—is perhaps the most prominent and well-known as a driving force behind the nurturing of what the Coalition proudly refers to as "...a special way of life."

Originally comprised of a select group of influential entrepreneurs and civic leaders whose businesses and personal fortunes flourished here in the 1980s, the founders of the Coalition decided they didn't want to take such prosperity for granted.

Charlie Loudermilk, CEO of Aaron Rents, a national furniture rental facility, is generally recognized as the person who first initiated formalizing the organization. Gathering together a dozen of his business associates, he discussed the prospect of supplementing basic governmental services for the Buckhead community with generous endowments and grants from an elite association that they themselves would personally create and fund.

Christened "The Buckhead Coalition" and officially incorporated as a

The Buckhead Coalition, a not-for-profit civic organization officially incorporated in August 1988 to promote and enhance a "special way of life," occupies a suite of offices in Tower Place, one of the community's most celebrated Peachtree Road landmarks. Photo by L.A. Popp.

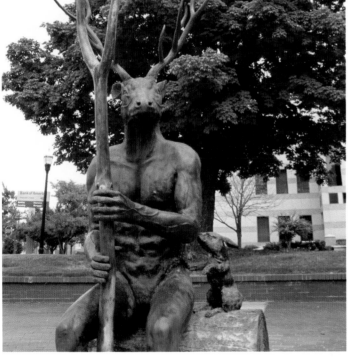

At top, Sam Massell, former mayor of Atlanta, serves as president of the Buckhead Coalition. *Above*, the Coalition commissioned Frank Fleming to create *The Story Teller*, a sculpture that commemorates the legend of how the community was first named. Photos by L.A. Popp.

not-for-profit civic organization on August 30, 1988, membership was offered, by invitation only, to seventy-five CEOs of major Buckhead firms and outstanding civic leaders for an annual fee of $5,000 per member. There is no discrimination based on race, sex, religion, age, or nationality, but to be awarded an invitation, a member must share the Coalition's mission and commitment to fostering, preserving, and improving all that is best within the Buckhead community.

Toward that end, the charter members of the organization sought an individual whose credentials made him an ideal candidate for the position of president of the Buckhead Coalition. One man came to mind: Sam Massell, former mayor of Atlanta and an enthusiastic resident of the Buckhead community for more than forty years.

Massell was delighted by the challenge. After various careers spent in commercial real estate, civic work, and politics—including eight years as the elected president of Atlanta's Board of Aldermen (now called the City Council), four years as Atlanta's mayor, and four-year terms on both the board of the Metropolitan Atlanta Rapid Transit Authority (MARTA) and the Atlanta Committee for the Olympic Games—Massell moved on to build a successful travel agency, enjoying the business of "selling dreams and traveling the world" with his wife and grown children. Proudly taking up the reins of office as the Coalition's first (and current) president, Massell has successfully led the group in spearheading some of its most ambitious projects.

To date, these projects include publishing the annual, prestigious *Buckhead Guidebook* aimed at visitors, new residents, and potential business investors; creating the Community Improvement District (CID), which oversees enrichment and beautification of the area; raising $400,000 to renovate Atlanta International School; and securing $887,000 in finances to fund construction of a magnificent new YMCA.

In recent years, the Coalition has taken important measures to improve security by installing twenty-one freestanding 9-1-1 telephones in locations throughout the community and thirty-six AEDs (Automatic External Defibrillators) in Buckhead's public buildings, thus establishing the community as the first of its kind in the nation to do so.

The Coalition's list of contributions to the Buckhead community also includes commissioning a $250,000 sculpture, *The Story Teller*, to commemorate the legend of how the area was first named. (According to local folklore, a hunter hung a deer head trophy on a pole near a local junction, which eventually became a popular landmark.)

The Coalition has also endowed a special reserve fund of $250,000 to finance

generous rewards for the conviction of anyone committing murder or rape in Buckhead, thus promoting public safety and good citizenship.

From the repair of the smallest pothole and maintenance of the famous local Duck Pond, to saving the day for a young couple who wished to exchange their wedding vows in a Buckhead park, the Buckhead Coalition is an accessible entity for one and all. Some residents see the organization as a unique chamber of commerce, while others perceive it as a convention and visitors bureau. Still others, says Massell, view the Coalition "...as a little town hall, although we have no official powers."

Unofficially, however, the Buckhead Coalition is greatly empowered by the sheer enthusiasm and goodwill of its seventy-five esteemed members, who seek to maintain and improve the already magnificent standard of living Buckhead residents and visitors have come to enjoy and expect.

However elite and accomplished the charter membership of the Buckhead Coalition may be, not everyone has to be wealthy or well-positioned on the corporate ladder to participate in its good work.

A popular mass-membership affiliate, the Buckhead Business Association has very affordable fees; its president automatically becomes an ex officio board member of the Buckhead Coalition, eligible to participate in all Coalition meetings and represent the interests of smaller businesses and civic groups within the community.

Now celebrating its fourteenth year, the Buckhead Coalition continues to plan and implement action programs for the ongoing improvement of the community as a whole and as an integral part of the

One of the Buckhead Coalition's most notable achievements is the creation of the Community Improvement District, an organization dedicated to improving mobility—traffic flow, transportation service, and pedestrian comforts. Photo by L.A. Popp.

corporate city of Atlanta. Its mission and long-range goal, as always, is to assist in coordinating the orderly growth of this unique community, while maintaining a harmonious balance and blending of Buckhead's many diverse residential, cultural, and commercial interests.

Although the Coalition does not get involved in zoning issues, its marketing efforts have led to predictions that Buckhead will become the skyline of metropolitan Atlanta. Photo by Patrick Kelly.

With a powerful presence within the community, the Buckhead Coalition often spearheads area fund-raisers. Through the efforts of the Coalition, $400,000 was raised for the campus expansion and renovation of one of Buckhead's premier educational institutions, the Atlanta International School. Photo courtesy of the Atlanta International School.

Buckhead Coalition, Inc.
Tower Place 100 • Suite 560
3340 Peachtree Road, NE
Atlanta, Georgia 30326-1059
Phone: 404.233.2228
Toll Free: 800.935.2228

Piedmont Medical Center

The early years of the twentieth century marked the beginning of a metamorphosis in the delivery of quality healthcare in Atlanta.

With the signing of an official charter in August 1905, Ludwig Amster, M.D., a gastrointestinal specialist, and Floyd W. McRae, M.D., an Atlantan surgeon, established a ten-bed medical facility known as Piedmont Sanatorium. First located in a family dwelling on the corner of Capitol Avenue and Crumley Street in downtown Atlanta, the sanatorium offered an intimate, home-like setting and a level of patient comfort that its founding doctors believed was critical in the healing process—a healthcare concept that prevails today at Piedmont.

The opening of Piedmont Sanatorium—now known as Piedmont Hospital—was indeed the introduction of a new era of medical practice in Georgia.

During its first two decades, the original fifteen-room residence was expanded to occupy a full city block. By the mid-1940s, advancements in medical services and technologies could no longer be contained at the downtown address. With the purchase of "Deerland," a twenty-six acre tract of property in Buckhead, the hospital moved to "the country" in March 1957, occupying its current Peachtree Road location.

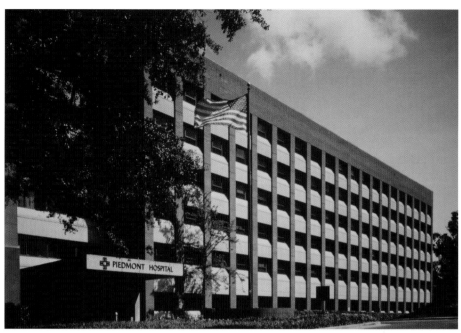

Originally established in 1905 as Piedmont Sanatorium, a ten-bed medical facility in downtown Atlanta, Piedmont Hospital is now a nationally renowned five hundred-bed, acute-care tertiary facility and the core subsidiary of Piedmont Medical Center. Photo courtesy of Piedmont Medical Center.

Today Piedmont Hospital is a nationally recognized five hundred-bed, acute-care tertiary facility that provides most major diagnostic, medical, and surgical services. This private, not-for-profit hospital has gained national prominence in several areas of specialty, including cardiovascular services, orthopaedics, and organ transplantation. Piedmont Hospital is staffed by more than nine hundred physicians and thirty-three hundred employees and governed by a seven-member board of trustees, six of whom are physicians.

Piedmont Hospital is a core subsidiary of Piedmont Medical Center, which also includes Fayette Community Hospital, the Piedmont Clinic, and the Piedmont Physicians Group.

Fayette Community Hospital, in Fayetteville, Georgia, is a one hundred-bed, not-for-profit general community hospital with more than three hundred doctors representing more than thirty specialties. Established in 1997, Fayette was the first hospital to open in metro Atlanta in fourteen years. It offers twenty-four-hour emergency care, including an FAA-approved helipad; full diagnostics, including X-ray, computed tomography (CT), magnetic resonance imaging (MRI), mammography, and nuclear medicine; and comprehensive outpatient services in a modern, hotel-like setting.

The Piedmont Clinic is a network of 480 physicians founded in 1992 in response to the managed healthcare movement. Governed by three boards of directors, the clinic includes the Primary Care Physicians Organization,

Piedmont Hospital is a state-of-the-art healthcare facility with six professional buildings located on Peachtree Road in Buckhead. Photo courtesy of Piedmont Medical Center.

Nearly five thousand babies are born annually at Piedmont's Women's Center, where comprehensive diagnostics and gynecological care, as well as a complete spectrum of medical and support services, are provided in a technologically advanced, yet compassionate environment. Photo courtesy of Piedmont Medical Center.

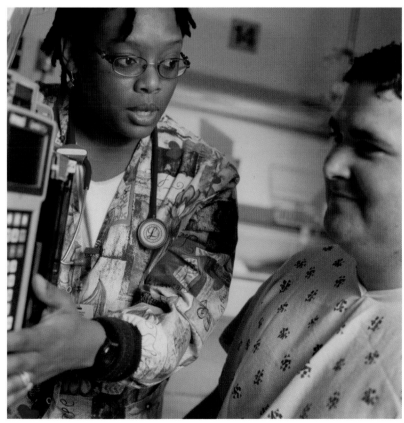

Patient-centered care is the hallmark of Piedmont Hospital, where physicians, nurses, technicians, and medical personnel use a collaborative approach in providing expert care in the quest for optimal health and well being. Photo courtesy of Piedmont Medical Center.

consisting of 120 physicians board-certified in internal medicine, family practice, or pediatrics, plus providers in urgent care and inpatient medical services; and the Specialty Physicians Organization, comprised of 360 board-certified specialists in nearly all the recognized disciplines.

The Piedmont Physicians Group is a fifty-member primary care physician group specializing in internal medicine, family medicine, and pediatrics in eight metro Atlanta locations. Services include preventive care, wellness counseling, early detection, immunizations, complete annual physicals, and health screenings. Primary care facilities also offer basic diagnostic capabilities; some offer mammography and ultrasound.

Six professional buildings constitute Piedmont Hospital's campus. On-site facilities include the Fuqua Heart Center of Atlanta; the Katherine Murphy Riley Outpatient Diagnostic Center; the T. Harvey Mathis Rehabilitation and Fitness Center (home of the Piedmont Hospital Health and Fitness Club); and a twenty-four-hour Emergency Department with its own helipad.

Nationally recognized for ninety-seven years of medical excellence, Piedmont enjoys a widespread reputation for expert, compassionate care in a variety of specialized disciplines. The Hospital's renowned Fuqua Heart Center of Atlanta is considered the Southeast's facility of choice for cardiovascular care. The center provides a complete continuum of comprehensive cardiac services—including cardiac catheterization, cutting-edge treatment of cardiovascular disease, and open-heart surgery—to more than fifteen thousand patients annually. Staffed by more than one 100 specialty physicians and 550 support personnel, the 138-bed center offers ultra-modern technology in a patient-centered environment.

Since its first kidney transplant in 1986, Piedmont's Organ Transplant program has evolved into a regional leader in both kidney and pancreas transplantation. Piedmont has performed more than one thousand transplants, having established an independent transplant program in 1999. Piedmont also offers an extensive range of renal dialysis

treatments at two on-campus locations and a nearby outpatient facility, as well as at Fayette Community Hospital.

With one of the most active and revered orthopaedic departments in the Southeast, Piedmont leads the industry in

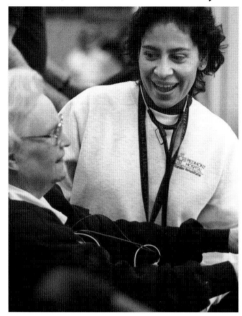

Piedmont's Center for Rehabilitation Medicine is known for its intensive program that integrates physical, occupational, speech, and recreational therapies.
Photo courtesy of Piedmont Medical Center.

spinal and joint replacement surgery. The Orthopaedic Department's surgical staff employs the newest technologies available to treat hard-to-heal fractures, complex pelvic fractures, and a range of other conditions.

As an integral part of the Orthopaedic Department, the Reconstructive Joint Center of Atlanta reigns as the market leader in joint replacement in metro Atlanta. Established in 1985, the center performs more than eight hundred ankle, elbow, finger, hip, knee, shoulder, toe, and wrist joint replacements each year.

Since the 1960s, Piedmont has provided medical services to Atlanta's major sports teams—including the Atlanta Braves, Falcons, and Hawks—as well as area high schools and colleges.

From minor injuries to lifesaving medical procedures, Piedmont's twenty-five-bed, twenty-two thousand square-foot

Emergency Department provides a spectrum of services to more than fifty thousand patients annually. New technologies and treatments are regularly integrated into the department to shorten wait times and enhance care.

Piedmont's Women's Center offers expert care for women in every stage of life, including comprehensive diagnostics and gynecological care, plus an array of medical and support services before, during, and after childbirth. Each year, nearly five thousand babies are born in the hospital's Maternity Center, where parents and their newborns receive compassionate care in a home-like, yet technologically advanced environment. The center is comprised of sixteen labor/delivery/recovery (LDR) rooms, a fourteen-bed antepartum unit, and thirty-two private postpartum rooms. Piedmont's newborn nursery has a six-bed Neonatal Intensive Care Unit and an intermediate care nursery, staffed by three full-time neonatologists and more than sixty neonatal nurses and other skilled professionals.

The Women's Center also features a twenty-bed women's service unit, providing diagnostic and surgical procedures and a range of educational and support programs designed to promote healthy lifestyles among women of all ages.

The Breast Health Center offers comprehensive diagnosis and treatment of breast disease, as well as educational and support groups. Piedmont's Mammography Center at Rich's Perimeter Mall provides screening mammograms at a convenient off-site location.

Piedmont's Neuroscience Department provides comprehensive diagnosis and treatment of an extensive range of neurological conditions, including stroke, brain and spinal injuries, epilepsy, and multiple sclerosis. Its twenty-bed nursing unit and eight-bed intensive care unit are staffed by eight neurologists, seven neurosurgeons,

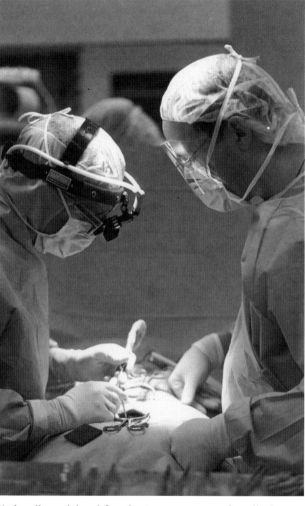

Nationally acclaimed for ninety-seven years of medical excellence, Piedmont Hospital provides most major diagnostic, medical, and surgical services.
Photo courtesy of Piedmont Medical Center.

and a full support staff. The department also offers radiation therapy, pain management, and occupational, physical, and speech therapies.

Of special interest is the Neuroscience Department's groundbreaking work with the Gamma Knife™. Piedmont was the first hospital in the Southeast to adopt this noninvasive, state-of-the-art procedure to treat a variety of brain tumors and other neurological conditions that were once

Piedmont Hospital maintains a low nurse-to-patient ratio to ensure that each patient receives the very best hands-on personal care.

Photo courtesy of Piedmont Medical Center

considered inoperable or presented a significant risk to the patient. Since its introduction at Piedmont in 1989, more than fifteen hundred patients have benefited from this procedure.

Piedmont's Oncology Services provide the latest advancements and therapies in cancer treatment, with the goal of improving the quality of life for cancer patients and their families. To optimize patient care, the twenty-bed medical oncology unit employs a collaborative approach among its physicians, oncology nurses, nutritionists, social workers, technologists, and other professionals. More than seven hundred patients receive radiation therapy each year at both the onsite Oncology Department and at the Radiation Oncology Center at Howell Mill Road.

Piedmont's Center for Rehabilitation Medicine offers intensive inpatient services to restore patients to optimal independence following the loss of functional ability caused by illness or injury. The center enjoys the highest level of accreditation attainable from the Commission on Accreditation of Rehabilitation Facilities,

in recognition of its comprehensive, integrated inpatient rehab program that encompasses physical, occupational, speech, and recreational therapies.

Piedmont's history is rich with milestones that continue to impact health-care—not only in Georgia, but nationwide. One of Georgia's first female obstetricians joined Piedmont in 1910. Seven years later, the first orthopaedic service was organized. In 1951, staff physicians performed the first renal biopsy in the South. In the 1960s, Piedmont performed the nation's first total hip replacement and was one of the first hospitals in Georgia to establish a separate coronary care unit to treat heart attack patients.

While facing the formidable challenges of managed care, exploding patient populations, and ever-evolving technology, Piedmont's fundamental approach to care remains defined by its mission statement:

To provide superior healthcare and health-related services delivered by a professional and compassionate staff, guided by physicians and inspired by our patients, in a not-for-profit setting.

Clearly, "service to others" is an operative phrase at Piedmont Medical Center, where personal compassion goes hand-in-hand with pioneering healthcare technologies and forward-thinking practices. Piedmont's commitment to service extends throughout the entire footprint of the medical center. Atlanta-

area residents are invited to participate in community education classes, support groups, early-detection/disease prevention screenings, and other programs that share a common focus: good health. Many programs are free of charge; others require only a nominal fee.

Piedmont also sponsors a speaker's bureau, in which staff physicians and health professionals volunteer to address schools, churches, clubs, and other nonprofit groups on a variety of health-related topics.

Piedmont Medical Center's quest to promote community health and well being is evident in its twenty-five thousand square-foot Health and Fitness Club, which offers aerobics classes, educational programs, wellness seminars, comprehensive personal profiles, and customized fitness plans.

From the boardroom to the community, Piedmont Medical Center has made its mark, working cooperatively with area business leaders to provide workers' compensation medical treatment and employee health programs.

"Piedmont Medical Center is poised for greatness," declares R. Timothy Stack, president and CEO of Piedmont Medical Center. "It has all the underlying attributes and characteristics necessary to become an unrivaled healthcare facility, above and beyond the incomparable services it currently provides to the communities we serve."

1968 Peachtree Road N.W.
Atlanta, GA 30309
404.605.5000
www.piedmonthospital.org

Carter's

Carter's innovative clothing and accessory displays, featured in department, chain, specialty, and retail outlet stores nationwide, reflect the company's focus on imagination as an inspiring element in its celebration of childhood. Photo courtesy of Carter's.

Trust. Emotion. Awareness. For more than 135 years, Carter's has led the baby and young children's industry by earning the respect and trust of generations of mothers and grandmothers. Every eight seconds, a new baby is born in the United States, and Carter's is there as part of that momentous occasion as the most widely purchased brand of baby clothes in the country.

"We don't take our role lightly," says Frederick J. Rowan II, Carter's chairman, president, and CEO. "We believe our most important job is to provide great products to these new families."

Headquartered in Atlanta, Georgia,

Carter's was founded in Needham, Massachusetts, by William Carter in 1865. Formally known as The William Carter Company, the firm has achieved its stature as America's most recognized and trusted baby and young children's brand through its steadfast commitment to children, as expressed through consistently superior quality and strong product innovation.

With an estimated four million births each year in the United States, Carter's sells more than twenty products for every American baby born. Carter's is best known for baby's layette—the clothing and accessories a newborn needs, including bibs,

booties, bodysuits, receiving blankets, and sleepers. Carter's is the No. 1 brand in this core business with a dominant 29 percent market share.

According to company legend, when Shirley Temple was expecting her first baby, she asked Carter's to produce a layette in different colors. In response, Carter's introduced yellow, green, and purple into the traditional palette, which proved to be yet another innovative trend that is a hallmark of the brand.

In addition to layette, other product categories include sleepwear, playclothes, and licensed accessories, which are

segmented into four age groups: newborns, infants, toddlers, and four-to-seven year olds, creating a product lineup that encompasses every child's apparel needs from "birth to (school) bus."

Carter's also dominates the sleepwear category with more than 36 percent of the market share and has a growing share of the playclothes market with products for children from birth to age seven. Carter's venture into playclothes is highly successful since the company has been able to leverage the brand's reputation for quality, durability, comfort, and wearable fun into its collection of t-shirts, rompers, bodysuits, and jumpsuits, creating playclothes that let kids play.

Carter's has also built a large and equally successful licensed-product business that extends the brand into product categories that mothers want, such as bedding, strollers, play yards, toys, gifts, footwear, socks, and more.

Innovation extends from product design to business development. By being one of the first clothing manufacturers to stitch a brand label into every garment and to institute a direct sales approach, Carter's

established the concept of "branded apparel" and revolutionized the apparel industry.

Today the Carter's brand is sold through department, chain, and specialty stores, as well as more than 150 retail outlet stores throughout the United States. *Tykes*, a division of Carter's, features layette, sleepwear, and accessories exclusively at Target.

The company has a singular objective: to provide great products, focusing on high quality, soft fabrics, popular price points, easy-to-shop formats, a strong value proposition, and, most importantly, consistency.

In addressing this focus, Rowan offers an interesting analogy: Just as coaches count on consistent performance from their

From bath time to playtime, Carter's is there, with high-quality layette, sleepwear, and playclothes in soft, colorful fabrics for newborns, infants, toddlers, and four-to-seven year olds. Photos courtesy of Carter's.

team athletes from season to season, customers have come to expect high quality in every product that carries the Carter's name with each and every purchase they make.

"Consistency over time really builds high brand awareness and a high volume of repurchases," says Rowan, who reports an impressive intent-to-purchase rate of 80 percent among Carter's consumers.

"When mothers and grandmothers are pleased with their first purchase, they are likely to continue to purchase Carter's

products as the child grows," he adds.

Consistency is just one part of the Carter's story. At Carter's, children's clothing and accessories are much more than mere wardrobe items or nursery furnishings; they are "celebrations of childhood," which is the brand's theme, expressed in this sentiment: "Childhood is an experience that inspires, teaches, and warms everyone it touches. It's an adventure of the heart, and Carter's is there every step of the way."

It is this emotional content that sets Carter's apart, according to Rowan. "We feel that a brand must have a distinctive point of view in order to differentiate it from other brands in the marketplace. Our distinctive point of view, or differentiator, is the emotional content that we attach to a garment through the embroidery, the prints, the colors, and the language," he explains. "We believe it's our responsibility to connect emotionally with the elements of the garment to help build a stronger bond between us and the child, the mother, and the grandmother."

Imagination is another important element in Carter's celebration of childhood. Believed to be the key to "fostering happy, hopeful lives," the company has made imaginative artwork, children's sayings, and

fun colors the essential ingredients in its products.

In 1999 Carter's introduced Limited Editions products inspired by imaginative concepts and people. The first collection, *John Lennon's Real Love*, captured the "innocence and playfulness" of the drawings of this talented musician, artist, and poet, which he created to teach and amuse his son. Another collection incorporated the artwork of Emu Namae, featuring prints and embroideries inspired by this amazing blind artist and storyteller.

The newest addition to the Limited Edition series, which will launch in Spring

The company's pioneering vision and abiding success are attributed to the exceptional talent of approximately six thousand employees, led by Rowan. Serving at Carter's helm since 1992, Rowan was formerly employed with Dupont Corporation before assuming senior-level positions at Aileen, Inc. and Mast Industries. From there, he joined VF Corporation as group vice president. In this capacity, he oversaw the Lee Jeans, Bassett-Walker, and Jan Sport divisions of the firm, while also holding the position of president and CEO of the H. D. Lee Company.

With a skill for recruiting people who

personal growth. The company even offers paid time off and assistance with expenses to employees who are in the process of adopting children.

Carter's products are designed and developed in Atlanta by an in-house design, art, and merchandising staff of more than 150 people. More than twenty-five full-time artists create exclusive art and artistic applications that differentiate the Carter's brand and lead the industry.

An essential partner to the success of Carter's creative team is the customer. Prior to the release of new products, Carter's conducts research with retail customers

2003, is a celebration of the artwork of renowned author Eric Carle, creator of *The Hungry Caterpillar* and more than forty other children's books. Utilizing Carle's recognizable collage, style, and art, Carter's has created new artistic applications for its core products.

Carter's celebrates childhood in the shopping environment, too, installing Imagination Shops in selected department, specialty, and retail outlet stores throughout the country. Showcasing the Carter's brand, the shops incorporate interactive toy elements onto fixtures throughout the shop, inviting children to play and imagine by drawing on special walls, banging on drums, and visualizing themselves ten-feet tall in fun-house mirrors, providing an entertaining diversion while shopping with mom.

are self-motivated achievers with drive, ambition, and integrity, Carter's has assembled a team that is noted for its creativity and collaboration, from product conception to point of purchase. As a testament to the critical role employees have played in Carter's success, Rowan says, "I believe the single denominator that separates and drives our company is talent. We believe that attracting and keeping talent has made us what we are and are the main contributors to our long and successful track record.

"Finding talent and building a powerful chemistry," Rowan adds, "are the most important things we do here."

In return for outstanding employee performance, Carter's offers a generous compensation and benefits package, as well as opportunities for professional and

As the No. 1 brand in layette—the clothing and accessories newborns need—Carter's sells more than twenty products for every baby born in America, which is estimated at four million births each year.
Photos courtesy of Carter's.

and adheres to a disciplined internal review process. Customers also provide feedback on product via Carter's toll-free telephone number or its Internet site, where the company maintains a strong presence.

The company's Web site also enables visitors from around the neighborhood and around the world to browse product categories and receive information about Carter's products and promotions. While the site links to retail business partner sites through which consumers may buy products, Carter's does not sell directly to consumers online.

It is Carter's continued focus on developing core products that best illustrates the company's approach to maintaining industry leadership. Adhering to the business mantra, "Trust the power of fewer things," Carter's focuses its collective efforts on strengthening its core before extending into other markets. "It is critical to maximize the core before you reach for more," cautions Rowan. "If you don't do that, then the extensions are weak and actually damage the core business and, ultimately, the brand's image."

Consequently, Carter's main objective is to achieve even greater dominance in each of its product categories domestically before contemplating expansion into the international marketplace.

Another natural extension of Carter's commitment to its customers is its philanthropic involvement in the communities in which it conducts business through the company's support of causes that provide assistance to children and their families. Carter's makes financial donations and clothing contributions to education and health care organizations, halfway houses, and children's hospitals. In addition, many of Carter's employees donate their time and money to charitable causes that benefit children.

"It's vital to be dedicated to a larger community," Rowan says. "There's no question that companies and corporations are indebted to the community."

Similarly, parents and grandparents are indebted to Carter's not only for continuing its tradition of producing superior quality children's clothing and accessories, but, more importantly, for the company's genuine concern for the well-being of their littlest loved ones.

It is, after all, a matter of trust.

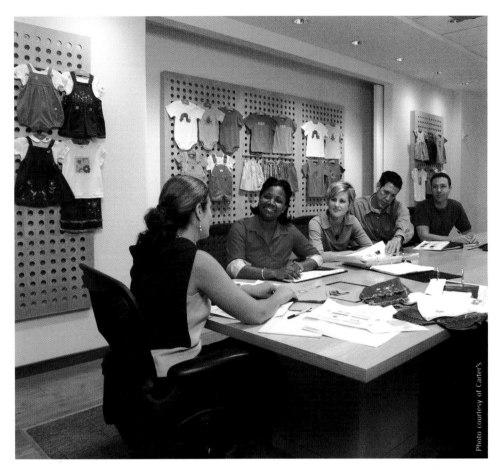

Prior to the market release of new products, staff members from Carter's in-house design, art, and merchandising departments participate in a disciplined internal review process that incorporates input and recommendations from retail customers.
Photo courtesy of Carter's.

carter's®
celebrating childhood™

Carter's Corporate Offices
1170 Peachtree Street • Suite 900
Atlanta, GA 30309
404.745.2700
www.carters.com

Goldstein, Garber, Salama &

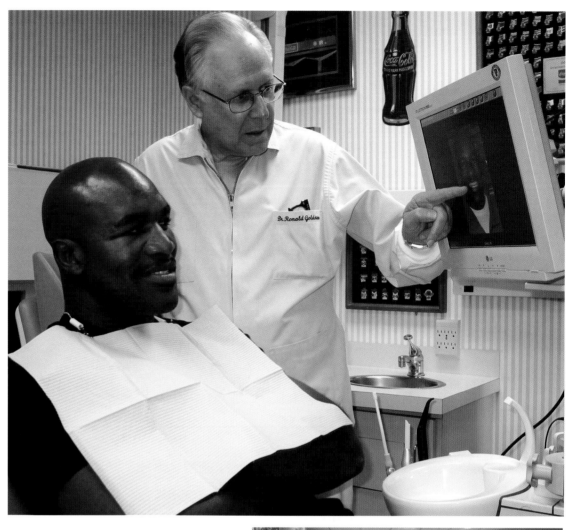

In the community of Buckhead, a world-class team of dentists equipped with the most advanced technological tools in existence has revolutionized the practice of dentistry by pioneering the development of esthetic dentistry.

They are known worldwide as "Team Atlanta," and although they didn't choose the name, it is how the practitioners at Goldstein, Garber, Salama & Beaudreau (GGS&B) are now identified and recognized by their colleagues and the profession at large. It is a name that is spoken with the utmost respect by those in the industry who are aware of how, through the skilled proficiencies of the team's practitioners, a thriving dental office on the outskirts of downtown Atlanta has rightfully earned its reputation as the premier dental practice in the world.

Buckhead native Dr. Ronald Goldstein is both the backbone of Team Atlanta and the firm's senior partner. Although it was his father, Dr. Irving H. Goldstein, who established the practice and promoted the value of preventive dentistry more than seventy years ago, the younger Goldstein, along with his colleagues, is responsible for propelling the practice from a local office to an internationally acclaimed dental group.

Goldstein's father is also credited with encouraging his son to combine his journalistic skills with a career in dentistry. But it was a dentist to some of Hollywood's brightest stars that became his mentor. After they met, Goldstein began a lifelong pursuit of introducing and refining techniques to improve people's smiles.

Now regarded as "the chief architect of esthetic dental care," Goldstein is a world-renowned author, an international lecturer, a dental researcher, and an inventor/designer.

At top, The practitioners at GGS&B are internationally known as the "dentists to celebrities," creating million-dollar smiles for the world's rich and famous. Here, Dr. Ronald Goldstein counsels heavyweight champion Evander Holyfield, who aspires to have a smile as bedazzling as his footwork in the boxing ring.

Above, With a keen eye for esthetics beyond the practice of dentistry, the doctors and their associates at GGS&B have selected luxurious and comfortable appointments to create a peaceful, yet welcoming ambiance in the reception area of their suite of offices on West Paces Ferry Road.

Photos courtesy of Goldstein, Garber, Salama & Beaudreau.

At top, World-renowned author, international lecturer, designer/inventor, researcher, and dental practitioner, Dr. Ronald Goldstein is GGS&B's senior partner and "captain" of Team Atlanta.

Above, On-site consultations among GGS&B's specialists offer patients innumerable advantages. From left to right, master ceramist Pinhas Adar, Dr. Ronald Goldstein, Dr. Maurice Salama, and Dr. David Garber discuss a case in Adar's state-of-the-art, in-house laboratory, providing recommendations from four specialized perspectives.

Photos courtesy of Goldstein, Garber, Salama & Beaudreau.

In the late 1970s, the first volume of Goldstein's groundbreaking textbook, *Esthetics in Dentistry*, was published, forever changing the perception of esthetic dentistry on a global level. The original work has since been revised and expanded to three volumes. They are now used as texts in the study of dental esthetics worldwide.

Goldstein's second book was written for dental consumers— the patients—and went on to become a bestseller on esthetic dentistry. Now in its third edition, *Change Your Smile* has been translated into six languages and read by more than one million people.

As a contributor to or co-author of more than fourteen additional dental books, Goldstein has appeared in television and video productions, has been filmed for television's *P.M. Magazine*, and has lectured at more than four hundred dental meetings worldwide. He also writes a beauty column for the magazine *Season*.

For Goldstein and his partners, international recognition clearly has its advantages. Nearly 20 percent of GGS&B's clientele journey from foreign countries, while almost 50 percent travel from beyond state lines, all for an opportunity to experience Team Atlanta's unparalleled dental treatment—from the simplest, routine dental cleaning to the most complex cases that make other dentists shake their heads in bewilderment.

On the home front, however, the dental practice is, perhaps, one of Buckhead's best-kept secrets. Surprisingly, some locals are unaware of the far-reaching scope or caliber of dental treatment performed in their own backyard.

But the achievements of the three dual-specialists—who are also world renowned—and the general dentist that comprise Team Atlanta have earned international acclaim that has reverberated across vast oceans and distant continents, creating what has become a worldwide impact on modern-day dentistry. These are the experts who write the books and teach other dentists in locations around the globe.

It is, however, within their suite of offices on West Paces Ferry Road that countless smiles have been revamped and lives have been changed. Here in Buckhead is where the practice of esthetic dentistry was developed and perfected.

Known in layman's terms as cosmetic dentistry, this specialized discipline has one primary focus—the smile. Believed to be the face's most expressive feature by the practitioners at GGS&B, the smile contributes to each person's uniqueness and influences self-image.

"If the eyes are the windows of the soul, the smile is the window of the heart" is the creed adopted at the practice and the inspiration for the thousands of remarkable facial transformations that have taken place in GGS&B's offices. Numerous men, women, and children, as well

as a notable number of celebrities, have received new smiles here.

The doctors' fundamental goal, however, extends beyond esthetics to an all-inclusive approach to dental care. The lifelong preservation of natural teeth, coupled with maintenance of optimal oral health, is the underlying principle that guides the group's practice of dentistry.

A complete range of professional services is offered by Team Atlanta, including diagnostics, periodontics, orthodontics, bleaching, restorative work, implantology, prosthodontics, preventive care, special effects (for film production) and, of course, esthetic dentistry.

Equally impressive are the professional credits of the practitioners who perform this extraordinary work.

As both a periodontist and prosthodontist, Dr. David Garber has achieved universal recognition for his clinical work in manipulating gum tissue to enhance a patient's smile. In addition to his extensive writing credits, Garber is active in numerous dental societies and lectures frequently throughout the world. He has also served as co-editor-in-chief of the *Journal of Esthetic Dentistry*.

before

While Dr. Maurice A. Salama earned dual-specialty certification in orthodontics and periodontics, he also completed a fellowship in implant dentistry. Formerly appearing as the dental expert on Fox (WAGA) TV's *Good Day, Atlanta!*, Salama travels the world to lecture on topics related to his specialties. He has also written extensively on adult orthodontics and implantology.

Dr. Henry Salama's specialties include periodontics, prosthodontics, and implant surgical techniques. Serving as director of GGS&B's Implant Center, Salama is also a published author who has lectured at dental conferences throughout the states and in Europe, Israel, and South America.

Recognized for his expertise in fixed and removable bridges, Dr. Brian Beaudreau brings an astute proficiency in esthetic dentistry and all phases of general dentistry to the practice.

As a general dentist, Dr. Angela Gribble Hedlund has earned accolades for her work in restorative and esthetic dentistry. She has published articles for the *Journal of Esthetic Dentistry* and the *Journal of the American Dental Association*.

In addition to their vast writing credits, which include eight textbooks and

after

Top left, GGS&B's doctors have an impressive collection of "before" and "after" photos that illustrate thousands of success stories in their practice of esthetic dentistry. Florida resident Lourdes Zaczac did not like her old, discolored crowns and crooked smile line. She traveled from Miami to experience Team Atlanta's "masters' touch."

Top right, Believing the "smile is the window of the heart," the doctors at GGS&B place considerable emphasis on the relationship between a beautiful smile and a positive self-image. Patient Lourdes Zaczac is radiant, now that Team Atlanta has totally revamped her smile and aligned her gum margins with her lipline.

Photos courtesy of Goldstein, Garber, Salama & Beaudreau.

hundreds of scientific articles, the practitioners at GGS&B collectively hold teaching professorships at seven universities nationwide.

Unlike other practices, GGS&B also has its own dental laboratory with a ceramist and four technicians on-site. Experts in their own right, these professionals work closely with the doctors to achieve natural-looking results in restorations.

For patients, the advantages of such a professional, cohesive team are visibly abundant. In-house consultations, extensive collaboration, and precise coordination of all dental services are conducted under one roof.

"To the best of our knowledge, there is no other practice in the world with three dual-specialists," claims Garber. "What we have created in Buckhead is the

Individual staff conferencing is an important part of coordinating patient treatment. *Above*, treatment coordinator Kristin Callais confers with Dr. Brian Beaudreau to determine an appropriate course of treatment for one of GGS&B's patients.

Photo courtesy of Goldstein, Garber, Salama & Beaudreau.

future of dentistry: different specialists working together in one practice to provide total dental services."

Ongoing conferences and orchestration of treatment with an extended team of specialists—including oral and plastic surgeons, cosmetologists, and hairstylists—exemplifies GGS&B's full-service approach to holistic dental care, where care of—and attentiveness to—patients as individuals and not just dental conditions is paramount.

"Our first priority is to address the patient's mouth functionally to create a disease-free environment before proceeding cosmetically," states Beaudreau. "Function is never compromised for esthetics."

"We then determine the motivation for esthetics by carefully listening to our patients' goals," adds Maurice Salama, "going above and beyond what most practices do to achieve a patient's optimal look."

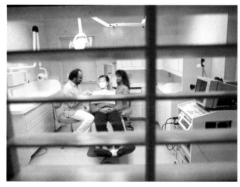

At work in one of GGS&B's pristine, technologically advanced surgical suites, Dr. David Garber and his dental assistant treat one of the practice's patients. Garber has achieved worldwide recognition for his clinical expertise in enhancing smiles through the skilled manipulation of gum tissue, implants, and brighter-than-original ceramic restorations.

Photo courtesy of Goldstein, Garber, Salama & Beaudreau.

To ensure complete satisfaction, computer imaging—one of a host of state-of-the-art technologies used at the practice—enables patients to visualize proposed changes prior to initiation of treatment.

Other advanced technologies utilized in patient care at GGS&B include:

- Painless laser cutting of teeth without anesthesia;
- Digital radiography, which radically minimizes traditional radiation exposure by 90 percent;
- Air-abrasive technology, used to spray away decay without drilling or anesthetics;
- Three varieties of "invisible" orthodontics;
- Laser technology, used in early cavity detection and gum surgery;
- Whitening teeth modalities, for in-office "power bleaching" and at-home use;
- CAD-CAM ceramic inlays or onlays, often completed in one day;
- Three microscopic diagnostic and treatment instruments, including surgical microscopes and the Perioscope™, a device that looks under the gums' edges;
- Implants, which can give patients "teeth in a day";
- Intraoral videos, which allow patients to observe what the dentist sees;
- Two computerized, color-selection systems that ensure restorations precisely match adjacent teeth;
- Voice-generated, hands-free charting in the hygiene department;
- The Wand™, a computerized anesthesia system that virtually eliminates the discomfort of injections.

"Most new technologies come to us first," states Goldstein, who has worked closely with many companies in the development of innovative dental instruments; "that's the advantage of having world-renowned teachers on staff. Manufacturers want us to teach their technologies and make recommendations for their improvement. We are in a unique position to give our patients the newest, most modern technology."

Born near Piedmont Park, Goldstein and his family moved to Buckhead at the age of seven. "When I was young," he says, "it was my dream to either live or work on West Paces Ferry Road."

The practitioners' offices at this prestigious Buckhead address is, according to Goldstein, "a work in progress," noting that the dental facility has undergone four major expansions to its current size of 7,800 square feet. "We are constantly updating and remodeling, adding equipment, enhancing our technology, and renovating the interior décor.

"A visit to our offices should be a pleasant experience," Goldstein continues. "We provide a healthy, comfortable, home-like setting that is esthetically appealing, as well."

The professional, attentive personnel at the practice further enhance the office's welcoming ambiance. With more than forty people on staff, each patient is ensured the utmost attention and unparalleled care.

"It definitely takes a team to accomplish everything we do," concludes Goldstein. "The extraordinary talent here makes it exciting to go to work every day."

At GGS&B, the practitioners and their clients do, indeed, have much to smile about.

Goldstein Garber Salama & Beaudreau

Team Atlanta Esthetic Dentistry

1218 West Paces Ferry Road • Suite 200
Atlanta, Georgia 30327
404.261.4941
goldsteingarber@goldsteingarber.com
www.goldsteingarber.com
www.teamatlanta.com

Regent Partners

Embracing challenge, seizing opportunities, taking risks. One would question, in these unpredictable economic times, if these strategies represent a prudent approach to business.

Yet for David B. Allman, founder and president of Regent Partners and a self-described "opportunistic investor," this approach has successfully proven to be the only way to do business.

College with a BA in economics, spent three years employed in several fields before creating his own niche in the real estate industry.

Following his tenure in office leasing with Cushman & Wakefield and in marketing working with a Texas developer, Allman liberated his entrepreneurial spirit, launching Regent Partners in 1988.

with J.A. Jones, Inc., the staff at Regent Partners gained access to a global continuum of resources in development, engineering, construction, finance, operations, maintenance, and information technologies.

Continuing in his position as president of the new subsidiary, Allman assembled a senior management team with more than 150 years combined experience in developing, leasing, constructing, and managing commercial real estate assets.

With each project, Regent Partners demonstrates expertise in identifying opportunities, assessing risks, and negotiating for the necessary rights to secure a transaction before initializing execution. Then, from the preliminary stages of design, budgeting, and financing through construction, leasing, and final disposition of the property, Regent Partners is skillfully involved in each project's full life cycle.

Instrumental to the company's continuing success has been its market-driven focus.

"At Regent Partners, we stay attuned to what's happening in the market and respond to opportunities and needs as they arise," explains Allman. "Our ability to diversify enables us to shift the emphasis from one product type to another, based on current demands."

In response to recent market conditions, the company has become increasingly involved in multi-family projects. As the current owner/developer of more than sixteen multi-family residential properties with 6,500-plus units nationwide, Regent Partners also earned the distinction of being awarded the first major privatized United States Army military housing contract in the nation in 1999.

The first privatization project is now underway at Fort Carson in Colorado Springs, Colorado. In addition to building 840 new units and renovating the post's

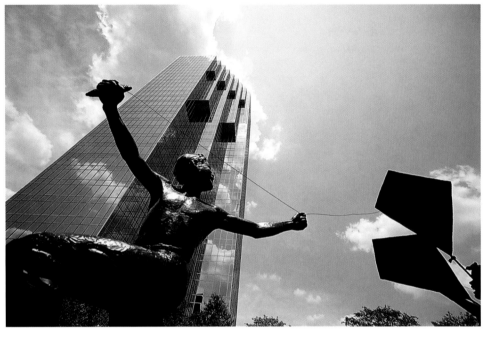

Since the firm's acquisition of Tower Place in 1993, Regent Partners has transformed the site by renovating the buildings, adding streetscapes, and enhancing green space. *Pictured above*, a whimsical sculpture titled *Windy Days* by Gary Price attracts visitors to the twenty-six acre complex, which is located in "the new heart of Buckhead." Photo courtesy of Regent Partners.

As a full-service commercial real estate company, Regent Partners has acquired and developed more than ten million square feet of property valued in excess of $1 billion since its inception a little more than a decade ago.

Thriving on an "outside-the-box" orientation, the Atlanta-based firm defies industry standards of specialization by operating as a broad-based specialist in the acquisition and development of residential, retail, office, hotel, land, military housing, and mixed-use projects.

Prior to establishing Regent Partners, Allman, who graduated from Dartmouth

The new company's goal was simple: to add value to properties. "Our vision was to enhance rather than just sustain the value of the properties we acquired and developed, which is both riskier and more challenging," comments Allman. "From the outset, we chose not to be institutional in our behavior or attitude. As a result, we are now perceived as being astute investors and assessors of risk and opportunity."

In January 1991, Regent Partners became a wholly owned subsidiary of J.A. Jones, Inc. a worldwide company founded in 1890 and headquartered in Charlotte, North Carolina. Through its affiliation

1,823 existing units, the company will add playgrounds, jogging trails, and a community center.

As the Department of Defense continues its effort to improve both the quality and quantity of residences to attract and retain qualified personnel through the privatization of military housing, Regent Partners is aggressively pursuing similar ventures throughout the United States.

While Fort Carson represents a momentous undertaking and a major coup for Regent Partners, the firm's most industrious and highest profile project, by far, is located much closer to home.

In 1993 Regent Partners acquired a celebrated Atlantan landmark, Tower Place. Since assuming the property, which originally housed a hotel, a college building, and several retail establishments, Regent Partners has completely transformed the site, refurbishing the existing buildings, adding streetscapes, and enhancing the green space within and around the complex.

Situated on twenty-six acres in the "new heart of Buckhead," the complex now includes three office buildings with 1,000,000 square feet of space; 165,000 square feet of retail and entertainment space, including unique eateries, Buckhead's largest health club, and a movie house; 2,875 parking spaces; and 418 hotel rooms in two premier hotels—The Courtyard by Marriott and The DoubleTree Hotel.

While additional land is available for future development, the construction of a thirty-five story, high-rise residential tower is currently in development. The Regent at Tower Place will feature six premium penthouses and 280 one-, two-, and three-bedroom units. Skyline views, a swimming pool, guest suites, a fitness center, a penthouse club room with an exterior balcony, and a business center are among the amenities that promise to make The Regent one of Buckhead's most prestigious addresses.

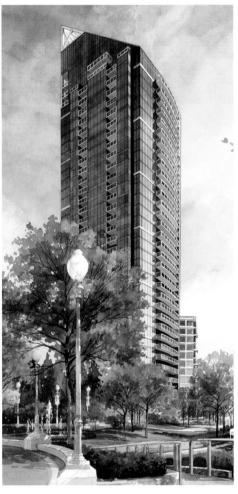

Destined to become one of Buckhead's most sought-after addresses, The Regent at Tower Place is a thirty-five story luxury apartment tower that features 286 units, including six superlative penthouses, an exclusive club room, and a lounge. Skyline views, guest suites, a business center, a swimming pool, and a fitness center are among the amenities that are being designed for the enjoyment of the hi-rise's new residents.
Rendering courtesy of Regent Partners.

"Our vision is to create a first-class, mixed-use environment at Tower Place," comments Allman, "and we are committed to a long-term evolution of the complex.

"This project is destined to have a transformative impact, not just on Tower Place, but on Buckhead," Allman continues. "We are working on the front lines to create a pedestrian environment in which residents can live, work, shop, and play without necessitating travel. Every component we add will enhance the vibrancy of the complex and the quality of life in Buckhead."

As a member of the Buckhead Coalition, Allman is, in fact, spearheading the transformation of Peachtree Road—the thoroughfare that runs through the hub of Buckhead's commercial district—into a more pedestrian-friendly boulevard. Serving as chairman of the Buckhead Community Improvement District, one of the local entities that is financing and directing the project, Allman is postured in a leadership role to not only enrich the corridor that is adjacent to Tower Place, but to enhance the uniqueness of the Buckhead community—his native hometown.

Allman, who also maintains an active involvement in several local organizations, is certain about Regent Partners' future.

"Our mission is to continue to explore opportunities as a value-added investor and developer of real estate," Allman concludes. "As each new opportunity emerges, there will always be challenging avenues to pursue."

**3348 Peachtree Road, N.E.
Tower Place • Suite 1000
Atlanta, Georgia 30326-1008
404.364.1400
www.regentpartners.com**

Georgia Power

In today's energy marketplace, it's good to find a power company committed to economic development, energy conservation, community service, environmental stewardship, and affordable rates.

Its name is Georgia Power.

As the largest subsidiary of Southern Company, one of the nation's largest power generators, Georgia Power has provided electricity to state residences and businesses for more than one hundred years. An investor-owned, tax-paying utility, the company serves nearly two million

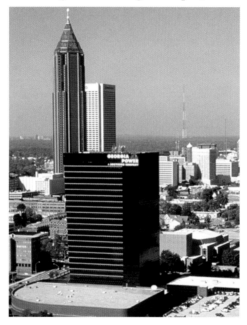

customers in fifty-seven thousand of Georgia's fifty-nine thousand square miles.

It was Georgia Power's first president, Preston Arkwright, Sr., who conceived the vision that would guide the company in each endeavor, expressed in this simple, yet powerful motto: *A Citizen Wherever We Serve.*

Headquartered in Atlanta, Georgia Power has approximately nine thousand employed "citizens" in local and regional offices statewide; men and women who work faithfully and diligently to uphold the values defined by their predecessors.

Today, these values—*superior performance, citizenship, leadership, shareholder value, ethical behavior, teamwork,* and *diversity*, as well as attitudes that always put the *customer first* and create a *great place to work*—are collectively known at Georgia Power and its sister companies as *Southern Style*. Together, they are the foundation and motivation for the good work and goodwill that have been an integral part of the company's heritage since its inception.

Georgia Electric Light Company of Atlanta was first incorporated in 1883, not long after electric lights were introduced in New York City. Determined to be the Southeast's first city with electric streetlights, Atlantans raised the necessary capital to form the new company, which purchased its first electric plant of forty-five lights from Southern Light Company of New York.

Within five years, eight hundred streetlights and businesses, and another new invention—streetcars—were powered by the plant's generation.

In 1890 it was an Atlanta banker by

the name of Henry Atkinson who laid the foundation for what would become Georgia Power. Atkinson met Atlanta's demand for electricity by building plants to provide needed power. Working with Arkwright, whom he elected president, Atkinson developed numerous streetcar lines and power plants. Twelve years later, Georgia Railway and Electric Company was chartered as the parent company of Atkinson's mounting electric interests.

Through the years, the company flourished, merging with seven major electric

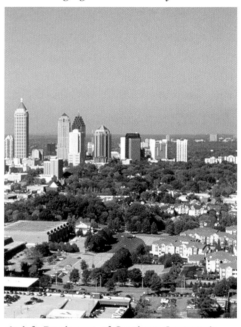

At left, Employees of Southern Company's largest subsidiary are frequently seen driving Georgia Power's electric-powered automobiles on the city's highways. *At right*, Buckhead is a compelling backdrop for Georgia Power's corporate office, which is located at the northeast corner of downtown Atlanta. Photos courtesy of Georgia Power.

systems in five southeastern states in the 1920s. During that same decade, the company officially changed its name and, by 1935, achieved a significant milestone by selling one billion kilowatt-hours of electricity.

Under the leadership of its twelfth president and CEO, David Ratcliffe,

Georgia Power's total electricity sales to the company's service-area customers reached seventy-three billion kilowatt-hours in 2001.

Such phenomenal growth between the mid-1930s and the beginning of the twenty-first century is attributed to several key factors, including the astute decision to shift from hydroelectric power as a primary fuel source to coal- and gas-burning facilities; multi-million dollar investments to build plants or enhance existing facilities; construction of nuclear facilities in the 1970s; adoption of new technologies, such as combustion turbines, to provide power at lower-than-the-national-average rates in the 1980s; and the ongoing exploration of innovative ways to provide cost-efficient power to customers.

Throughout its history, exceptional customer service—best demonstrated by low rates and high reliability—has always been Georgia Power's No. 1 priority.

In keeping with the company's commitment to secure affordable power costs, the Georgia Public Service Commission implemented innovative rate-making measures that resulted in no increase to Georgia Power rates since 1991. In fact Georgia Power has reduced its rates by 8.5 percent since then. Currently the company's rates are 15 percent below the national average.

To ensure reliability, power outage preparedness plans are in place year-round to restore electricity quickly and safely should inclement weather conditions interrupt service.

Nationally Georgia Power is recognized for outstanding customer service. In addition to winning numerous awards, the company was ranked in the top quartile for customer satisfaction among peer utilities in 2001.

Customer service, however, extends beyond rates and storm restoration to those locales Georgians call "home"—their communities. On individual and corporate levels, Georgia Power's employees support civic and political organizations, education and health initiatives, and, most importantly, economic development and environmental concerns.

Through the years, the company has made significant contributions to Georgia's economic development, working with local and state governments to support relocation or expansion of businesses and assisting communities in attracting new commerce and workforces.

In fact, key executives at Georgia Power were instrumental in bringing the 1996 Olympics to Atlanta. As a major supporter, the company provided infrastructure development, security, and volunteers, while proudly promoting its role as "The Official Power Source for The Centennial Olympic Games."

Consistently ranked among America's top Economic Development agencies, Georgia Power was also named one of the world's best community and economic development organizations by *Site Selection* magazine in 2000.

Perhaps even more important, however, is the company's role in environmental protection.

Georgia Power is investing $850 million in environmental controls on seven power plants to reduce the company's ozone-contributing emissions to just 6 percent of the Atlanta region's total by 2003.

Fostering clean air through annual tree plantings, building and improving wildlife habitats, and endorsing "Smart-Ride," a company-sponsored commuter program, are among Georgia Power's noteworthy environmental projects.

Of special significance is the company's role in environmental stewardship. As the state's largest nongovernment provider of recreational facilities, Georgia Power owns 60,000 acres of lakes, 1,350 miles of shoreline, and numerous parks that are near its hydro plants. Fishing, swimming, boating, picnicking, hiking, and camping can be enjoyed at these picturesque sites that have been developed into public recreation areas.

Energy conservation is also of paramount importance. In addition to helping customers improve energy efficiency in homes, businesses, and communities statewide, Georgia Power funds ongoing research and development to explore alternative energy sources and develop advanced transportation technologies using electricity to power vehicles. Studies are also under way to determine the viability of gasifying coal to generate electricity, which, although less efficient, may prove to be an environmentally friendly alternative.

At Georgia Power, "We live here, too," is more than just an advertising slogan. It is a testament to the company's continuing presence and its commitment to protect, to preserve, and to promote a better quality of life…now and in the future.

GEORGIA POWER
A SOUTHERN COMPANY

241 Ralph McGill Boulevard
Atlanta, Georgia 30308
404.506.6526
www.georgiapower.com

Reliance Financial Corporation

Betty Jean Wall, *at left*, and Betty Nance welcome clients in Reliance Financial Corporation's well-appointed lobby. Photo courtesy of Reliance Financial Corporation.

In an era marked by economic uncertainty, there is a broadly diversified financial services company in Atlanta whose clients worldwide have entrusted the firm with more than $10 billion in assets. The company is appropriately called Reliance Financial Corporation.

For more than ten years, this company has been providing a full array of personalized investment, fiduciary, consulting, advisory management, and financial services to individuals, corporations, nonprofit organizations and institutions, as well as to other banks, brokerage firms, investment advisors, insurance companies, and strategic alliance partners.

In Reliance Financial Corporation's formative years, the company's managing principals, led by Chairman and CEO Kenneth J. Phelps, developed a long-term business strategy to direct and administer the controlled growth of subsidiaries that would serve the specific financial needs of the company's varied clients. Reliance Financial, headquartered in Buckhead with an operations center north of Atlanta, serves as the corporation's holding company.

Ranked among the nation's largest independent trust companies, Reliance Trust Company is also the company's largest subsidiary. As a state-chartered bank, Reliance Trust focuses on providing investment management, trust administration, fiduciary services, retirement programs, fee-based financial planning, and wealth management. Reliance Trust

also offers many specialized financing services to churches, schools, and other nonprofit institutions. With a 40 percent share of this highly specialized market, the company is the largest provider in the country. In addition to services provided directly to clients, it is also a key private label provider of technology and administrative services to scores of banks and other financial intermediaries.

According to Managing Principal James T. Maxwell, "We have developed and implemented state-of-the-art technology and securities processing, which are sought by many financial services providers who recognize the importance of advanced, efficient systems delivery."

Reliance Securities, LLC, is a subsidiary providing securities brokerage and unrivaled expertise in the management of stocks, bonds, mutual funds, unit investment trusts, and IRAs.

With investment and financial advisory firms located across the United States, the company's subsidiary, Reliance Capital Advisors, provides financial planning, asset management, and comprehensive trust and fiduciary services, as well as brokerage and insurance services. Managing Principal Anthony A. Guthrie states, "Reliance Capital Advisors allows us to provide comprehensive wealth management encompassing financial, investment, and insurance services, as well as a local presence in select markets across the country."

A wide range of insurance products is offered by Reliance Financial's insurance subsidiary, The Holmes/Shaw Agency, whose specialty has been delivering group insurance products to community banks, small businesses, and individuals since 1965.

Reliance Financial's Synergistics Research Corporation is one of the

country's leading providers of multi-client consumer and small business marketing research for the financial services industry. The company provides consulting and secondary research services, product evaluation and design, and overall strategic analysis.

To successfully implement its financial services delivery strategy, Reliance has recruited trust, investment, operations, and information technology specialists who are among the most experienced in the industry, each with an average experience of more than twenty years. "Our executives and associates have worked on Wall Street and at respected securities firms, law firms, and investment companies nationwide," claims Phelps; "they are major league players. Rather than work for large, impersonal companies, however, they have brought their expertise to a smaller firm to work with a group of people who also want to make a difference and who want to have an impact."

Ongoing education is critical to keeping company associates at the "top of their game." The company offers a liberal college and graduate school tuition reimbursement plan to qualified associates in addition to executive education at

CFO Jerry Dawson and General Counsel Ron Stallings offer unrivaled expertise in providing professional solutions to the firm and its clients. Photo by L.A. Popp.

top business schools and in-house training in management and supervision, software and technologies, industry regulations, and new products and services.

With millions of dollars invested in information technology, Reliance has state-of-the-art systems in place to conduct its day-to-day business. In 1993, long before "Internet" was a household word, Reliance's clients had online access to their account information twenty-four hours a day. The company works with leading financial software firms to share ideas in the development of new products and information technology that, once introduced, are frequently adopted by the company prior to industry-wide implementation, thus giving Reliance a

Managing Principals Anthony A. Guthrie and James T. Maxwell bring years of experience to the firm. Photo courtesy of Reliance Financial Corporation.

competitive edge.

"We have the same—if not better—technical competencies as larger firms," Maxwell says, "but, because we are smaller, we can deliver our services faster, better, and more efficiently."

"At Reliance," he adds, "we offer clients professional solutions coupled with strong personal relationships."

To ensure the utmost attentiveness to each client's interests, Reliance also takes advantage of its technology to develop relationships and stay connected with clients, either through a broadcast approach to communication via e-mail or one-on-one communication. Personal contacts by telephone and frequent face-to-face conferences are also conducted,

epitomizing Reliance's "high tech with a human touch" philosophy of business.

Whether corporate clients or company associates, it is clearly people who matter most. "We have a pervasive belief that the people who work here make a difference in everything that we do," states Phelps. "A company can have unlimited capital and access to leading-edge technology, but without a dedicated, conscientious staff with the right attitude, it's all meaningless.

"Everyone at Reliance is on a first-name basis," Phelps adds. "Each person has his or her own important duties; if he or she does not fulfill those responsibilities, the organization is likely to fail to meet the clients' needs and expectations."

The internal affinity at Reliance is based, in part, on the company's flat organizational structure. As a privately held, employee-owned firm, the workplace is culturally different from most corporations with typical hierarchical formats.

"People work here because they want to, not because they have to," states Phelps; "that makes a significant difference in their work ethic."

The company's camaraderie extends beyond corporate walls to the community, where staff members are encouraged to actively volunteer. Twenty to thirty organizations in the metro Atlanta area do, in fact, benefit from the goodwill of Reliance employees, who generously contribute their time and talent. "We are passionate about giving something back to the community," explains Phelps. "It is fundamental to our system of core beliefs that all of us—individually and collectively—do more than just 'take'; we willingly give back to others."

There is no mistaking the pride that Phelps personally takes in the outstanding achievements Reliance Financial and its subsidiaries have realized since the company's inception. "We started with

Direction and leadership by Chairman and CEO Kenneth J. Phelps ensure client satisfaction and corporate success.
Photo courtesy of Reliance Financial Corporation.

literally nothing more than an idea, a core of initial people, and a set of beliefs about how best to do business," Phelps comments. "Together we built a company that now provides wages and benefits for two hundred families, which allow them to realize their goals and dreams…of a home, lifestyles, vacations, sending their kids to college, and security for the future. Without a major name or big firm behind us, we have become a progressive and rapidly growing company with clients in every state and worldwide who have entrusted billions of dollars in assets to our care.

"It is a powerful testimony to what people can do as a team," Phelps concludes, "if they work together and share a vision and a dream."

Reliance
FINANCIAL CORPORATION

3384 Peachtree Road, NE • Suite 900
Atlanta, Georgia 30326
404.266.0663 • 800.749.0752
www.relico.com

Lenox Square

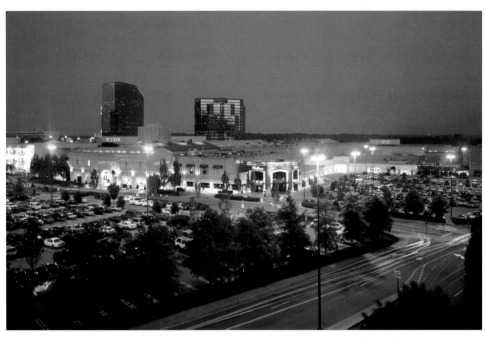

As a favorite gathering place for community events, Lenox Square is often called the "town hall" of Buckhead. Photo courtesy of Simon Property Group.

The year was 1955.

A young, visionary entrepreneur purchased a country estate on seventy-two acres in Atlanta with aspirations of building a shopping mall.

The man, an Ardmore, Oklahoma, native, was Ed Noble, and the mall, which celebrated its opening in August 1959, was Lenox Square.

As one of only six malls nationwide, Lenox Square attracted shoppers from throughout the Southeast to the community of Buckhead. According to Jeff Pierce, the mall's marketing director, "The opening of Lenox Square signified Atlanta's arrival on a retail level."

During its forty-plus year history as an Atlantan landmark, Lenox Square has undergone several major renovations. Originally built as an open-air mall with covered walkways, the complex was enclosed in 1972 when the Neiman Marcus wing was constructed. In subsequent years, a food court was added, additional retail space and a promenade linking the mall with the J.W. Marriott Hotel and the Lenox Building office tower were constructed and, in the mid-1990s, an

upper retail level was completed.

Today, with 1.5 million square feet of prime space, Lenox Square is anchored by Rich's, Macy's, and Neiman-Marcus and features 230 specialty stores, kiosks, and eateries, as well as a six-screen movie complex. There are, in fact, more than twenty-five tenants that are exclusive not only to Buckhead, but also to the city of Atlanta.

Lenox Square is one of a select number of malls nationwide with four full-service restaurants, including the Clubhouse, a popular gathering place owned by Hollywood celebrities Kevin Costner and Robert Wagner.

Owned and managed by Simon Property Group, an Indianapolis-based retail real estate firm that is recognized as one of the world's most innovative shopping retailers, Lenox Square is nicknamed the "town hall" of Buckhead and serves as the hub of many of the community's major outdoor events.

The Southeast's largest fireworks display, which is telecast live on the Fourth of July, is enjoyed by more than two hundred thousand people each year at the mall.

Another annual tradition in Buckhead,

Rich's Tree Lighting, is a two-hour event televised from Lenox Square on Thanksgiving, featuring live entertainment by top vocalists, such as Trisha Yearwood and Alicia Keys.

The world's largest 10K event—the Peachtree Road Race—attracts as many as fifty-five thousand runners to the starting line at the mall's front entrance during July.

In addition to hosting numerous events and fund-raisers, Lenox Square is committed to Buckhead's growth and preservation.

"We are actively involved in almost every local association or board that impacts the quality of life in Buckhead," comments Pierce. "Lenox Square has an enduring history, not only as a community supporter, but as a premier shopping destination in the Southeast.

"Visitors and area residents who think of Atlanta and think of shopping, think of Lenox Square."

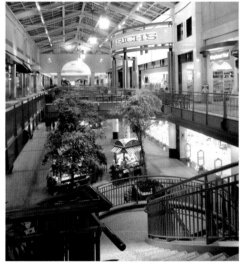

The atrium at Lenox Square welcomes shoppers from throughout the Southeast. Photo courtesy of Simon Property Group.

LENOX SQUARE
legendary shopping

**3393 Peachtree Road, NE
Atlanta, Georgia 30326
404.233.6767
www.lenoxsquare.com**

Phipps Plaza

For area residents and visitors with a penchant for life's finest, there is one address in the state of Georgia that has become synonymous with the ultimate cosmopolitan shopping experience.

That locale, which is in the heart of Buckhead at the intersection of Peachtree and Lenox Roads, is Phipps Plaza.

Anchored by three of the country's most elite retail establishments—Saks Fifth Avenue, Lord & Taylor, and Parisian— Phipps Plaza has 822,000 square feet and three levels of prime retail space that is home to more than one hundred specialty stores, many of which are unique to the Southeast.

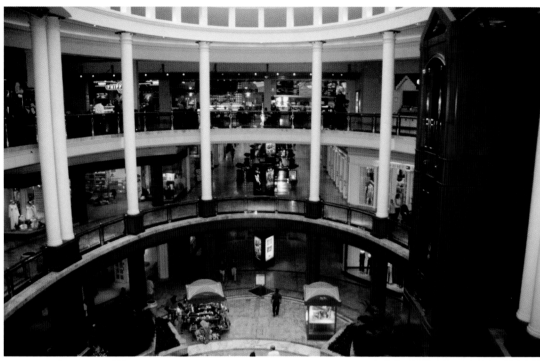

Brass fixtures and railings, cherry wood trim, and imported, European marble floors give an air of sophistication to Phipps Plaza's three shopping levels. Photo by L.A. Popp.

Gucci, Tiffany & Co., Cole Haan, Gianni Versace, and A|X Armani Exchange are among the many distinguished tenants in the Southeast's premier shopping hub that has been cited as a "Southern Best" in *Southern Living* Magazine's prestigious "Readers' Choice Awards."

Walk through any of the mall's entrances and, within moments, one can unquestionably appreciate why. Outstanding architectural features enhanced by cherry wood trim, brass fixtures and railings, and marble flooring that has, in fact, been imported from Europe are more reminiscent of a palatial home than a shopping center.

Especially noteworthy is the "Court of the South," which serves as center stage for the many social and charity events hosted there. Modeled after a stately Georgian mansion during the mall's major renovation in 1992, the court features a grand, circular staircase with a luminous chandelier, creating a welcoming ambiance

with the utmost sophistication.

Four restaurants and a fourteen-screen AMC theatre also make Phipps Plaza a premier place in Buckhead to enjoy a delectable meal or the latest Hollywood blockbuster.

Owned and managed by Simon Property Group, the Indianapolis-based retail real estate firm renowned for developing the nation's highest quality retail properties, Phipps Plaza benevolently opens its doors to local and non-profit organizations. From silent auctions and design showcases to gala dinners and under-the-tent outdoor events, Phipps Plaza partners with community groups to raise funds, often donating a percentage of the proceeds to the Simon Youth Foundation, a nationwide, corporate-sponsored effort that provides educational assistance to "at-risk" children.

Valet parking, an on-call taxi service, and a gift card program are among the many amenities available to shoppers.

Since opening in 1969, Phipps Plaza has had a definitive impact on furthering

Buckhead's standing as an eminent place to live, work, and, of course, shop.

"For more than thirty years, Phipps Plaza has grown with Buckhead, contributing to the community's economic growth," comments Nicole Bostic, marketing director for Phipps Plaza. "As new stores open, not only are employment opportunities created, but additional revenues are realized as new patrons are drawn to the area.

"Phipps Plaza maintains a powerful presence and strong affiliation with the community," Bostic concludes. "We continually strive to make Buckhead a better place for everyone, while providing a beautiful setting in which to shop."

**3500 Peachtree Road, NE
Atlanta, Georgia 30326
404.262.0992
www.phippsplaza.com**

PricewaterhouseCoopers

Mark Poczman, Partner, Tax.
Photo courtesy of PricewaterhouseCoopers.

Shanel Alsup, Senior Associate, Assurance and Business Advisory Services. Photo courtesy of PricewaterhouseCoopers.

In the corporate world, quality and consummate service is unquestionably vital to success.

At PricewaterhouseCoopers, where the firm's fundamental goal is to "be the world's leading professional services firm," three critical values—teamwork, leadership, and excellence—have been prudently cultivated to provide unsurpassed expertise in professional services, thus generating a global reputation for pre-eminence in this highly specialized and equally competitive field.

While its core business—assisting clients in solving problems by providing tactical counsel—is elemental, the firm's approach is far more intricate.

Indeed, there are no boilerplate solutions offered at PricewaterhouseCoopers. Instead, the firm calls upon a stringently selected team of experts worldwide to work in accord to develop, then implement a strategic plan unique to each client.

This is teamwork.

Employing 125,000 professionals in more than 130 countries, Pricewaterhouse-Coopers has earnestly recruited top-echelon industry professionals with unrivaled knowledge and experience, as well as an unwavering commitment to the firm. Collectively, they share a primary task: to provide the highest quality professional services to organizations both locally and globally, within all key industries.

This is leadership.

PricewaterhouseCoopers' depth in talent and size in numbers allows the firm to provide talented, trained professionals wherever and whenever its clients need them. Exceptional resources, knowledge, and experience allow delivery of world-class client service that sets

the firm apart from other companies. PricewaterhouseCooper's consistent global methodology, common technology platforms, and communications tools enable the firm to mobilize, manage, and leverage its resources to effectively support its multinational audit, tax, and business advisory needs.

This is excellence.

Client-specific needs are appropriately addressed in each of the firm's service areas, which include assurance, risk management, corporate tax, human resource, transaction, and dispute resolution services. Within these areas, professionals focus within industries to provide clients solutions that are specific to the issues they face.

Here in the United States, the eye at PricewaterhouseCoopers has long been focused on Atlanta as a marketplace with

Mike Gumin, Senior Associate, Assurance and Business Advisory Services. Photo courtesy of PricewaterhouseCoopers.

tremendous potential. In addition to its pervasive global presence, the firm has become a bastion in Atlanta's corporate community.

According to Robert M. Bird, a partner in the Atlanta office, "The firm sees amazing potential in Atlanta and has made a significant investment here. This means that Atlanta organizations benefit from the breadth and depth of a pool of talented professionals, from firm leaders who are residents of Atlanta down to our capable associates."

Recently ranked by the *Atlanta Business Chronicle* as the city's largest professional services firm, the Atlanta office is the corporate home to more than seventy partners and nine hundred employees.

Providing services to more of Atlanta's principal companies than any other

professional services firm in the region, PricewaterhouseCoopers boasts an impressive local client roster, including BellSouth, Delta, Lend Lease, SunTrust, and United Parcel Service, among others.

Locally, the firm has the leading Transaction Services, Human Resource Solutions, and Information Security practices among the Big Four. It is services like these that help PricewaterhouseCoopers assist their clients in solving complex business problems, managing risk, and improving quality and performance.

PricewaterhouseCoopers' dynamic influence in the region, however, extends beyond business to the heart of Atlanta— its benevolent community. Through its active Contributions and Community Involvement (CCI) program, the Atlanta office is a leader in its support of local charitable efforts. Staff involvement through board membership and volunteerism, as well as monetary support originating from corporate donations, exemplify PricewaterhouseCoopers' steadfast commitment to Atlanta's altruistic endeavors and its generous contributions to the communities it serves.

The Woodruff Arts Center, the Metro Chamber of Commerce's Partners for Education, Junior Achievement, and countless other area groups and organizations

are counted among PricewaterhouseCoopers' largest beneficiaries. The firm was, in fact, the 2001 recipient of Atlanta's "A+ Award," given by Partners for Education for its professional participation in student tutoring and mentoring programs at Willis A. Sutton Middle School.

As a staunch supporter of the Alexis de Toqueville Society, the United Way's unique leadership-giving program, PricewaterhouseCoopers ranks first in total membership among the Big Four accounting firms in the city of Atlanta. The firm is proud of its standing as the leading professional services firm in the area in terms of society membership and dollars donated.

"At PricewaterhouseCoopers, being a business leader means being responsible for the communities in which we live and work," states Bird. "In line with our commitment to 'Change the World,' we have dedicated dollars and hundreds of volunteer hours to dozens of organizations in Atlanta that are working to make our community a better place to live, work, and raise a family."

Undeniably, it is the relationships the firm establishes both with its clients and within the communities it serves, as well as the solutions offered through the unparalleled expertise of its professionals worldwide, that represent the veritable value of PricewaterhouseCoopers and provide an unyielding foundation for a destiny that has the assurance of infinite success.

PRICEWATERHOUSECOOPERS

**10 Tenth Street • Suite 1400
Atlanta, Georgia 30309
678.419.1000
www.pwcglobal.com**

The Heiskell School

It was in the fall of 1948 that doctors told Miriam and Jim Heiskell the devastating news: Their five-year-old son was in a coma, his once-energetic body and vibrant spirit paralyzed by polio.

Young Andy Heiskell was not expected to live through the night. If he did survive, it was unlikely he would ever walk again.

Kneeling in prayer, Andy's family fervently asked God to use this debilitating illness to His glory.

home-based preschool to start her son's formal education.

And so began The Heiskell School, a Christ-centered learning environment that has become one of Atlanta's preeminent educational institutions.

Offering an independent, nondenominational preschool education since 1949, the school opened its doors to elementary school students two decades later. Today the school enrolls boys and girls in its

integrates the Word of God into everyday academic studies, instilling leadership qualities and developing strength of character that provide the foundation for a successful future as followers of Christ and "lights of the world."

Situated on five manicured acres near the Governor's Mansion in Buckhead, the school's facilities include a preschool building, an elementary/junior high building, a multi-purpose court, a mini-track, and a softball/soccer field.

Students come from throughout metropolitan Atlanta —and around the world—to attend the school that has earned an international reputation of excellence.

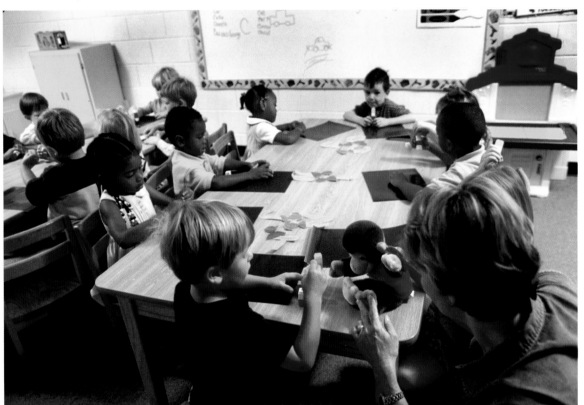

Internationally renowned for fostering academic excellence, The Heiskell School offers preschool, elementary, and junior high school students a Christ-centered learning environment that encourages the development of leadership skills and builds character, while bringing God's Word to life. Photo courtesy of The Heiskell School.

Miraculously, Andy defied medical odds and not only survived, but thrived, "running" through high school and college as a track star and traveling the globe as executive vice president of a major corporation.

Indeed, a family's heartfelt prayer was answered.

In the spring following his illness, as Andy continued his amazing recovery, Miriam Heiskell established a small,

preschool (two years through prefirst), elementary school (first through fifth grades) and junior high (sixth grade through eighth grade) programs.

At Heiskell, learning is "a multifaceted exploration of God's magnificent creation," where students are nurtured spiritually while being challenged to excel academically. Using an innovative blend of traditional and modern methodologies, the school provides a teacher-directed education that

"At Heiskell, we have a unique blend of students from various cultural, racial, and socioeconomic backgrounds, who are united by their faith in God," states Cyndie Heiskell, who assumed the role of school director following her mother's retirement in 2001.

The school's outstanding educators are carefully selected based on their own personal commitments to the Lord. Applications are stringently evaluated to ensure that faculty and staff exemplify the Christian values and principles that are inherent in the Heiskell learning experience.

"Our fundamental objective is that every child knows Jesus Christ as his or her personal savior," states Miriam Heiskell, who remains actively involved in the school. "Our teachers demonstrate this

in their own lives and in their day-to-day interaction with the children entrusted to their care. We are truly a Christian community, not just in name only."

As an extension of one of the leading academic programs in the Buckhead area, The Heiskell School also provides an opportunity to learn and explore outside the classroom by sponsoring numerous field trips and overnight educational adventures for its first through eighth graders.

Physical education classes, quarterly intramural athletic activities, and afternoon sports also play an important role in the Heiskell curriculum. At different grade levels, students are taught true sportsmanship through participation in softball, soccer, track, basketball, tennis, and cheerleading.

Upon graduation, Heiskell students successfully transition to Georgia's finest college prep schools. Heiskell graduates do, in fact, have a noteworthy history of acceptance at the secondary school of their choice.

One of the greatest testaments to the school's academic excellence is its impressive roster of top-ranked colleges and universities at which Heiskell alumni have continued their education. Harvard, Princeton, Duke, Oxford, and Georgetown Universities, Covenant and Wheaton Colleges, and the United States Air Force and Coast Guard, as well as other military and naval academies, are among the prestigious, post-secondary educational institutions at which Heiskell students have been accepted.

Perhaps most impressive is the sense of exuberance that is clearly visible to those who attend the school's open houses, which are held throughout the academic year.

"Our students are very secure in the love and the education they receive

here," comments Jim Heiskell, one of the Heiskells' sons, who serves on the administrative staff. "Visitors invariably tell us that the children truly seem happy.

"Heiskell students aren't just numbers," Jim Heiskell continues. "Our student body is around four hundred children, which gives us an opportunity to get to know every child and their parents and siblings as part of The Heiskell School family."

Whether working independently or with the compassionate guidance of the school's carefully selected faculty, Heiskell students receive a dynamic academic and spiritual foundation that includes the integration of scripture in their everyday studies.
Photos courtesy of The Heiskell School.

"In a smaller school like ours, every child is valued for who he or she is by the faculty, the administrators, and Heiskell's parents," states Cyndie Heiskell. "We are all here to pour our lives into establishing meaningful relationships with each of our students. This enables us to build a secure

foundation for academic achievement and social, emotional, and spiritual maturity.

"In addition," Cyndie Heiskell adds, "we cultivate the development of skills that enable students to become leaders in their homes, churches, and communities, as well as in business. Our most important goal, however, is to continue Heiskell's tradition of providing an education with the highest academic standards that is lovingly integrated with strong Biblical principles."

When asked if she anticipated that the school she began more than fifty years ago would have such a life-changing impact on so many lives, Miriam Heiskell comments, "I never expected the school to thrive as it has. I am so grateful that God has used me as an instrument to make an impression on young lives, including my own grandchildren."

The Heiskells have received countless testimonies through the years, commending them on the quality of education provided in a compassionate, family-like atmosphere.

One letter, in particular, written by a parent whose children attended the school, epitomizes the Heiskell experience: "They were challenged academically in a loving environment in which Jesus Christ is honored."

"I could know no greater joy," concludes Miriam Heiskell. "To have a life-shattering experience become such a blessing is truly a gift from God."

The Heiskell School

**3260 Northside Drive, NW
Atlanta, Georgia 30305
404.262.2233
www.heiskell.net**

Atlanta International School

Offering global learning opportunities for students from seventy nations worldwide, Atlanta International School is the only educational institution in the country to require enrollment in the universally renowned International Baccalaureate program. Photo courtesy of Atlanta International School.

Never before in our nation's history has a need for international understanding and unity been more prevalent.

Since opening in 1985, Atlanta International School (AIS) has taken the lead in fulfilling that need through its endeavor to create a global educational community in Buckhead, where awareness of and respect for the citizens of the world is as integral to the curriculum as academics.

Located on the historic campus of the former North Fulton High School,

AIS is an independent, non-profit secular school that welcomes four-year kindergarten through twelfth-grade students from around the globe. Fifty percent of the school's eight hundred students come from seventy countries worldwide; 50 percent are American citizens.

The faculty at AIS is equally diverse, representing more than thirty nationalities. Most teachers are fluent in at least one foreign language; more than 70 percent hold advanced degrees.

"Making a world of difference" is the

maxim that epitomizes the educational approach at AIS, where a rigorous program of academic excellence has been designed around the International Baccalaureate (IB) program. AIS is, in fact, the only American school to require enrollment in this world-acclaimed, pre-university program.

Offering an intensive and highly challenging curriculum in the final two years of high school, the IB program encourages the development of individual talents, while providing skills to successfully integrate educational experiences with the realities of life outside the classroom. The program cultivates critical thinking, interconnectedness, effective leadership, lifelong learning, and active citizenship.

Studies at AIS begin in the Primary School, where four-year-old kindergarteners through fifth graders are engaged in a curriculum based on the International Baccalaureate Primary Years Program, fostering the students' development as inquirers, thinkers, communicators, and risk-takers.

Core subjects are taught and learned in two languages. Alternating on a daily basis, classes are conducted in both English and a chosen language—French, German, or Spanish—to help students develop bilingual skills.

The Secondary School includes a middle-school program for sixth through eighth graders and an upper-school program for ninth through twelfth graders.

In grades six through ten, students follow a curriculum that is designed to further advance their language skills and academic proficiencies, while preparing them for the IB program, which they take as juniors and seniors.

For students who have not attended the Primary School, intensive language courses—in levels that range from beginner through native speaker—are also taught

at AIS, allowing students to enroll at any grade level.

All students at AIS enthusiastically participate in extracurricular activities, such as sports, performing arts, special interest clubs, and musical ensembles, including a jazz band, an orchestra, and several choirs.

Intramural sports are played by fifth and sixth graders, while seventh through twelfth graders compete in local, interscholastic athletic programs in basketball, baseball, cross-country, soccer, softball, tennis, track and field, and volleyball.

Of special interest are AIS's "Model United Nations" (MUN) conferences that give upper-school students an opportunity to research and debate contemporary global issues with their peers from other nations. AIS students have participated in MUN conferences regionally at Georgia State University and internationally in South America, Ireland, and The Hague, the site of the world's largest MUN conference.

"At Atlanta International School, students are immersed in an international context," states Dr. David B. Hawley, who has served as AIS's headmaster for seven years. "Everything they do, everything they experience is from a global perspective."

In addition to the traditional liberal arts curriculum pursued in the upper school, juniors and seniors must also participate in advanced studies that are an integral part of the IB program.

To foster independent study skills mandated at institutions of higher education, students must research and write a four thousand-word essay on an approved topic of personal interest.

To emphasize the importance of worldwide stewardship, students are required to complete 160 hours in a supervised CAS (Creativity, Action, and Service) activity prior to graduation. In past years, projects have included participating in sports and theatre productions, teaching Internet skills to the elderly, and volunteering in community service projects. "International Students Against Landmines," a program that encourages students to unite in the effort to eradicate landmines, is a worldwide project AIS students established in 1997.

IB students are also required to take a challenging, interdisciplinary course called "Theory of Knowledge (TOK)." Designed to promote skills in questioning, analyzing, evaluating, and reasoning, TOK fosters independent thought while instilling an appreciation of other cultural perspectives.

Upon graduation seniors receive an AIS diploma in addition to the prestigious IB diploma.

Accepted throughout the world as a premier secondary school qualification, the IB is recognized as an honors program in the United States and earns students advanced standing and college credit in many esteemed American and international colleges and universities.

Since graduating its first class in 1992, AIS has had alumni who have continued their education in seventeen countries in Asia, Europe, and North and South America.

Continuing its legacy of academic excellence, AIS has developed "Expanding Horizons: The Twentieth Anniversary Campaign for Atlanta International School," a three-phase capital campaign that defines the school's future growth and development.

The school will modernize the North Fulton Drive campus with the construction of two new buildings: a sports activity center and a new primary school.

The Campus Master Plan also calls for the renovation of current structures to include new art studios and visual arts classrooms and the expansion and enhancement of the library and computer labs.

A portion of the "Expanding Horizons" campaign will also be an endowment fund for faculty development initiatives in an effort to "recruit, retain, and strengthen the best faculty and staff available locally, nationally, and internationally."

First and foremost, however, AIS remains committed to four all-encompassing values that have contributed to its enduring success: to nurture an intrinsic joy of learning and to foster hope; to embrace mutual understanding and respect; to encourage achievement that comes from sustained and purposeful effort; and to enrich the overall educational experience by creating a diverse community of students and faculty from different cultures, nationalities, religions, and socioeconomic backgrounds.

The AIS experience is best summarized in the words of its headmaster, Dr. Hawley: "At AIS, our students go to school with the world."

2890 North Fulton Drive
Atlanta, Georgia 30305
404.841.3840
www.aischool.org
Email: info@aischool.org

Rotary Club of Buckhead

The Rotary Club of Buckhead is one of 30,000 clubs that represent Rotary International in more than 160 countries worldwide.
Photo courtesy of Rotary Club of Buckhead.

"Service above self" has been the long-standing motto of Rotary, the world's first service club that originated in February 1905 in the state of Illinois.

As the brainchild of Paul P. Harris, a Chicago attorney who saw the development of a professional club as a way to replicate the "friendly spirit" of small-town life he enjoyed in his youth, the Rotary concept quickly became contagious. Soon similar clubs were chartered nationwide and, by 1921, Rotary had expanded to six continents.

Today 30,000-plus clubs in more than 160 countries comprise Rotary International, a global organization with a membership of approximately 1.2 million business and professional leaders who share the desire to "provide humanitarian service, encourage high ethical standards in all vocations, and help build goodwill and peace in the world."

As one of 180 clubs in Georgia's three Rotary districts, Buckhead Rotary held its inaugural meeting in 1951. The club's first call to action was a program that remains integral to the community today. "Buckhead Beautification" was initiated to target projects that focus on environmental improvements and historic preservation within the community.

Since its inception, Buckhead Rotary has served as an educational resource for area schools. In addition to sponsoring a literacy program to teach English to multilingual students, Rotarians teach the basics of free enterprise to grammar and high school students through an ongoing Business Project.

Each year Buckhead Rotary also participates in two international education programs.

The Group Study Exchange is a reciprocal program in which Rotary clubs worldwide select "sister clubs" in other countries to which six-person teams of young, non-Rotarian businesspeople and Rotary leaders travel for four-week work experiences.

Buckhead Rotary annually participates in the Georgia Rotary Student Program (GRSP) by awarding scholarships to two students, who travel from international homelands to spend one year of study at a state college or university. Students' expenses are paid in full by the club and the Georgia Rotary Student Program, which designates two host families with whom students visit when not on campus.

Statewide, GRSP welcomed eighty-nine students in 2002.

In its commitment to service, Buckhead Rotary develops and/or unites in service projects that wield a powerful influence on local, state, national, and international levels. Although many contemporary issues are addressed, universal health concerns are of paramount importance.

Commemorating "A Century of Service; A New Century of Success" in its forthcoming centennial celebration in 2005, Rotary International, headquartered in Evanston, Illinois, has been one of the primary fund-raisers in the worldwide effort to eradicate polio. Through the united efforts of Rotarians around the world, the "Polio Plus Initiative" expects to raise an additional $80 million by its centennial year for a total of $500 million since the program originated in the 1980s.

AIDS is another issue of global magnitude that is addressed at all levels of Rotary.

Like local clubs throughout the world, Buckhead Rotary conducts AIDS awareness programs at area schools by asking three to five HIV-positive teenagers to conduct two-hour assemblies to share their personal experiences with students, discuss how the virus has impacted their lives and threatened their futures, and most importantly, emphasize how infection can be avoided.

Described as "the most revolutionary program I have ever seen" by George Ivey, president of the Buckhead Rotary, the model program was introduced by the Dunwoody Rotary Club in Georgia and later adopted by Rotary International.

One of Buckhead Rotary's proudest achievements is the Tommy Nobis Center,

In a year and a half, the Rotary Clubs of North and South Carolina and Georgia have raised nearly $1 million for Alzheimer's Research. Photo courtesy of Rotary Club of Buckhead.

an Atlanta-based, not-for-profit rehabilitation program that provides extensive job training and employment services to mentally and physically challenged individuals. Named for the former, much-admired Falcons linebacker who serves as the program's CEO, the one hundred thousand-square-foot facility was launched in response to a plea by a Buckhead Rotary couple whose daughter required special care. Since opening in 1977, the center has assisted more than six thousand individuals.

Buckhead Rotary also supports a

Above, from left to right, Al Weatherly, Buckhead Rotary's immediate past president, Rosalind Carter, former First Lady, Ann Ragsdale, Public Relations chairman, and George Ivey, current president, pose for a photograph at a meeting of the Buckhead Rotary. Photo courtesy of Rotary Club of Buckhead.

therapeutic riding program for disabled individuals at Chastain Horse Park. A long-time equestrian venue, the club hosted a major fund-raising event called "Rotary Round Up" in 2002.

Throughout the year, Buckhead Rotary hosts a variety of additional fund-raisers, including annual golf and tennis tournaments, to support its varied service efforts.

The President's Ball, held each February, is the club's largest benefit, which generates revenue from ticket sales and a silent auction.

Additional revenue is raised through membership dues and matching- and dou-

bling-fund programs offered by state districts and Rotary International, respectively.

In the early 1990s, the club created the Buckhead Rotary Foundation, a not-for-profit corporation to serve as the club's financial infrastructure. Net proceeds from fund-raisers, as well as contributions from wills, endowments, memorial donations, and member contributions, ensure that the generous work of Buckhead Rotary can continue.

Voted the "best all-around club" in its district in 2001-2002, Buckhead Rotary holds luncheon meetings each Monday at Anthony's Restaurant on Piedmont Road. Members are required to attend at least 40 percent of all meetings at their "home" clubs; others can be enjoyed in the camaraderie of Rotarians around the world.

"One of a member's greatest benefits is the welcome Rotarians receive at other clubs," comments Ivey. "You can travel to New Delhi, St. Petersburg, or Oslo, walk into a meeting, and you're with family. Worldwide, members share Rotary's philosophy and value system; the link that exists is amazing."

Membership in Rotary is by invitation only. However, the real emphasis, explains Ivey, is not for clubs to expand, but to charter and nurture new clubs.

Since its inception, Buckhead Rotary, with approximately 175 members, has chartered five clubs and is currently partnering in projects with its most recently chartered offspring, the Atlanta-Peachtree Rotary Club.

For Ivey, an Atlanta native who has lived in Buckhead since the age of three,

Shirley Franklin, mayor of Atlanta, visits with Buckhead Rotary President George Ivey and Past President Al Weatherly at one of the Buckhead Rotary's weekly Monday meetings. Photo courtesy of Rotary Club of Buckhead.

involvement with Rotary is a family legacy; his father was one of the club's first members.

"Participation in Rotary has been one of the most fulfilling, satisfying experiences in my life," comments Ivey, who is manager of marketing and public relations for Northside Hospital - Forsyth. "I have learned that businesspeople in the marketplace on a day-to-day basis are looking for a place to serve and to use their professional achievements to help the community.

"When people discover Rotary," Ivey continues, "they want to invest; they see the good it does and the great value that is here.

"People are seeking significance in their lives," Ivey concludes. "There is no better place to find significance than as a member of Rotary."

ROTARY CLUB OF BUCKHEAD

CHARTERED 1951

P.O. Box 12151
Atlanta, Georgia 30355
770.844.3269
www.rotaryclubofbuckhead.com

Buckhead Life Restaurant Group

Feeding the hungry—that has been the lifelong profession and passion of Pano Karatassos. Whether overseeing the day-to-day operations of the twelve restaurants, private event facility, European-style bakery, and private club he has established, or raising millions of dollars to put food on the tables of those in need, the founder and president/owner of the Buckhead Life Restaurant Group has devoted his life to nourishing people…and nourishing them well.

As a Culinary Institute of America graduate, Karatassos has built an internationally acclaimed culinary empire since opening his first restaurant in 1979. Credited with bringing a new benchmark in fine dining to Atlanta, he quickly earned the reputation of being one of the nation's premier restaurateurs.

"Running a restaurant is not one big thing," claims Karatassos, "it is a thousand little things." As such, Karatassos makes it his business to be intimately involved in the management of each establishment, using a hands-on approach to ensure that his customers—and his standards of excellence—are always satisfied.

Quality of service is only rivaled by the group's exceptional food. Insisting on only the finest ingredients, Karatassos goes to great lengths to ensure freshness, flying in fish daily, for example. This type of attention to detail is undeniably the key ingredient in the gourmet cuisine that has become Buckhead Life Restaurant Group's trademark.

Perhaps what is most unique about the group is that no two eateries are alike; each was developed with a distinctive personality. From the creative American cooking of the Buckhead Diner to the sophisticated menu of Bluepointe, the ambiance is unduplicated; only the presentation, taste, and service are remarkably consistent.

Despite his successes, Karatassos remains a humble man. This is best reflected in the compassionate work that he continues as the Atlanta chairperson for Share Our Strength (SOS) Taste of the Nation for which he has spearheaded efforts, raising more than $4.5 million in his fourteen-year involvement with the nationwide anti-hunger event.

Karatassos is also attributed with developing the first prepared food program for the nation's hungry, donating freshly made fare rather than canned goods or leftovers each week to Atlanta's Table, a city-wide, anti-hunger organization he founded. Encouraging other area restaurants to do the same, Karatassos says, "Those who make a living in the hospitality industry have a duty to give something back."

Joined in business by his two sons and his daughter, Karatassos continues to cultivate the culinary landscape of Atlanta, creating a legacy of unparalleled dining experiences in the heart of Buckhead.

Enjoy the consummate dining experience, compliments of Buckhead Life Restaurant Group. *Below, top row, from left to right,* Pano's & Paul's, Atlanta Fish Market, 103 West, Pricci, Buckhead Diner, and Chops. *Middle row, from left to right,* Lobster Bar, The Club at Chops, Veni Vidi Vici, and Buckhead Bread Company & Corner Café. *Bottom row, from left to right,* Nava, Bluepointe, and Kyma.

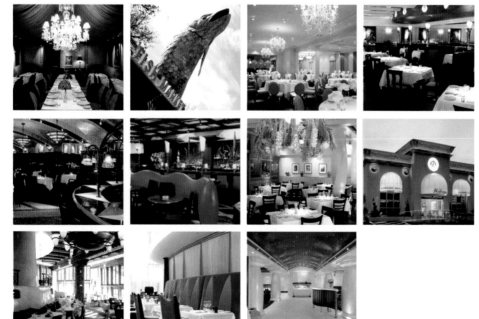

Photos courtesy of Buckhead Life Restaurant Group.

BUCKHEADLife
RestaurantGroup

265 Pharr Road
Atlanta, Georgia 30305
404.237.2060
www.buckheadrestaurants.com

Harry Norman, Realtors

Harry Norman, Realtors® "Sold" signs are a familiar sight in and around Buckhead.
Photo courtesy of Harry Norman, Realtors®.

As a leader in the residential real estate marketplace for more than seventy years, Harry Norman, Realtors® has established an unparalleled tradition of excellence in service.

Since opening the doors at its first Buckhead office in 1930, the firm has adhered to one fundamental policy: to provide knowledgeable and dedicated assistance to Atlantans at all income levels who are in the market to buy or sell a home.

Now, with more than nine hundred agents serving in eighteen offices throughout greater Atlanta and one out-of-state office in Highlands, North Carolina, Harry Norman, Realtors® makes home buying and selling an uncomplicated process by providing a comprehensive array of services.

The company's six sales offices and nearly five hundred agents in the Buckhead region ensure that the company maintains its dominance in Buckhead with a market share of more than 40 percent based on sales volume. Agents at Harry Norman, Realtors® sell more than 55 percent of the company's Buckhead area listings.

Strategic partnerships with several of Atlanta's most prestigious firms enable clients at Harry Norman, Realtors® to enjoy "one-stop shopping."

Through an alliance with the Norton Agency, the realty firm created

HN Insurance, a full-service, in-house independent agency offering personal and commercial insurance to both customers and sales associates.

Academy Financial Services, a joint venture mortgage company with Wells Fargo, provides viable financing options.

Title services are available through Heritage Title Services, LLC, another joint venture the company established with a leading Atlanta legal firm.

In addition to a property management division and a developer services division, Harry Norman, Realtors® also offers the Southeast's largest, full-service relocation department for individual, regional, and corporate moves.

Although the firm has an impressively enduring history, it is undeniably a twenty-first century company.

"The world has changed, and we've changed with it," comments Lewis Glenn, the firm's president. "In response, we have adopted state-of-the-art technological tools to assist customers in home buying and selling, which is our core business."

For example, the firm hosts an all-inclusive Internet presence, profiling each service, while offering more than twelve hundred pages of answers to real estate questions at the "Ask Harry

Norman" Web site.

Key to the abiding success of Harry Norman, Realtors® are its sales associates, who tirelessly continue the tradition of excellence established by the firm's founders.

To ensure outstanding sales associate training, pre- and post-license real estate courses are provided through the Career Development and Learning Center at the firm's School of Real Estate.

"We pride ourselves not only on how well-trained and knowledgeable our agents are," says Glenn, "but how they consistently strive to exceed client expectations.

"At Harry Norman, Realtors®," Glenn concludes, "excellence is measured by customer satisfaction and loyalty. Buyers and sellers come here because of our reputation and integrity, as well as our tradition of quality service. That's what Harry Norman, Realtors® is all about."

HARRY NORMAN,
REALTORS®
Since 1930

5229 Roswell Road
Atlanta, GA 30342
404.255.7505
www.harrynorman.com

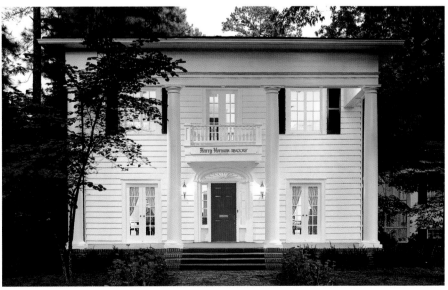

The realty firm's corporate office welcomes clients to its gracious Roswell Road location.
Photo courtesy of Harry Norman, Realtors®.

Pace Academy

Pace Academy is an exemplary environment for students to explore, connect, and excel. Established in the heart of Buckhead in 1958, the independent college preparatory school has imparted generations of Atlantans with a strong foundation in academics, leadership, service, athletics, and the arts.

With 835 students ranging from pre-first through twelfth grade, Pace Academy is the ideal size for maximizing

aesthetic, spiritual, moral, and physical capabilities that make each student a unique individual. Diversity and individuality, as well as community, cooperation, and competition are valued and promoted at Pace Academy.

Offering more than forty extracurricular activities and more than fifty athletic teams, Pace provides opportunities for achievement that are numerous and varied in scope. In 2002, for example:

Photo by L.A. Popp

finest in the Southeast, the program has earned ten state drama titles, seventeen regional play championships, and two Gold Key National Scholastic Art Awards.

At the forefront of Service Learning for more than two decades, Pace was one of the first schools in Atlanta to require forty hours of community service for graduation. Today, students contribute more than sixty-five hundred hours annually through metro Atlanta service agencies and community providers. The Service Learning Program has earned numerous national awards, and in 2002, the Atlanta Community Food Bank named Pace Academy "School of the Year."

While Pace Academy is steeped in tradition, exciting changes are underway. In 2000 Pace dedicated the Inman Center, a multi-purpose student activity facility housing the athletic departments and basketball court, the bookstore, and the college counseling and deans' offices. A state-of-the-art middle school, uniquely tailored to foster learning among sixth- through eighth-grade adolescents, is scheduled to open in 2004.

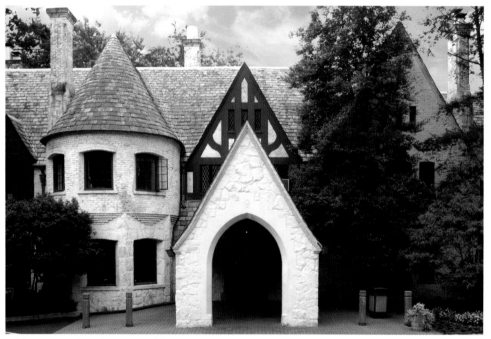

With 835 pre-first through twelfth grade students, Buckhead's renowned Pace Academy is the ideal size for maximizing academic, extracurricular and interpersonal development.
Photo by Patrick Kelly.

academic, extracurricular, and interpersonal development. The student-teacher ratio is ten to one, and class sizes average fifteen students. The school provides a warm and caring, yet stimulating environment; students are nurtured yet challenged to explore their world, connect with the greater community, and excel beyond perceived limitations. Pace Academy's students and faculty live by the school motto, "To have the courage to strive for excellence."

Because of its ideal size, faculty members truly know Pace students and their families. The teachers are committed to ushering students through all critical stages of child development—the totality of intellectual, emotional,

- The Pace Debate team won the national high school debate championship and was the only undefeated team in the thirty-one-year history of the Tournament of Champions. Pace debaters have also captured the state title for fifteen consecutive years.
- More than 40 percent of juniors and seniors taking Advanced Placement exams were named AP scholars.
- Of the eighty-three members of the class of 2002, ten were National Merit finalists and fourteen were Commended Scholars.
- Nineteen of twenty varsity athletic teams reached the state playoffs.

Also notable is the school's Fine Arts Program. Recognized as one of the

PACE ACADEMY

966 West Paces Ferry Road, NW Atlanta, Georgia 30327 404.262.1345 www.paceacademy.org

Grand Hyatt Atlanta

Majestically situated in the heart of Buckhead is a magnificent hotel that has earned the distinction of being one of the "Top 100 Hotels in the U.S." on *Condé Nast* Magazine's Gold List in 1999 and has been rated among the "Top 50 Hotels in the U.S." in the 1998 Zagat survey.

It is celebrated because it is the city's only hotel that features an authentic Japanese garden bordering a three-floor waterfall that gently cascades into a colorful, out-of-door fish pool, providing fascinating views from the lush, second-floor lobby or the lavish, first-floor restaurant.

It is unique because it is also Atlanta's only luxury hotel with an outdoor pool and sundeck.

It is unparalleled because of its steadfast commitment to providing the utmost in personalized service.

It is Grand Hyatt Atlanta.

Originally constructed in 1990, the hotel became part of the Hyatt tradition of excellence in 1997.

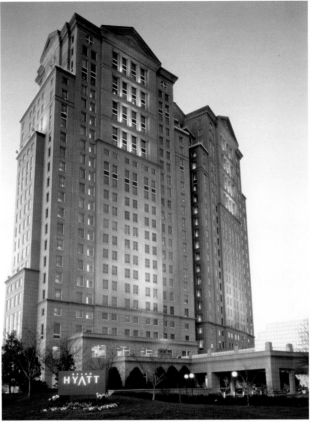

Photo courtesy of Grand Hyatt Atlanta.

An authentic Japanese garden is one of the hallmarks of Grand Hyatt Atlanta.
Photo by L.A. Popp.

To ensure that the hotel's credo of appointing "exceptional people who create exceptional experiences" is satisfied, the 325 staff members at the Grand Hyatt Atlanta undergo extensive quality assurance training.

"Our staff goes above and beyond guest expectations," comments Michele Oberst, director of sales and marketing. "We pride ourselves on being No. 1 in service."

To enhance the Grand Hyatt Atlanta experience, a $5.6 million guest room renovation was completed in 2001. From fixtures and furnishings to wall coverings and carpeting, each of the 438 rooms—including the hotel's twenty spacious suites—was transformed to provide ultimate away-from-home accommodations.

Renowned for its extensive array of personal amenities, Grand Hyatt Atlanta offers complimentary use of the hotel's fitness center, with state-of-the-art cardiovascular and strength training equipment, as well as his-and-hers saunas and steam rooms. Guests can also indulge in twenty-four-hour room service, a daily massage, or gratis car service within two miles of the hotel.

Continental cuisine can be enjoyed at Cassis, the hotel's picturesque restaurant overlooking the waterfall. Especially noteworthy is Sunday's "Jazz Flavors Brunch," featuring a tantalizing menu of smoked scallops, caviar, pasta, eggs, and more, complemented by live jazz performances.

Locals and travelers alike gather in the hotel's Lobby Lounge, where choice libations are amiably served, premium cigars are savored, and mesmerizing views of the waterfall are enjoyed.

Celebrations and corporate functions are graciously accommodated. There are twenty thousand square feet of meeting and banquet space, including two striking ballrooms. Three outdoor terraces provide exquisite settings for weddings, luncheons, and receptions for up to 150 guests. Sixteen meeting rooms, including three boardrooms, create the ideal setting in which to conduct business.

With convenient access to the city's premier dining, entertainment, and shopping venues, Grand Hyatt Atlanta is, indeed, one of the city's most prestigious hotels.

3300 Peachtree Rd, NE
Atlanta, GA 30305
404.365.8100
Toll-free reservations:
1.800.233.1234
www.hyatt.com

Christ the King School

Christ the King School shares its campus with the magnificent Cathedral of Christ the King. Photo by L.A. Popp.

Since 1937 Christ the King School has remained faithful to its mission "to inspire a love of learning and to prepare students for active participation in, and contributions to, the Church and wider community."

With class sizes limited to twenty-two students, Christ the King School offers a traditional K-5 program, as well as a sixth through eighth grade middle school program.

The recently restored d'Youville convent chapel is a peaceful setting for Christ the King School's prayer services and liturgies. Photo by Patrick Kelly.

Learning in a Christ-centered environment, the school's 540 students are presented with an academic program that incorporates recent advances in the core disciplines and new technologies, while fostering independence and responsibility through intellectual, emotional, social, physical, and spiritual growth.

All students receive daily instruction in the Catholic faith and participate in beautiful school and class masses, prayer services, and liturgies.

Community involvement is stressed through school-wide and grade-level goodwill service projects. Students gain first-hand involvement in experiencing the value of Christian service to others.

Committed to growth and change, the school recently completed a major, three-year building and renovation project. Improvements included restoration of the lovely d'Youville convent chapel, once used for daily mass by the Grey Nuns of the Sacred Heart who staffed the school from 1937 until 1990. Forever dear to the hearts of parishioners and students, the chapel continues to embrace baptisms, weddings, anniversaries, class masses, liturgies, and private prayer.

In addition to the construction of a graceful, welcoming entrance plaza and reception area, the project added eight new classrooms, a state-of-the-art science lab, and a new media center. Renovations and upgrades addressed all existing spaces, and created learning areas for tutoring and small groups. An additional "kindertech" computer lab was created in 2001

through the generosity of an anonymous donor, offering the school's youngest students an opportunity to reinforce developmental learning skills through technology.

The playground was redesigned to include shade, green spaces, picnic tables, and new equipment for the youngest set.

The Cathedral's construction project provided the school with three of the eight new classrooms, a new media center, and a second story to the breezeway.

At Christ the King School, creating the optimal learning environment is a priority. "We view education as a collaborative effort," comments Peggy Warner, the school's principal since 1989. "The supportive and cooperative spirit that exists between the school, our families, and our Cathedral parish underscores the strength and success of Catholic education at Christ the King."

With this enduring sustenance, Christ the King School continues its legacy of effectively integrating academic excellence with the historic principles of Catholic education.

In an era when education is a prime concern in our nation, our communities, and our families, the students of "CKS" continue to be nurtured within a loving school community and to learn in a program that fosters Catholic/Christian values and a desire to do one's best.

46 Peachtree Way, NE
Atlanta, GA 30305
404.233.0383
www.christking.org

Jenny Pruitt & Associates, REALTORS

"Service beyond belief in every step of home buying" is the axiom by which business is conducted at Jenny Pruitt & Associates, one of Atlanta's premier residential real estate companies.

Representing more than 1,500 years of real estate experience, the company's 370 sales associates and 75-member support staff have brought buyers and sellers together locally, regionally, nationally, and globally to more than $7.3 billion in sales since the company's inception in 1988.

As founder, president, and CEO, Jenny Pruitt credits longstanding "values of honesty, credibility, integrity, and commitment to excellence" for the company's phenomenal success.

"Our positive reputation in the community has been earned by the character and quality of our sales associates," observes Pruitt, who had impressive achievements in Atlanta's real estate industry prior to launching her own firm.

The company's Career Development division provides the educational training that has helped Pruitt's sales associates excel. Intensive instruction for new and veteran sales agents is offered, as well as mentoring programs, advanced seminars, and weekly training sessions.

Of special interest is the "eAgent certification" program, a twelve-week course that focuses on mastery of today's technology.

"Our company's commitment to new and relevant technology enhances the customer's experience in finding the perfect home," says Pruitt.

In addition to a comprehensive Internet site that is updated several times daily, the firm offers a wireless version of its site that is easily accessed via Web-enabled mobile phones and handheld devices, providing complete specifications—and images—of thirty-six thousand Atlanta-area homes, including the firm's own listings and those found in the First Multiple Listing Service.

To further enhance the customer's experience, the company provides personal and business insurance through Jenny Pruitt Insurance Services, as well as title and mortgage services, which are offered through joint ventures established with McCalla, Raymer, Padrick, Cobb, Nichols & Clark, LLC, and Wells Fargo Home Mortgage, respectively.

Corporate relocation, international relocation assistance, a new homes division, and a seniors real estate division—

Jenny Pruitt is founder, president, and CEO of the realty firm that bears her name.
Photo courtesy of Jenny Pruitt & Associates, REALTORS.

the first of its kind in Atlanta—complete the spectrum of personalized services.

The company, which has four sales offices and one corporate office in metro Atlanta, also maintains the city's exclusive affiliation with Christie's Great Estates, as well as other notable relationships with RELO, the Registry of Real Estate Brokers, and Who's Who in Luxury Real Estate, among others.

In October 2001, HomeServices of America, Inc., the second-largest, full-service independent residential real estate brokerage firm in the country, purchased the company, establishing a nationwide network of real estate expertise at Jenny Pruitt & Associates to promote "continued and positive growth."

"Each person in our organization," Pruitt summarizes, "contributes to creating the best experience possible for clients buying and selling homes in metro Atlanta."

JENNY PRUITT
&
ASSOCIATES
R E A L T O R S®

990 Hammond Drive • Suite 300
Atlanta, GA 30328
770.394.5400
www.jennypruitt.com

Jenny Pruitt's sales associates are well-versed in today's cutting-edge technology, thanks to the eAgent certification program offered at the firm. Photo courtesy of Jenny Pruitt & Associates, REALTORS.

Second-Ponce de Leon Baptist Church

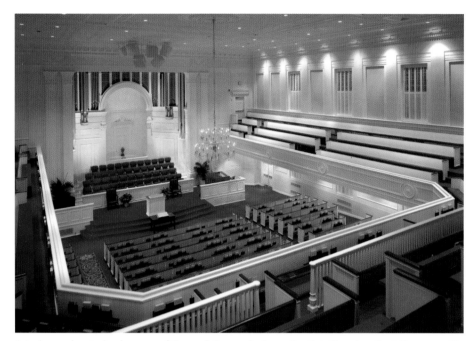

Interior and exterior images of Second Ponce-de Leon Baptist Church reflect the magnificence of this beloved Buckhead landmark.
Photo at left by Harrison Northcutt Architectural Photography; photo at right by Bita Honarvar.

Each year November 20 marks a commemorative occasion in the life of Second-Ponce de Leon Baptist Church.

It was on this day in 1932 that the congregations of the Ponce de Leon Avenue Baptist Church and downtown Atlanta's Second Baptist Church united as one.

While initially motivated by the economic strains of the Great Depression, the merger resulted in the establishment of an important and influential Buckhead institution and, more importantly, a dynamic Christian fellowship.

In an era when America's churches are challenged by declining attendance, Second-Ponce de Leon Baptist Church, with approximately thirty-four hundred members, is poised for the future.

David Sapp, who has served as senior pastor for four years, attributes the church's congregational strength to two key factors. "We offer innovative programming that seeks to meet its members' needs, while hosting numerous outreach programs, which effectively open avenues for new members."

In addition to offering traditional, contemporary, and evening worship services, the church provides abundant opportunities to walk in faith through its various senior adult, prayer, Bible study, music, youth, and children's ministries.

Especially noteworthy is the church's Early Childhood School, a weekday preschool education program that provides a Christian-centered learning experience for children from infancy through six years of age.

One of the church's most success-ful outreach programs is its Family Life Center, an all-inclusive recreational facility that provides opportunities for physical, mental, social, and spiritual growth for church members and nonmembers alike.

The state-of-the-art center features a swimming pool, a gymnasium, saunas and steam rooms, racquetball courts, an indoor track, a weight room, a cardio center, and a game room.

In addition to an extensive array of seminars and health screenings, classes and programs for tots to seniors are offered at the center.

"Second-Ponce de Leon Baptist Church has had a strong voice in Atlanta for a long period of time," states Sapp; "its enduring quality is both unusual and remarkable."

Currently in the midst of a $12 million renovation, the church is readying the facilities for the future.

"Important things are unfolding as we redefine our identity for the future," says Sapp. "As Buckhead's demographics continue to change, we remain committed to extending our ministries to whomever comes our way."

Second-Ponce de Leon Baptist Church is, indeed, a sanctuary for those who wish to be welcomed into this prolific community of faith.

SECOND
PONCE
DE LEON
BAPTIST
CHURCH

2715 Peachtree Road, NE
Atlanta, Georgia 30305
404.266.8111
www.spdl.org

Blue Cross Blue Shield of Georgia

Within the state of Georgia, there is a company that has diligently championed quality, affordable health care services since the 1930s.

More than 2.1 million members have, in fact, entrusted the health and wellness of their loved ones to this company that bears a familiar and respected name: Blue Cross Blue Shield of Georgia.

Blue Cross Blue Shield of Georgia provides a comprehensive continuum of product and coverage options designed to meet the health care needs of individuals, small groups, large groups, and senior citizens.

Among the health insurance company's affiliates are Blue Cross and Blue Shield Healthcare Plan of Georgia, Inc., a health maintenance organization; Group Benefits of Georgia, Inc., a general insurance agency; and Greater Georgia Life Insurance Company, a life insurer.

Allied with one of the state's most extensive networks of professionals and health care facilities, Blue Cross Blue Shield of Georgia also provides members with an array of specialty products, including dental and vision coverage; life and disability insurance; pharmacy benefit management; behavioral health services; utilization management; flexible spending accounts; and COBRA administration.

Employing approximately three thousand full-time associates throughout the state, Blue Cross Blue Shield of Georgia has earned an enduring reputation for providing unrivaled customer support. Member satisfaction, along with flexibility of choice, quality products and services, and consistent financial performance are the company's key corporate goals.

As Blue Cross Blue Shield of Georgia continues to promote quality care through its Healthcare Quality Assurance Division, members of the state's largest health care provider are offered unparalleled choices within a wide range of innovative and progressive products and services that the company has introduced to enhance the health status of all Georgians.

"Our brand name says it all," comments Charlie Harman, vice president for Public Affairs, who was born and raised in Buckhead. "We are committed to products, services, and networks that put our members first. We are also particularly proud of the extensive network of dedicated physicians and excellent hospitals with which Blue Cross Blue Shield of Georgia is associated."

Most importantly, the company is committed to providing health security for its members through access to affordable, high-quality services, a policy that is especially reassuring in a market that is continually challenged by escalating costs.

"Our members," Harman concludes, "can rely on us."

**3350 Peachtree Road
Atlanta, Georgia 30326
404.842.8000
www.bcbsga.com**

Becky Kapustay serves as president and CEO of Blue Cross Blue Shield of Georgia.
Photo courtesy of Blue Cross Blue Shield of Georgia.

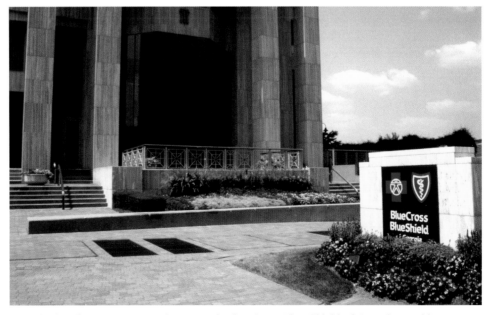

From its headquarters on Peachtree Road, Blue Cross Blue Shield of Georgia provides high-quality, affordable health care services to more than 2.1 million members.
Photo by L.A. Popp.

Wachovia

On April 16, 2001, First Union and Wachovia Corporations announced their intentions to merge into one company. Chairman L.M. "Bud" Baker and CEO G. Kennedy Thompson both expressed their belief that this new company, to be called Wachovia, would be better than either organization had been alone.

Today Wachovia is the fourth largest banking company in the United States, with $320 billion in assets. It is a leading provider of brokerage, investment banking, retail, small business, and commercial financial services to twenty million retail and corporate customers along the East Coast and throughout the nation. The company operates full-service banking offices in eleven East Coast states, from Connecticut to Florida, as well as in Washington, D.C.

In Atlanta, Wachovia offers more than 150 financial centers and 450 ATMs to satisfy its customers' banking needs. Wachovia boasts the No. 1 market share in Atlanta and has a workforce of 3,500 in the city. Signs featuring the new Wachovia logo appeared for the first time in Georgia in February of 2003.

In 2001 First Union and Wachovia Corporations merged, creating a new banking company called Wachovia, which now has eight Buckhead area branches.
Photo by L.A. Popp.

Though its name has only been in Atlanta since 1989, Wachovia can trace its roots in the city back to the Civil War. In 1865 General Alfred Austell formed Wachovia's predecessor, Atlanta National Bank, at the conclusion of the war. Upon merging with Fourth National Bank in 1929, Atlanta National changed its name to First National Bank of Atlanta. At the time of the merger, First National's net worth was $58 million, making it the largest financial institution south of Philadelphia.

First National has been a part of the Buckhead community since 1954. The branch existed across the street from the Peachtree United Methodist Church for forty years. It remained when Sears Roebuck bought the land and replaced the building in 1965 and when Wachovia and First National merged in 1985. It even remained when First National officially changed its name to Wachovia in 1989. Finally in 1994, the two-story Pharr Road branch was built around the corner, where it now stands. This Buckhead branch continues to be one of the most important branches throughout Georgia for First National and Wachovia. In the 1990s, it was the No. 1 branch in the Wachovia system by deposits and loans.

Through its merger with First Union, Wachovia now has eight branches in the Buckhead area, including the Pharr Road branch and the First Union branch at the corner of Piedmont and Peachtree Streets.

Wachovia ongoing commitment to enriching Georgia's neighborhoods and educational systems has been strong and sustainable. Whether it is through encouraging employees to read aloud and donate books to elementary school classrooms, contributing financial support to local organizations, providing volunteer leadership to local boards, or committing to community development projects, Wachovia is dedicated to building vibrant communities.

As the United States' fourth largest banking company, Wachovia serves twenty million retail and corporate customers nationwide, with a concentration in eleven East Coast states and Washington, D.C. Photo by Patrick Kelly.

Wachovia recently received "outstanding" ratings for Community Reinvestment Act lending in Georgia from the OCC, the federal agency that regulates banks.

Wachovia is proud of its leading position in Atlanta philanthropy. Wachovia and its Wachovia Foundation donated approximately $3.75 million to Atlanta in 2001. Included among these donations are gifts to the United Way, the Peachtree Road Race, and the Woodruff Arts Center. Wachovia is also trustee to millions of dollars more in managed foundation grants to local Atlanta charities and organizations every year.

"We will continue to partner with the Atlanta community in an effort to be a great corporate citizen for the city and state," says Hugh Long, regional president of Wachovia in Atlanta. "By providing exceptional and trustworthy service, Wachovia wants to help Buckhead and Atlanta residents achieve their personal financial goals."

WACHOVIA

www.wachovia.com

partners in progress index

Atlanta International School **Pages 194-195**
2890 North Fulton Drive • Atlanta, GA 30305
Phone: 404.841.3840 • Fax: 404.841-3873
Web site: www.aischool.org • E-mail: info@aischool.org

BCD Holdings **Pages 158-165**
Paran Place • Suite 20 • 2060 Mount Paran Road, NW • Atlanta, GA 30327
Phone: 404.264.1000 • Fax: 404.364.0477

CornerstoneBank **Page 165**
2060 Mt. Paran Road, NW • Suite 100 • Atlanta, Georgia 30327
Phone: 404.601.1250 • Fax: 404.601.1251
Web site: www.cornerstonebankga.com
E-Mail: customerservice@cornerstonebankga.com

Noro Management **Pages 162-163**
104 Interstate North Parkway East, SE • Atlanta, GA 30339
Phone: 678.589.9500 • Fax: 770.984.9810
Web site: www.noromgt.com • E-Mail: noro@noromgt.com

Park 'N Fly **Page 160**
Paran Place • Suite 207 • 2060 Mount Paran Road, NW • Atlanta, GA 30327
Phone: 404.264.1000 • Fax: 404.264.1155
Web site: www.pnf.com • E-Mail: park@pnf.com

Primary Capital **Pages 164-165**
Paran Place • Suite 101 • 2060 Mount Paran Road, NW • Atlanta, GA 30327
Phone: 404.365.9300 • Fax: 404.266.1448
Web site: www.primarycapital.com • E-Mail: info@primarycapital.com

TRX, Inc. **Page 161**
6 West Druid Hills Drive • Atlanta, GA 30329
Phone: 404.929.6100 • Fax: 404.929.6146
Web site: www.trx.com • E-Mail: marketing@trx.com

WorldTravel BTI **Pages 159-160**
1055 Lenox Park Boulevard • Suite 420 • Atlanta, GA 30319
Phone: 404.841.6600 • Fax: 404.814.2983

Blue Cross Blue Shield of Georgia **Page 205**
3350 Peachtree Road • Atlanta, GA 30326
Phone: 404.842.8000 • Web site: www.bcbsga.com

Buckhead Coalition **Pages 166-169**
Tower Place 100 • Suite 560 • 3340 Peachtree Road, NE
Atlanta, Georgia 30326-1059 • Phone: 404.233.2228
Toll Free: 800.935.2228 • Fax: 404.812.8222

Buckhead Life Restaurant Group **Page 198**
265 Pharr Road • Atlanta, GA 30305 • Phone: 404.237.2060
Fax: 404.237.2160 • Web site: www.buckheadrestaurants.com

Carter's **Pages 174-177**
Corporate Offices • 1170 Peachtree Street • Suite 900 • Atlanta, GA 30309
Phone: 404.745.2700 • Fax: 404.892.0968 • Web site: www.carters.com

Christ the King School **Page 202**
46 Peachtree Way, NE • Atlanta, GA 30305 • Phone: 404.233.0383
Fax: 404.266-0704 • Web site: www.christking.org

Georgia Power **Pages 184-185**
241 Ralph McGill Boulevard • Atlanta, GA 30308
Phone: 404.506.6526 • Web site: www.georgiapower.com

**Goldstein, Garber, Salama & Beaudreau
Team Atlanta Esthetic Dentistry** **Pages 178-181**
1218 West Paces Ferry Road • Suite 200 • Atlanta, GA 30327
Phone: 404.261.4941 • Fax: 404.261.4946
Web site: www.goldsteingarber.com • www.teamatlanta.com
E-mail: goldsteingarber@goldsteingarber.com

Grand Hyatt Atlanta **Page 201**
3300 Peachtree Road, NE • Atlanta, GA 30305
Phone: 404.365.8100 • Toll-Free Reservations: 1.800.233.1234
Fax: 404.364.3888 • Web site: www.hyatt.com

Harry Norman, Realtors® **Page 199**
5229 Roswell Road • Atlanta, GA 30342 • Phone: 404.255.7505
Fax: 404.256.1704 • Web site: www.harrynorman.com

The Heiskell School **Pages 192-193**
3260 Northside Drive, NW • Atlanta, GA 30305 • Phone: 404.262.2233
Fax: 404.262.2575 • Web site: www.heiskell.net
E-Mail: writeus@heiskell.net

Jenny Pruitt & Associates, REALTORS **Page 203**
990 Hammond Drive • Suite 300 • Atlanta, GA 30328
Phone: 770.394.5400 • Fax: 770.399.3022
Web site: www.jennypruitt.com • E-mail: corporate@jennypruitt.com

Lenox Square **Page 188**
3393 Peachtree Road, NE • Atlanta, GA 30326 • Phone: 404.233.6767
Fax: 404.233.7868 • Web site: www.lenoxsquare.com

Pace Academy **Page 200**
966 West Paces Ferry Road, NW • Atlanta, GA 30327
Phone: 404.262.1345 • Fax: 404.264.9376 • Web site: www.paceacademy.org

Phipps Plaza **Page 189**
3500 Peachtree Road, NE • Suite E-11 • Atlanta, GA 30326
Phone: 404.262.0992 • Fax: 404.264.9528 • Web site: www.phippsplaza.com

Piedmont Medical Center **Pages 170-173**
1968 Peachtree Road, NW • Atlanta, GA 30309
Phone: 404.605.5000 • Web site: www.piedmonthospital.org

PricewaterhouseCoopers **Pages 190-191**
10 Tenth Street • Suite 1400 • Atlanta, GA 30309
Phone: 678.419.1000 • Fax: 678.419.1239 • Web site: www.pwcglobal.com

Regent Partners **Pages 182-183**
3348 Peachtree Road, NE • Tower Place • Suite 1000 • Atlanta, GA 30326
Phone: 404.364.1400 • Fax: 404.364.1420 • Web site: www.regentpartners.com

Reliance Financial Corporation **Pages 186-187**
3384 Peachtree Road, NE • Suite 900 • Atlanta, GA 30326
Phone: 404.266.0663 • 1.800.749.0752 • Fax: 404.261.5715
Web site: www.relico.com • E-Mail: Kedwards@relico.com

Rotary Club of Buckhead **Pages 196-197**
P.O. Box 12151 • Atlanta, GA 30355 • Phone: 770.844.3269
Fax: 770.844.3227 • Web site: www.rotaryclubofbuckhead.com
E-Mail: president@buckheadrotary.com

Second-Ponce de Leon Baptist Church **Page 204**
2715 Peachtree Road, NE • Atlanta, GA 30305 • Phone: 404.266.8111
Fax: 404.261.6593 • Web site: www.spdl.org

Wachovia **Page 206**

Belle Isle • 4969 Roswell Road • Suite 250 • Atlanta, GA 30342
404.865.4920

Brookhaven • 3890 Peachtree Road • Atlanta, GA 30319
404.865.3470

Buckhead Piedmont • 3235 Peachtree Road, NE • Atlanta, GA 30305
404.865.4620

Buckhead • 31 Pharr Road, NW • Atlanta, GA 30305 • 404.842.2894

Buckhead Loop • 3465 Buckhead Loop • Atlanta, GA 30326
404.995.8740

Roswell-Wieuca • 4454 Roswell Road, NE • Atlanta, GA 30342
404.851.2960

West Paces Ferry • 3393 Northside Parkway, NW • Atlanta, GA 30327
404.841.1900

The Forum • 3290 Northside Parkway • Suite 100 • Atlanta, GA 30327
404.233.0670

Web site: www.wachovia.com

index

Symbols

1996 Olympics 41
2300 Peachtree Road 111, 119
2500 Peachtree 25

A

"Atlanta's Table" 97, 103
AAA 54, 56
Ace Hardware 117
ADA Act 94
Albrecht, Paul 126, 128
Alhambra Apartments 27
Allen, J.P. 8
Allen, Mayor Ivan, Jr. 8
Alliance Center 151
AMC Buckhead Backlot Cinema & Cafe 143
Americans with Disabilities Act 94, 95
American Cancer Society 97
American College of Physicians 94
American Institute of Architects 97
American InterContinental University 64, 69
American Society of Internal Medicine 94
Andrews Square 115
Annie's Thai Castle 132
Ansley Park 8
Antonio Raimo Galleries 37
Arthritis Foundation 97, 101
Atlanta Athletic Club 105
Atlanta Auto Spa 53
Atlanta Ballet Centre for Dance Education 47, 70
Atlanta Braves 95
Atlanta City Council 13
Atlanta Community Food Bank 97, 103
Atlanta Community Ministries 82
Atlanta Falcons 62, 95
Atlanta Financial Center 48, 50, 53, 65, 69, 153
Atlanta Fish Market 38, 126, 127
Atlanta Girls' School 70
Atlanta Hawks 95
Atlanta Historical Society 38
Atlanta History Center 8, 10, 12, 13, 15, 17, 19, 34, 38, 41
Atlanta History Museum 38, 41, 46
Atlanta International School 67, 77
Atlanta Journal 128
Atlanta Memorial Park 15
Atlanta Metro Plan 154
Atlanta Paralympic Games 95
Atlanta Pub Crawl 124
Atlanta Regional Commission 9, 12
Atlanta Speech School 76, 92, 97
Atlanta Speech School Fun Run 97
Atlanta Sympony Associates 100
Atlanta Symphony Orchestra 72, 97, 100
Atlanta Track Club 98
Atlas 39
Aunt Charley's 128
Australia 67

B

B.B. King 129

B52's 129
Bank of America 117
Barnard, Susan Kessler. 16
Battle of Peachtree Creek 15, 18
Bauder College 69, 115
BCD Holdings 54, 55
BellSouth 9, 53
BellSouth Corporation 154
Bennett Street 37, 69, 112
Bennett Street, NW 74
Beverly Hall Furniture Galleries 122
"Beverly Hills of the East" 12
"Beverly Hills of the South" 12
Bitsy Grant Tennis Center 42
Blain, Randy 39, 127
Blessed Trinity 88
Bluepointe 126
Blue Cross Blue Shield of Georgia 54, 59
Bobby Jones Golf Course 42
Bolling Way 128, 131, 140
Bolton, Michael 124, 129, 147
Bones 126
Boxwood Gardens & Gifts 114
Bradbury, A. Thomas 42
Brentwood 24
Bridgetown Grill 139
Broad Street 38
Brookhaven 20, 24
Brookhaven Buckhead Flowers 117
Brookwood Hills 24
Brookwood Square 112
Bryan, Margaret 8
Buckhead/Vinings Relay for Life 97
Buckhead: A Place For All Time 16
Buckhead's East Village 120
Buckhead's West Village 114
Buckhead Art Crawl 104
Buckhead Athletic Club 53
Buckhead Avenue 13, 128
Buckhead Baptist Church 70, 86
Buckhead Business Association 51, 55, 104
Buckhead Christian Ministry 96
Buckhead Coalition 9, 12, 14, 50, 51, 55, 150, 152, 156
Buckhead Coalition Buckhead Guide Book 54
Buckhead Community Fellowship 86
Buckhead Farmers Market 19
Buckhead Life Restaurant Group 54, 92, 97, 103, 124, 126, 127, 129, 135, 136
Buckhead Loop 29
Buckhead Park 38
Buckhead Plaza 8, 50
Buckhead Saloon 134, 140
Buckhead Theatre 8
Buckhead Village 22, 128, 131, 136, 143, 150, 156
Buckhead West Village 112
Bungalows 19
Burberry 8
Burns, Helen 113

C

"Congregation of Brotherly Love" 80
Café Tu Tu Tango 39

Capital Grille 124
Carlos McGee's 128
Carl E. Sanders Family YMCA 45
Carsen Lane 29
Carter's 156
Cartier 8
Cathedral Antiques Show 102
Cathedral of Christ the King 66, 67, 78, 82, 83, 84
Cathedral of St. Philip 78, 97
Catholic Cathedral of the Archdiocese for North Georgia 82, 84
Chapter 11 117
Chastain Bulls 34
Chastain Horse Park 43
Chastain Memorial Park 42
Chastain Park 20, 30, 34, 43, 66, 67, 97, 98, 124, 145, 147
Chastain Park Amphitheater 129
Chastain Square Shopping Center 70
Chattahoochee River 15, 69
Cherokee Indians 15
Cherokee Road 20
Cherokee Street 24
Cherokee Town and Country Club 8, 42
Chick-Fil-A 132
Chops 124, 126, 135
Christian Scientists 80
Christian Scientist Reading Room 86
Christ the King School 25, 66, 67
Chubb Group Insurance 53
Citysearch 143
Civil Rights 41
Civil War 13, 15, 18, 22, 38, 41, 46
Cobb County line 12
Coca-Cola Company 53
Coca-Cola Roxy Theater 129, 131
Collier family 24
Colonial-Revival homes 24
Colonial estates 22
Community Improvement District 156
Concert Southern Promotions 129
Confederate soldiers 13, 15, 18
Congregation Avahath Achim 80
Conlon, Peter 129
Cooley, Alex 129
Copelands 56
Cosmetic dentistry 53
Cottongim Seed Company 38
Country Club 24
Covenant Presbyterian Church 84
Coyote Ugly 134
Craftsman homes 24
Christian Science Monitor 86
Crohn's & Colitis Foundation's Walk-a-Thon 97
Crohn's & Colitis Foundation of America 97, 98, 105
Crook, Buck 3
Crowne Plaza Atlanta Buckhead 53, 145
Crunch Fitness 45
Crystal Ball 97, 101
Cystic Fibrosis Foundation 97, 100
C Lighting 114

D

Dallas, Texas 144
Dancers II 72
Dante 126
Dante's Down the Hatch 126
Davison's Department Store 108
Dean Witter Reynolds 53
Decorators' Show House 100
DeKalb County 38
DeKalb County line 12
Denver 115
Denver, Colorado 94
Design Place 123
Downtown Atlanta 50, 51, 80, 82
Down the Fairway with Bobby Jones 41
Dress for Success "Clean Your Closet
 Week" 97

E

"Emperors of Soul" 147
E. Rivers Elementary School 73
East Andrews Drive 114
East Coast 6, 10
East Paces Ferry Road 34, 48, 70, 114, 116,
 120, 128
East Shadowlawn Avenue 72
East Village 128
East Wesley 82, 83
Eclipse di Luna 112
Edaw, Inc. 152, 153
Edward R. Loveland Memorial Award 94
Einstein, Albert 70
Embassy Suites 53
Emerald City 50
Emergency 9-1-1 Cellular Telephone
 Call Boxes 150
Emory Marketing Association 51
Emory University 96
English Classical-style homes 38
English Cottage homes 24
English Country-style homes 42
Episcopalian church 78
Episcopalian congregation 82
ESPN Zone 126, 141
Esthetic dentistry 53
Eucharistic Celebration of Christ
 the King Parish 83

F

Federal Period furniture 42
Fidelity National 62
Five Points 15
Fogo De Chao 144
Fountain Oaks 119
Fourth of July 95, 98, 109, 111, 113
France 122
French Gothic architecture 78, 82
French Quarter 128
Frohsin's 8
Fulton County 96
Fulton County Alms House 67

G

Gallery Row 36
Galloway, Elliott 67
Galloway School 67
Galyan's 112
Garden Hills 8, 24, 67
Garden Hills Elementary School 72
General Sherman 16, 38
Georgian estates 22
Georgia 400 24, 50, 59, 153
Georgia Academy of Music 70
Georgia Department of Transportation 9
Georgia House of Representatives 12
Georgia State University 51
Georgia Tennis Hall of Fame 42
Gilmer Street 80
Glenn, Lewis 55
GNC 119
Goldstein, Ronald 53
Goldstein, Garber, Salama & Beaudreau 53
Gone with the Wind 41
Goodrum House 43
Good Ol Days 128
Governor's Mansion 24, 42
Grand Hyatt Atlanta 53, 56, 97, 152
Greek Revival-style estates 22, 42
Grey Nuns of the Sacred Heart 66
Gucci 8
Gymboree 119

H

Habersham Street 24
Habitat for Humanity 82
Harper, Lee 72
Harrison's 128
Harry Norman, Realtors® 55, 61
Hart's 8
Heiskell, Jim Jr. 12
Henderson, Ross 98
Henri's Bakery 143
Heritage 150
High Museum of Art 97
Holy Spirit Catholic Church 88
Horseradish Grill 145
Houston's Restaurant 144
Howell Mill Road, NW 77
Hudspeth, Ron 128

I

IBM Corp. 54
IB diploma 67
Ichiyo Arts Center 70
Ida Williams Library 13
IMAGE Film and Video Center 112
Inc. Magazine 9
Independence Day 109, 111, 113
inlingua International 76
inlingua Language Training Center 76
Inman, Edward and Emily 38
International Baccalaureate program 67, 77
Interstates 75 12
Interstate 285 50
Interstate 85 12, 50
Irby, Henry 15, 16, 80, 129

Irby's Tavern 15
Irbyville 15
Irby Avenue 143
Italian-style homes 38
Italianate estates 22

J

J. Walter Thompson 53
Jane J. Marsden Interiors & Antiques 119
Jehovah's Witnesses 80, 90
Jenny Pruitt & Associates, REALTORS 8
"Jewel in Atlanta's Crown" 12
Jewish community 80
Jewish synagogue 80
Johnny's Sidedoor 136
Jones, Bobby 44
Jones, Robert Tyre "Bobby," Jr. 41
JW Marriott Lenox Hotel 54

K

Karatassos, Pano 92, 97, 103, 126, 128, 129
Kaiser Permanente 53
Kaplan Educational Center 70
Kings 117
Kroger 119
Kurtz, Wilbur 15
Kyma 129

L

Lakeview Avenue 19
Land Rover Buckhead 116
Lee Harper & Dancers 72
Lee Harper Dance Studios 70
Lenox Marketplace 112
Lenox MARTA station 154
Lenox Road 54, 108, 111, 144, 151
Lenox Road, NE 76
Lenox Square 8, 10, 24, 50, 52, 53, 54, 57, 61,
 97, 108, 109, 113, 153, 155
Lindbergh-Piedmont 150
Lindbergh MARTA Station 152, 154
Living Water Ministry 86
Lord & Taylor 55, 110, 111
Lovett School 69

M

"Making a Case for Reading" 105
Macy's 55, 108
Maggiano's Little Italy 126, 132
Maggiano's Bakery 132
Making Strides Against Breast Cancer Walk 97
Mako's 136, 141
March to the Sea 46
Mardi Gras 136
Mardi Gras North 128
Marriott 53, 54
Marsden, Jane 111
MARTA 50, 54, 111, 154
Martin Dawe 127
Massell, Sam 9, 12, 13, 14, 50
Mathieson Drive 85
Mathieson Exchange Lofts 31

Mayor, City of Atlanta 14
MBA programs 74
McDuffie Building 13
Medical College of Georgia 96
Melissa Sweet Bridal Collection 115
Merrill Lynch 53
Metropolitan Pizza 140
Metropolitan Atlanta Rapid Transit Authority 50
Metropolitan Frontiers: Atlanta, 1835-2000 38
Miami Circle 37, 112, 122, 123
Miami Window Co 123
Milan 145
Mobil 54, 56
Monarch Court 105
Monarch Plaza 61
Monarch Tower 50
Moores Mill Road 67
Morris Brandon School 77
Mount Paran 23, 25
Mount Paran/Northside 20, 29
Mount Paran Road 20, 30
MS Walk 97
Mt. Paran Church of God 85
Mt. Paran Road 85
Murphy, Mike, Headmaster 67, 68
Muscogee Indians 15
Muscogee Street 24

N

Nancy Creek Nature Preserve 27, 151
National Merit Scholars 69
National Multiple Sclerosis Society 97
National Register of Historic Places 24, 27, 32, 38, 40, 72
National School of Excellence 66, 67
NAVA 135
Neiman Marcus 55, 107, 108
Neo-Classical furniture 42
Netherlands Antilles 54
Newsradio 640 WSGT 62
New Orleans 128, 136
Noble, Edward 108
Northside Drive 42, 64, 67, 88
Northside Parkway 70
Northside Parkway, NW 73, 76
North Atlanta High School 66
North Avenue MARTA station 154
North Carolina 115
North Fulton High School 67
North Georgia 111
Now & Again 115

O

Oberst, Michele 152
O'Hara, Bishop 83
Old Guard of Atlanta 18
Olympics 95
One Buckhead Plaza 55, 135
One Capital City Plaza 59

P

PaceSetter Walk 2002 98

Paces Ferry Road 69
Pace Academy 8, 24, 67, 68, 97, 98
Pace Academy Booster Club 98
Pace Race 97, 98
Palisades Road 13
Pano's and Paul's 126
Paralympic Games 95
Parisian 55, 110, 112
Park Avenue Condominiums 148
Park Place 91
Park Regency 151
"Party with a Purpose" 97
Peachtree 150
Peachtree-Beverly Hills 24
Peachtree- Dunwoody Road 80
Peachtree Battle 15, 18, 25
Peachtree Battle Avenue 8, 24, 73, 80
Peachtree Battle Shopping Center 112, 117
Peachtree Café 128
Peachtree Creek 12, 15, 19, 111, 112, 151
Peachtree Heights 19, 20, 32, 33
Peachtree Heights Historic District 24
Peachtree Heights Park 24
Peachtree Heights School 73
Peachtree Heights West 20, 33
Peachtree Hills 19
Peachtree Park 24
Peachtree Parkway 156
Peachtree Presbyterian Church 81, 85
Peachtree Road 8, 10, 13, 15, 17, 19, 26, 27, 46, 47, 48, 56, 59, 61, 74, 80, 82, 83, 85, 86, 91, 95, 108, 111, 112, 117, 129, 132, 136, 144, 145, 148, 156
Peachtree Road, NE 53, 60, 64, 86, 115, 117, 140
Peachtree Road, NW 55, 141, 143
Peachtree Road Race 95, 98, 111
Peachtree Road United Methodist Church 82, 90
Peachtree Street 37, 111, 128, 139
Peachtree Way 19, 66, 82, 83
Peach Tree Trail 15
Peridot Distinctive Gifts 120
Pharr Road 17, 39, 127
Phelps, Kenneth J. 16
Phipps Plaza 10, 52, 53, 61, 69, 91, 97, 105, 107, 110, 111, 112, 113, 119
Piedmont-Lenox 150
Piedmont Bank 57
Piedmont Center 50, 60
Piedmont Hospital 54, 95, 96
Piedmont Medical Center 59, 96
Piedmont Park 111
Piedmont Road 24, 29, 45, 50, 51, 56, 60, 62, 82, 112, 116, 122, 131, 136, 139, 144, 154
Pierre Deux - French Country 122
Pinnacle 50
PKF Consulting 53
Plantation-plain style house 38
Plaster, Benjamin 56
Plaster Bridge Road 56
Ponce de Leon Avenue Baptist Church 81, 82
Post Chastain 24, 27
Powers Ferry Road 66, 80
Powers Ferry Road, NW 145
Presbyterian congregation 81, 84, 85

Price, Gary 37, 46
PricewaterhouseCoopers 53
Professional Actors Studio 70
Prominence in Buckhead 51
Prudential Insurance 53
Pruitt, Jenny 8
Publix 117
Pub Crawl 104
Pulitzer Prize 86

Q

Quarry Garden 41

R

R.E.M. 129
R. L. Hope School 13
R. Thomas' Deluxe Grill 139
Ray Swords Photography 97
Reeves, Head Coach Dan 62
Reid, Neel 22, 33, 100
Reliance Financial Corporation 16
Resurgens Plaza 50
Revolutionary War 15
Rich's Department Store 8, 55, 108, 113, 155
Rich's Great Tree 111, 113, 155
Ritz-Carlton 53, 97, 101
Rodeo Drive 12
Rohrig, George 128
Romanesque period 88
Romanesque Revival architectural period 88
Roswell-Peachtree split 112
Roswell-Wieuca 150
Roswell Road 10, 13, 15, 17, 24, 27, 70, 81, 85, 86, 112, 119, 131, 132, 136
Rotary Club of Buckhead 42
Rowan, Fred 156
Roxboro Road 156

S

"Share Our Strength" (SOS) Taste of the Nation 92, 97
Saks Fifth Avenue 55, 110, 111, 119
Sallee, Jim 8
Sapp, Pastor David 81
Sardis United Methodist Church 78, 80
SAT scores 69
Schroeder, Henner 34
Second-Ponce de Leon Baptist Church 80, 81, 82, 91
Second Baptist Church 81, 82
Second Church of Christ, Scientist, Atlanta 86
Seeger, Gunter 126
Seeger's 126
Seventh-Day Adventists 80
Shepherd, Alana and Harold 94
Shepherd Center 54, 92, 94, 95
Sheraton 53
Sheridan Drive, NE 72
Shutze, Philip Trammell 22, 24, 33, 38, 40, 43, 72, 100
Silicon Valley Bank 53
Simon Property Group 53, 113
Singer Sewing Store 19

Sixty-Five Roses Ball 97, 100
Smith, Robert 44
Sobu Row 37
Southern Baptist congregation 81, 82, 86
Southern Center for International Studies 24, 43
South Buckhead 36, 37
Spirit of ADA Torch Relay 94, 95
Stack, R. Timothy 59
Standing Peach Tree 15
Stan Milton Salon 112
Starbucks 53, 131
Steamhouse Lounge 131
Stevens & Wilkinson 73
Stone Mountain 15
Stratford 86
Super Bowl 108
Swan House 38, 40, 41
Sweet, Melissa 115
Swissôtel 53, 57, 97
SYNAVANT 60

T

"Taste of the Nation" 97
"Team Atlanta" 53
"The Buckhead Blueprint" 150
"The Dining Room of Georgia" 126
"The Park Avenue of Atlanta" 25
"Trail of Tears," 15
Talbot's 117
Target 53, 112
Taylor, James 129
Temptation of Eve 47
Tennis Magazine 42
Tenth Annual Crohn's & Colitis Foundation of
 America Golf Classic 105
Terry College of Business 74. *See also* University
 of Georgia - Terry College of Business
Thanksgiving 111, 113, 155
The Battlefield of Peachtree Creek 13
The Bilt-House 48, 107, 120
The Buckhead Diner 136
The Cathedral Antiques Show 97
The Cheesecake Factory 126
The Children's Museum of Atlanta 105
The Christian Science Publishing Society 86
The Coca-Cola Cafe 38
The Decorators' Show House 97
The DeFoor family 15
The Dining Room at the Ritz-Carlton 126
The Episcopal Church Women of the Cathedral
 of St. Philip 102
The Era of Reconstruction 41
The Feast of Christ the King 83
The Gipsy Kings 129
The Great Fish 38, 127
The Great White Hunter 34
The Grove Buckhead 29
The Gym at Buckhead 119
The Heiskell School 12, 64, 67
The High Museum Atlanta Wine Auction 97
The Howell family 15
The Kite Children 38
The Landmark Diner 136
The Lodge 15
The Manor at Buckhead 20

The Montgomery family 15
The Moore family 15
The Morrison Agency 56
The Netherlands 54
The Pace family 15
The Peacock House 24, 43
The Phoenix 26
The Portfolio Center 69, 74, 112
The Powers family 15
The Rhodes-Robinson House 100
The Robert Smith family 38
The Southeast 9, 25, 52, 53, 55, 69, 76, 94,
 100, 102, 108, 109, 111, 115, 150
The Storyteller 38
The Swan Boy 34
The Temptations 147
The University of Georgia Alumni Club 53
Three Dollar Cafe 143
Tiffany & Co. 8
Time magazine 73
Toccoa 15
Thompson,Gary 52
Tower Place 12, 37, 38, 46, 50, 148
Tower Place Park 46, 148
Tower Walk Shopping Center 143
Transitional Housing Program 96
Trinity School 70, 73
Truman, Harry S. 13
Trygveson/Pink Castle. 22
Tudor estates 22
Tullie Smith Farm 38, 41, 44
Turning Point: The American Civil War,
 1861-1865 41, 46
Tuxedo Park 20, 22, 33
Two Securities Center 62

U

Union soldiers 16
United Methodist congregation 82, 90
University of Georgia - Terry College of
 Business 74

V

van Vlissingen, John Fentener 54, 55
Vespermann Gallery 34, 36
Village district 37
Villa Juanita 22

W

Wachovia Bank 52, 53
Warner, Peggy 25
Washington, D.C. 128
Washington Seminary 69
Wender & Roberts Drugstore 8
Westminster School 69
West Paces Ferry Road 8, 15, 22, 24, 31, 41, 42,
 53, 61, 67, 68, 100, 134
West Wesley Street 24
Wheelchair Division, Peachtree Road Race 95
Weinberg, Elbert 47
Wieuca Road 80
Wieuca Road, NE 90

Wieuca Road Baptist Church 80, 86, 91
William Carter Company 156
Williams, Ida 13
Willis A. Sutton School 66
Wingate Inn 53
Wings 46
Woodhaven 22, 24
Woodward Way 44
World Series 108
World War II 16, 24

Y

Yellow Pages 9
YoungBucks 55, 104

Z

Zagat Survey 8, 56
Zeist, the Netherlands 54
Zeus 39
Zone 2 Precinct Headquarters 150